WHEN million-footed Manhattan descends to her pavements,
When Broadway is entirely given up to foot-passengers
* and foot-standers, when the mass is densest,*
I too arise, answering, descend to the pavements,
* merge with the crowd and gaze with them...*

City of hurried and sparkling waters! city of spires and masts!
City nested in bays! my city!

<div style="text-align: right;">

WALT WHITMAN
from *Leaves of Grass* (1881)

</div>

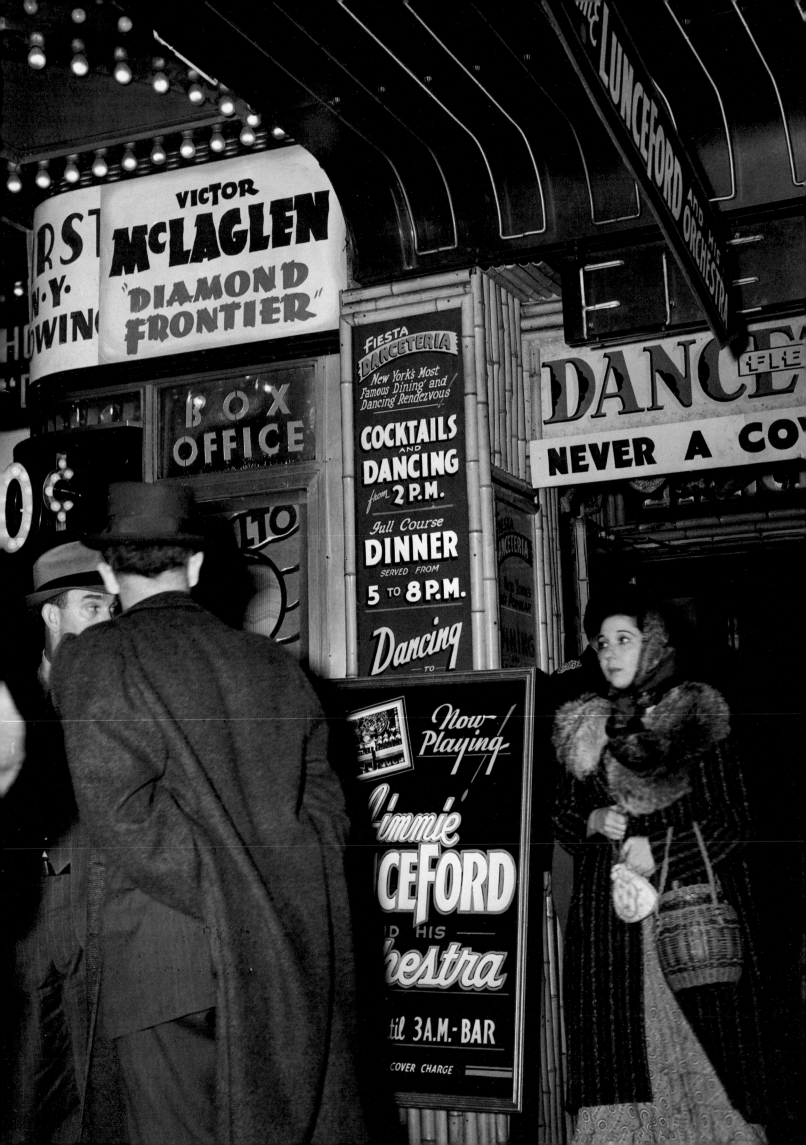

TIMES SQUARE
45 Years of Photography
LOU STOUMEN

APERTURE

NEW YORK

Times Square/45 Years of Photography
was designed and produced at Hand Press,
Los Angeles, by Lou Stoumen.

Design Assistant Marissa Roth
Production Assistant Kate Scanlon
Literary Representative Roberta Pryor

Production and Research Assistance
Lucille Bunin Askin, Byron Goto, Alma Hecht,
Liza Kevin Hennessey, Sonoko Kondo, Joel Levinson,
Ted Orland, Mariette Risley, Carol Tinker

Editors for Aperture Carole Kismaric, Mary Wachs
Publisher Michael Hoffman

Typeset in Times Roman, Univers and Pointille by
Heath & Associates, Los Angeles.
Printed in laser-scan duotone by
South China Printing Co., Hong Kong.

All rights reserved under International and
Pan-American Copyright conventions.
Published by Aperture, a division of Silver
Mountain Foundation, Inc. Distributed in the
United States by Viking Penguin, Inc.; in
Canada by Penguin Books Canada Limited, Markham,
Ontario; in the United Kingdom and Europe by
Phaidon Press Ltd.; and in Italy by Idea Books, Milan.
Times Square was made possible in part by a grant
from the Florence V. Burden Foundation.

ISBN: 0-89381-164-5, cloth; 0-89381-165-3, paper.
Library of Congress Catalogue Card Number: 84-71747.

C O N T E N T S

Aperture publishes a periodical, books and portfolios
to communicate with serious photographers and creative
people everywhere. A complete catalogue will be mailed
upon request. Address: Millerton, New York 12546.

(frontispiece) **TEN CENTS A DANCE 1940**

THIS
RESONANT
ACRE

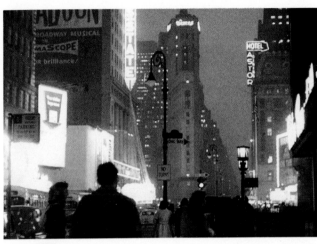

1956

I'VE BEEN PHOTOGRAPHING TIMES Square since 1939, almost half a century. The work began as a Pennsylvania country boy's love letter to his adopted city. Over the decades it grew into an obsession.

I couldn't let go. Times Square was (and is) a power place, a microcosm of New York City, the nation and the world. All the changes that happen anywhere seem to become evident here. I felt if I could eyewitness this resonant acre, photograph it persistently as Brady chronicled the Civil War, then I would understand cities, nations and why people do what they do. I would achieve public service, riches and the love of beautiful women.

Mostly, it didn't turn out that way. The big change of World War Two took me to Puerto Rico, India, Burma and China for four years, and after that to Los Angeles. But by the 1950s I was managing photographic trips to Manhattan most every year. In the end, the reward of my Times Square work seems to be itself—a few thousand negatives, some prints and this book.

My camera mapped Times Square broadly. North to the green rim of Central Park. East to the promenade of Fifth Avenue. South by tour bus to the Statue of Liberty. Up to the roof of the old New York Times Building (now "Number One Times Square"). And Down into the fierce underworld of the subway.

I did learn through all this work something about change. The old 1940s pictures in

particular project a very spooky time sense. "I" was there, but I'm somebody else now. Americans don't look like that anymore. Young or older, our faces are different. We were a younger people then, ingenuous. Men wore hats. Women wore skirts. Teenagers seemed to behave. Couples stayed married. Practically everybody in Times Square was white and middle class, or snooty rich come to the theatah. Top hats, mink coats and diamonds fearlessly walked their owners down Broadway.

Looking at these photographs, the old ones and today's, you and I have to see them through a filter of 1980s consciousness. Like Adam and Eve expelled, we all have guilty knowledge—of World War Two and Hiroshima, of the planet's environment being progressively ravished, of sophisticated massacres on all continents, of hunger, unemployment and crime, of the possibility of World War Three and goodbye Charlie . . .

While we wait and hope, the news in retrospect is that 1940 was quaint but OK, with seldom a mugging in Central Park. A funny capable mayor read comics to the city's children on radio. Most inhabitants figured they could trust their government—city, state and Washington. Most places in the country had clean air, woods, food and water. Kids had reason to expect they'd do better in life than their parents.

I never expected in 1940 that almost fifty years later I'd still be working in Times Square, trying to photograph it all. Or that on the corner of Broadway at 47th Street, just as I was finishing this work, I'd get slugged in the face by a doped-up objector to photography. *"Whyyoumakepitchers!?"* he screamed. Good question.

I pushed him away, my only injury a torn camera strap. But I did think: he could have had a gun or a knife.

The metaphor of "The Big Apple" is fun, but simplistic. An artifact imagined by organized merchants. Times Square and its City has never been a single, pretty, crunchy thing. What we have here is more of a mix, a puree. New batch each day.

Applesauce. The Big Applesauce! It's tart. Sometimes sour, even rotten. Mostly delicious.

Here's the book, a paper movie. A photographic time machine. Welcome aboard! Hope you enjoy the trip.

Lou Stoumen

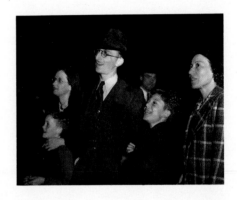

1 BACK IN 1940

*This generation of Americans has a
rendezvous with destiny.*

FRANKLIN DELANO ROOSEVELT

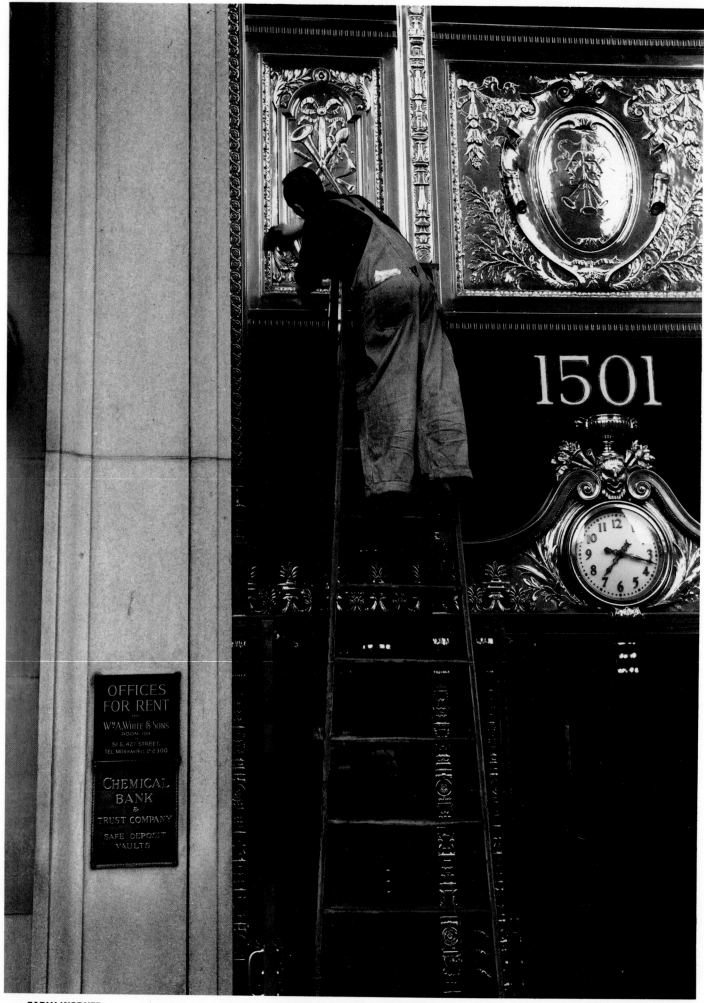

EARLY WORKER At 7:17 AM workman hand-polishes bronze grill of the Paramount Building at 1501 Broadway. This art deco facade is one of Times Square's few architectural landmarks still surviving in its original form into the 1980's.

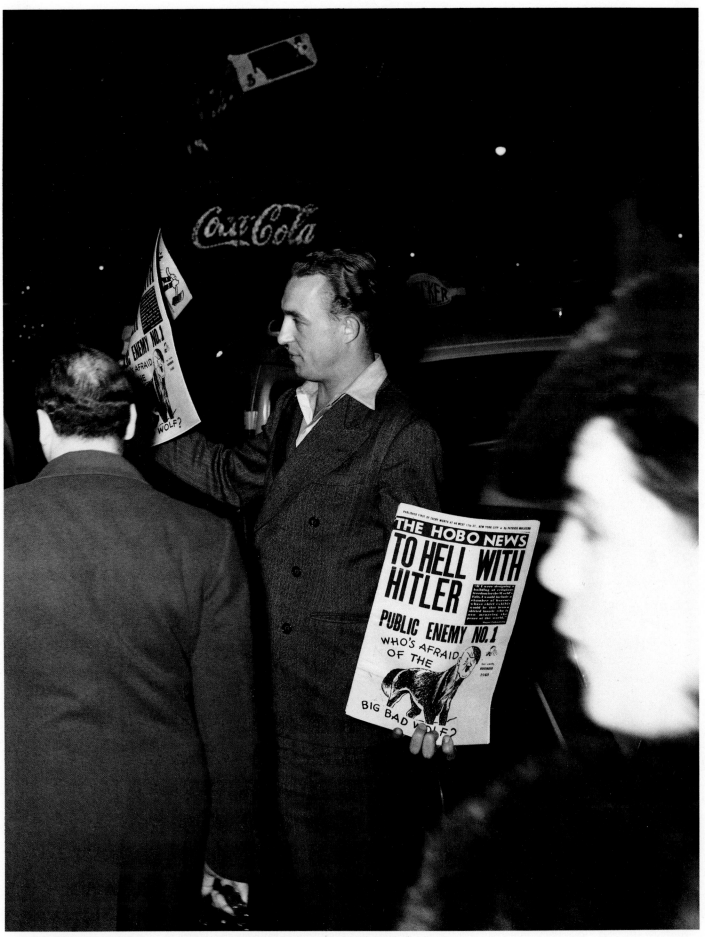

TO HELL WITH HITLER In 1940 the Hobo News was not a gag but a regular
weekly newspaper, maybe vulgar in tone, but fun.

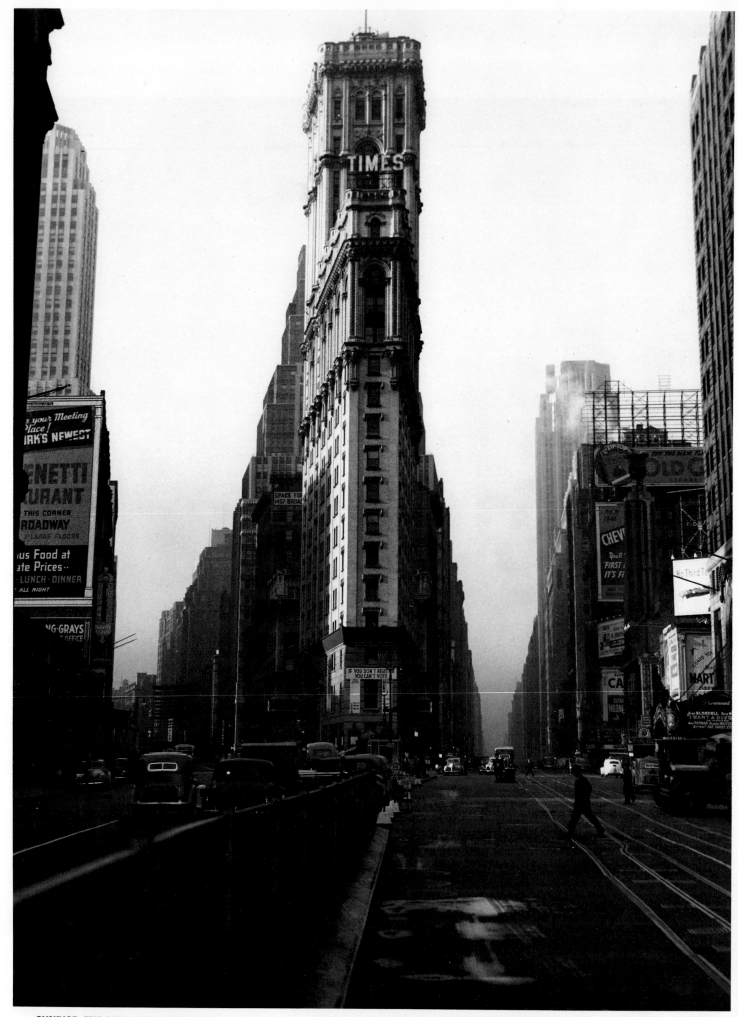

SUNRISE, THE NEW YORK TIMES BUILDING 1940

This stately structure was built by the Times in 1904.
After the newspaper moved its editorial and production
facilities to 43rd Street, the old structure was sold
three times.

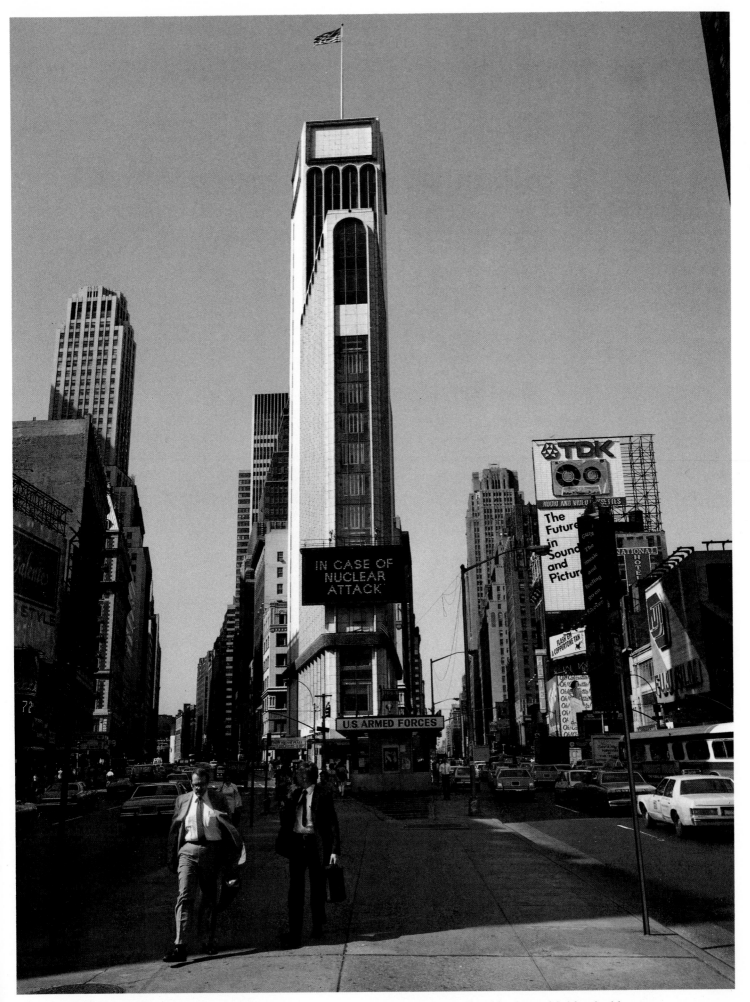

SUNRISE, "NUMBER ONE TIMES SQUARE" 1982

It was new owner Allied Chemical Company that gutted the old Times Building, refurbished its inner offices and resurfaced its face with bland white stone. The famous electric news bulletins circumnavigating the building were replaced by a single commercial billboard.

UNEMPLOYED 1940

US Government statistics were not kept accurately those
days, but during the great Depression approximately
14,000,000 Americans were unemployed. This situation
and its attendant foreclosures, hunger and suicides
persisted from the stock market crash of 1929 until cured
by a great new growth industry, World War Two.

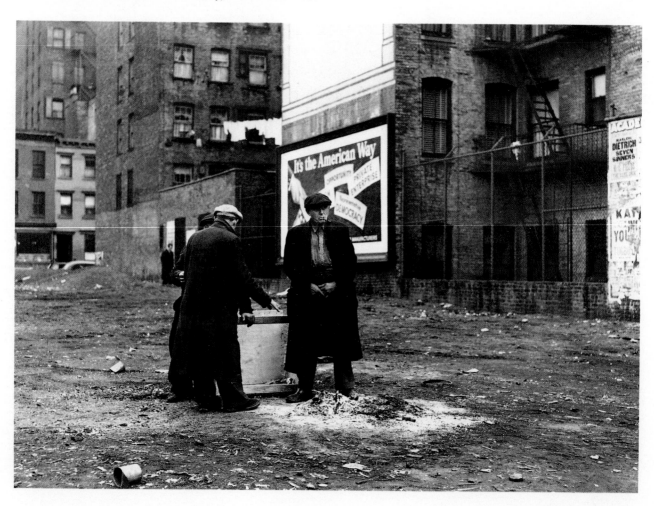

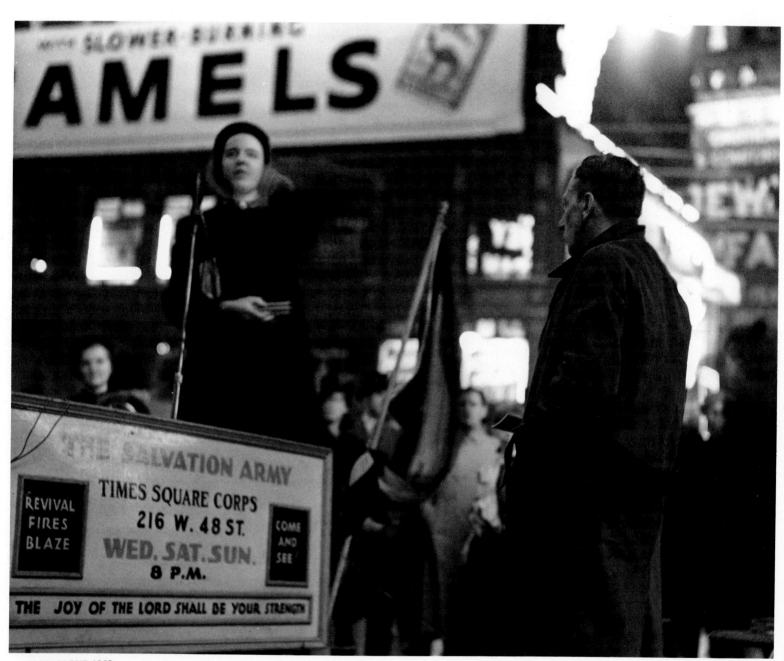

MAN ALONE 1940

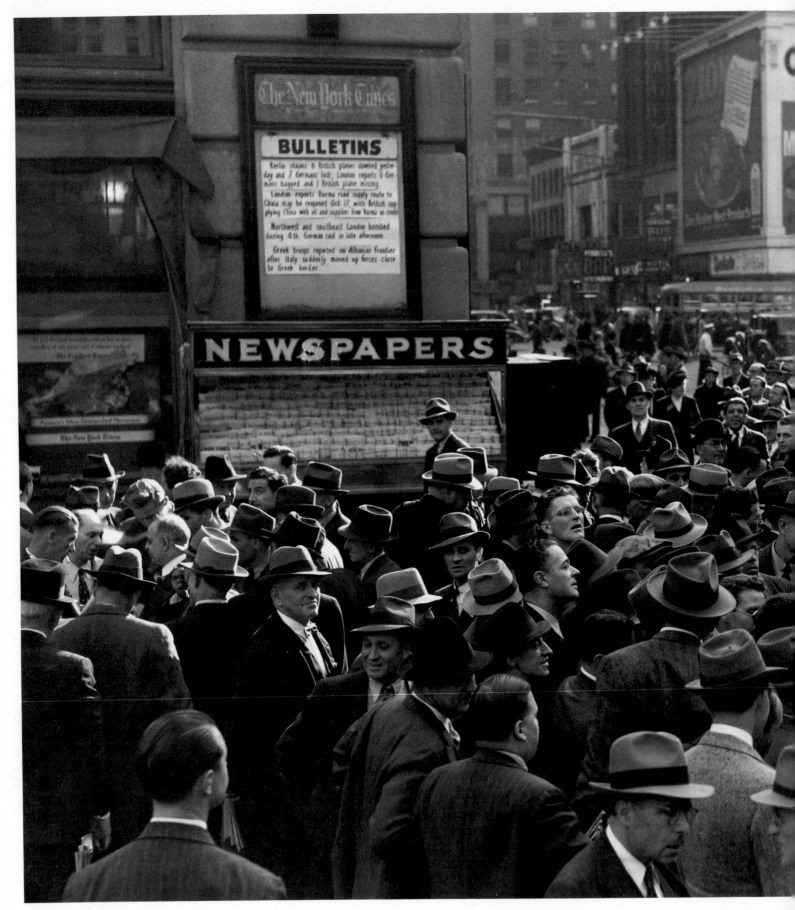

NEWS BULLETINS

In 1940 Europe was already at war with Nazi Germany. The United States was still at peace. In the late afternoon each day Times Square office workers would descend to the pavements back of the Times Building to read and discuss the latest war bulletins from London and Moscow. Sartorial note: most men those days wore suits, neckties and especially hats. They all

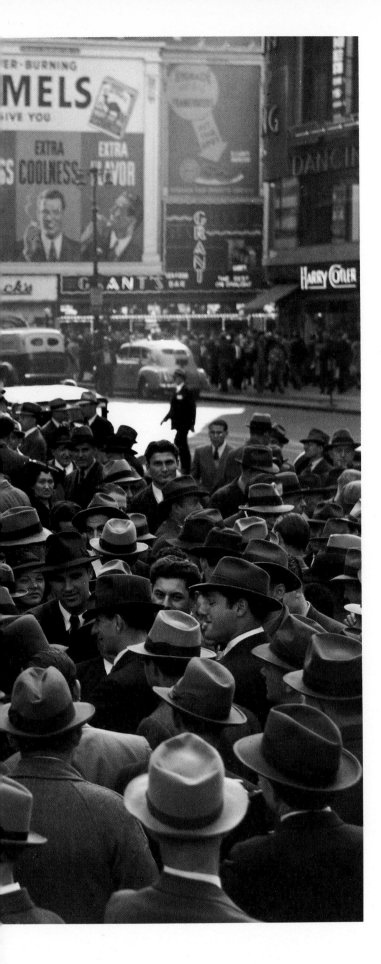

looked like George Raft or FBI agents. Sociological
note: Where are all the Women? If you look closely
you'll find two (under their hats). And no Blacks or Latinos.

In those days minority people stayed uptown in Harlem
unless they had jobs in restaurants, hotels or the
railroad station.

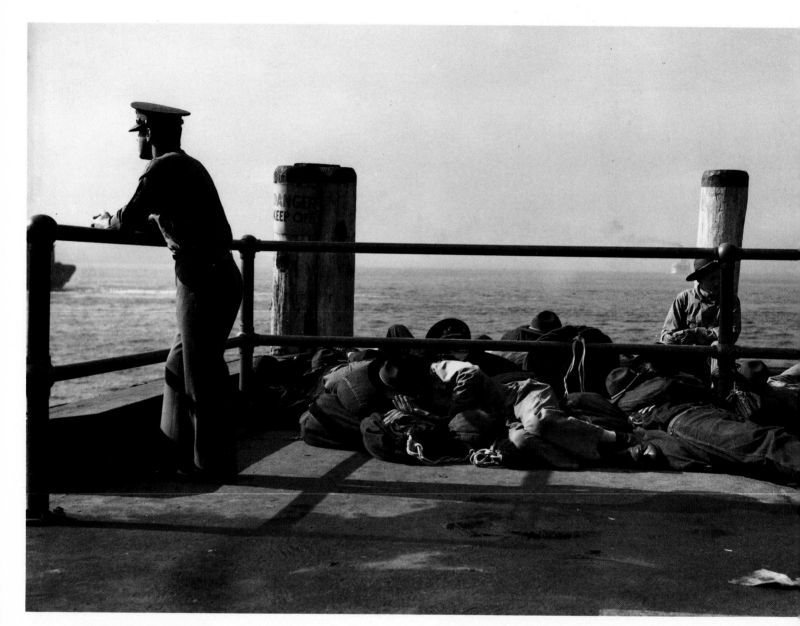

WAITING FOR THE WAR 1941

This photograph was made at the southern tip of
Manhattan Island, the Battery. US Army draftees
catch sleep on their barracks bags. I asked the sergeant
what was going on. He said they were "waiting for
transportation." I didn't ask where to. The soldiers
still wear the old World War One hats, like Boy Scouts.
Soon after making this picture I went into the army
too. Ended up in China, and in a B-29 over Japan.
Didn't get back to photograph Times Square again till
the 1950s.

2 MAKING IT

We will now discuss in a little more detail the Struggle for Existence.

CHARLES DARWIN
from The Origin of Species

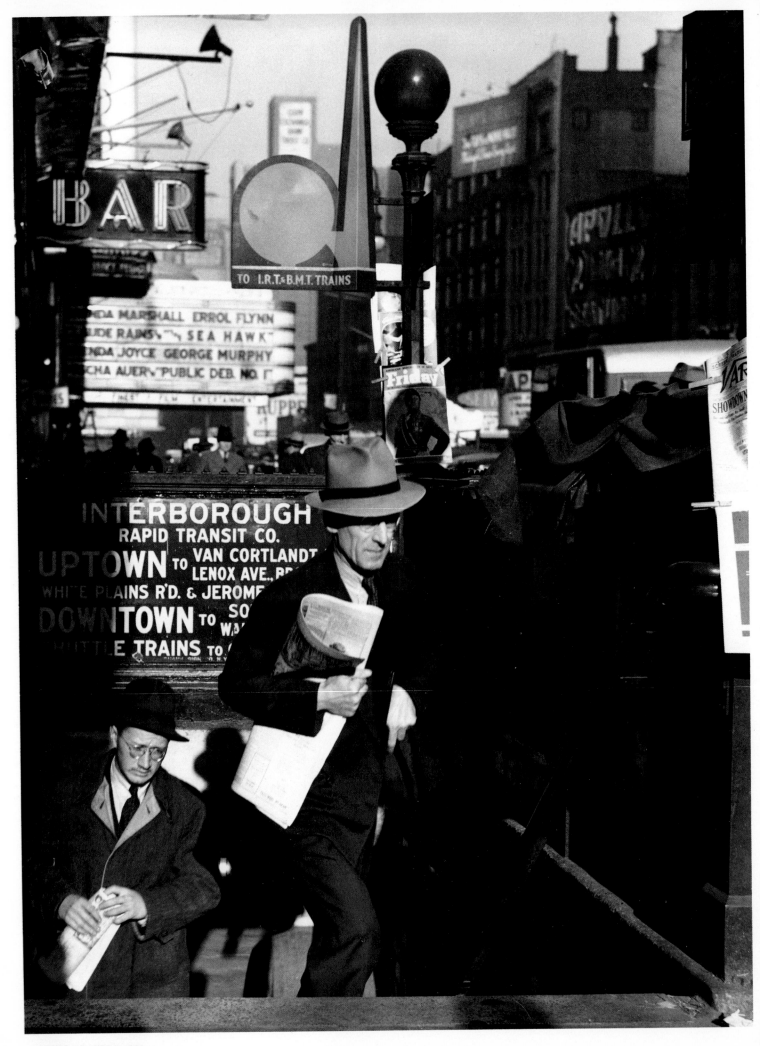

GOING TO WORK 1940

Office workers rise from the subway to meet the morning sun.

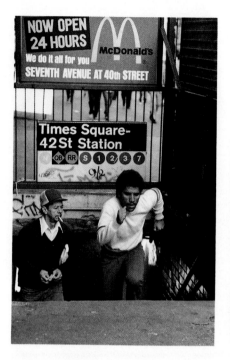 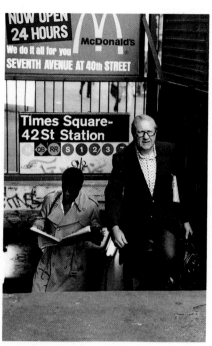

GOING TO WORK

Same subway exit, corner of 42nd Street and 7th Avenue, 42 years later.

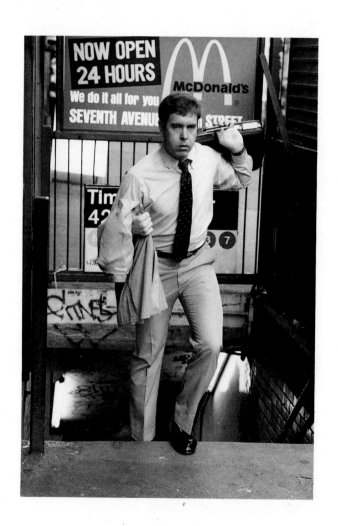

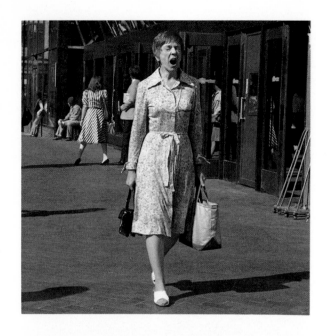

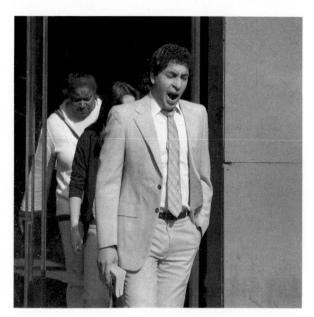

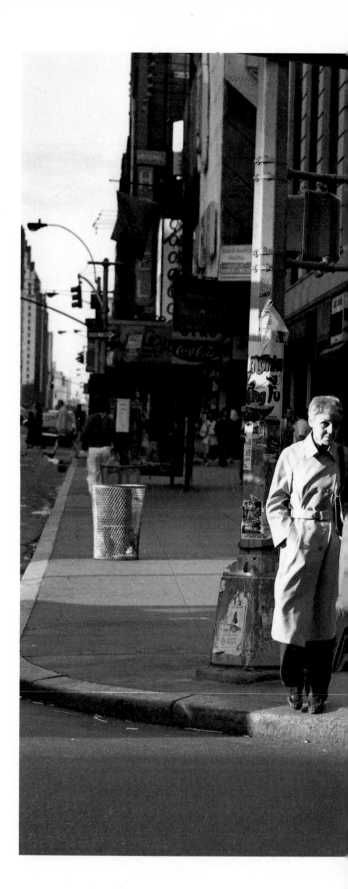

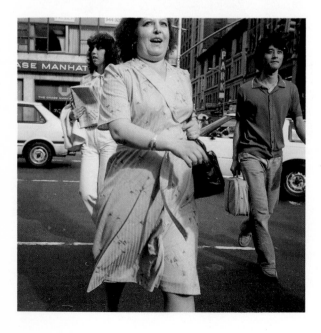

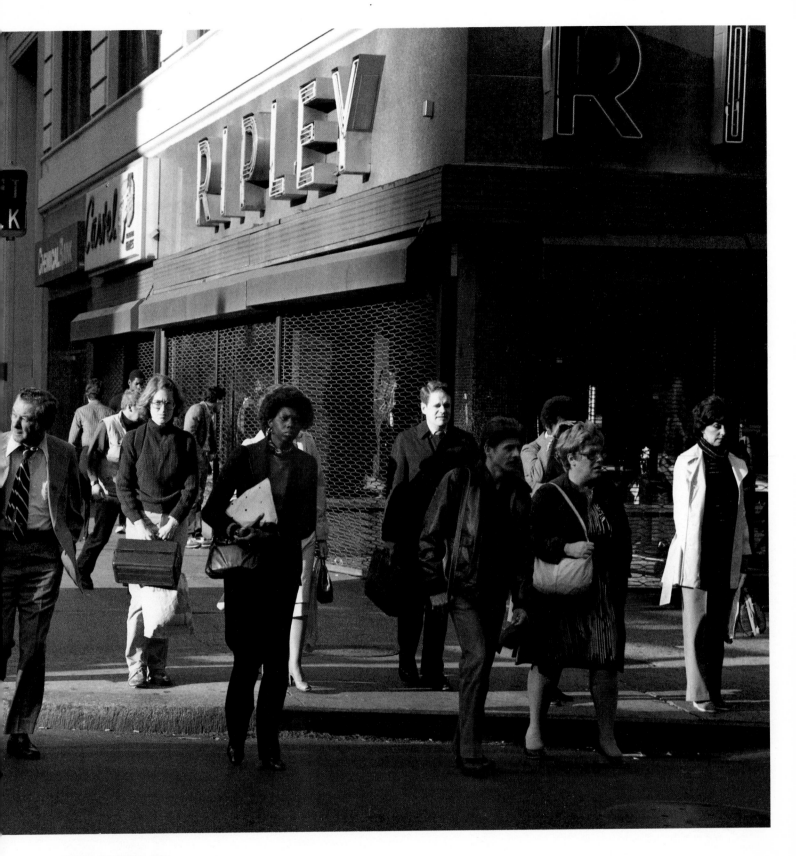

GOING TO WORK 1981

Monday mornings seem especially hard to accomplish.
The rising sun spotlighting down 43rd Street discovers
no joy. Yet some people march to a different drummer.
Lady in picture at far left was actually singing.

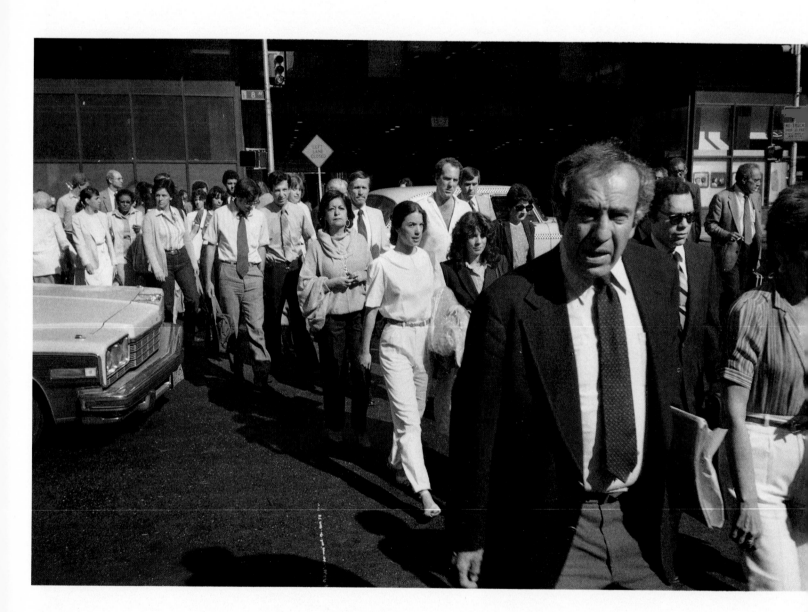

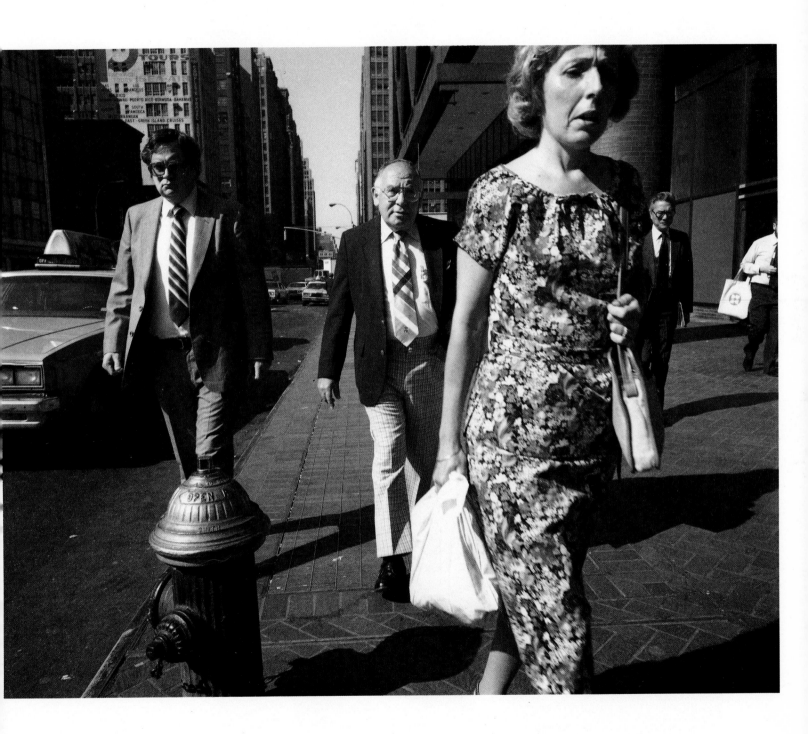

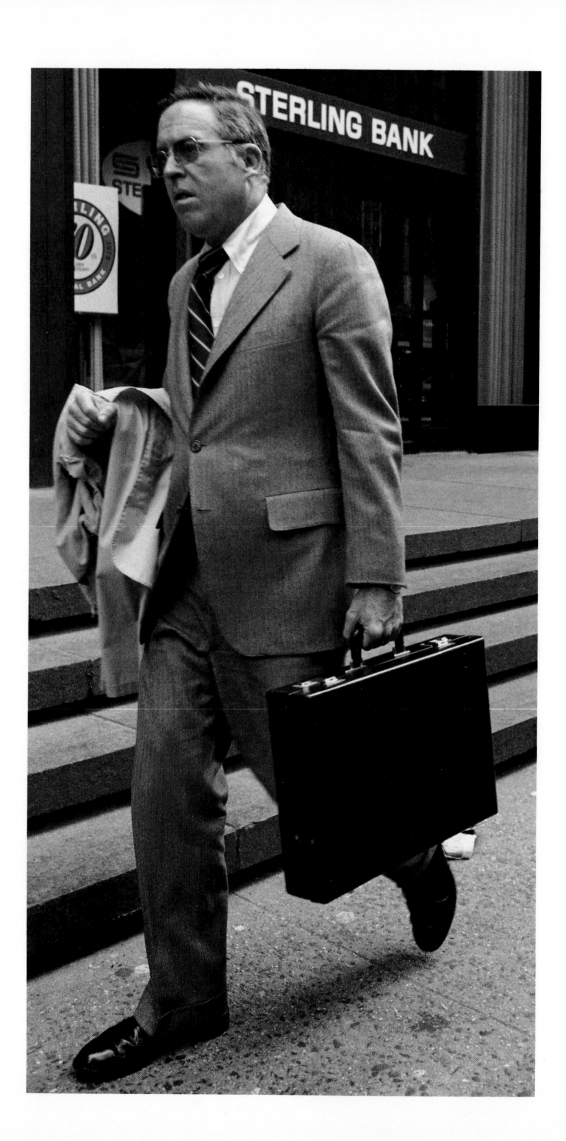

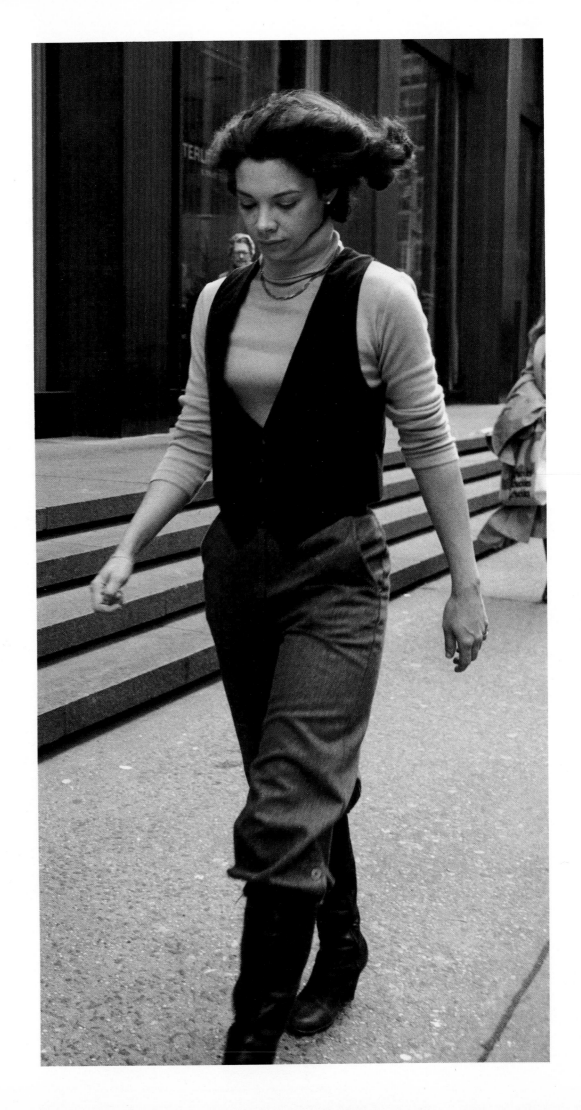

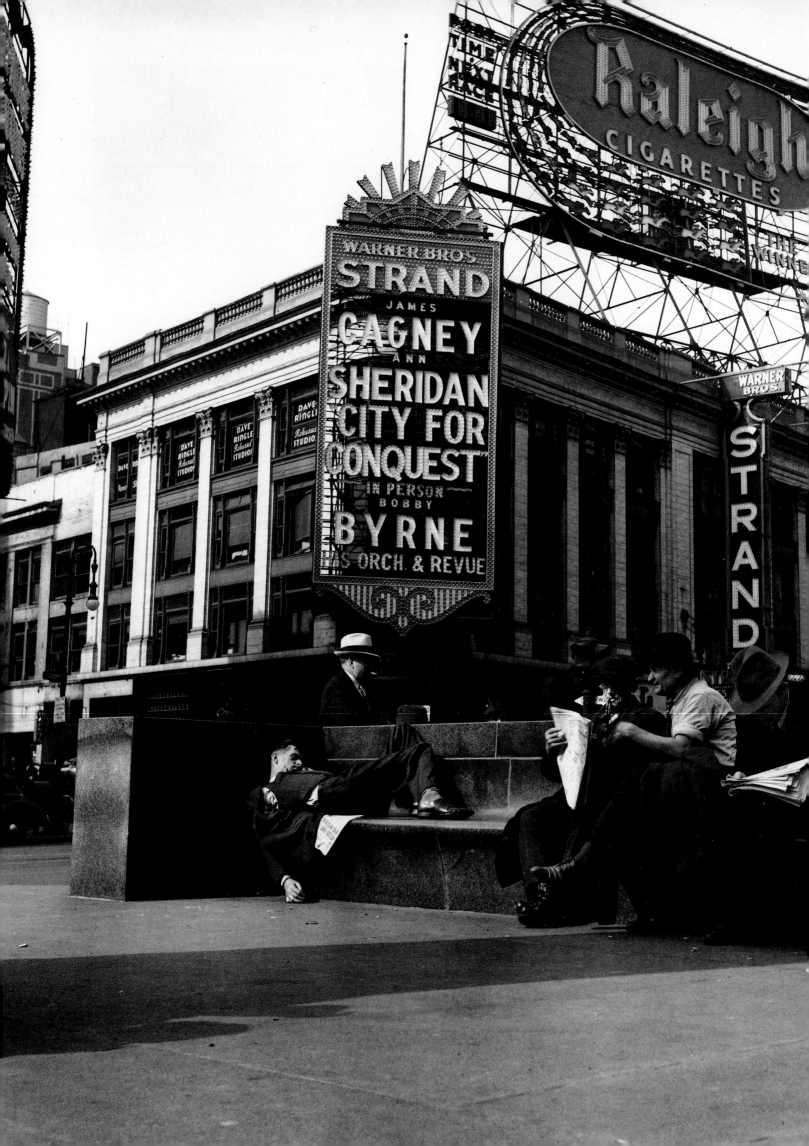

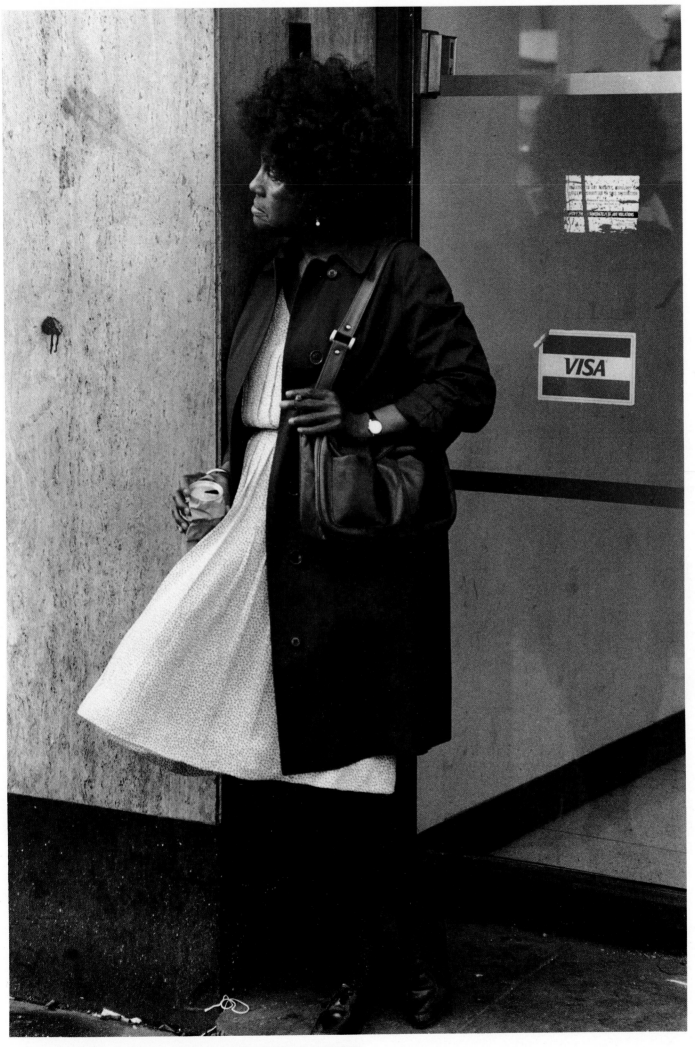

LADY WAITING, WATCHING, SMOKING AND DRINKING IN THE WIND

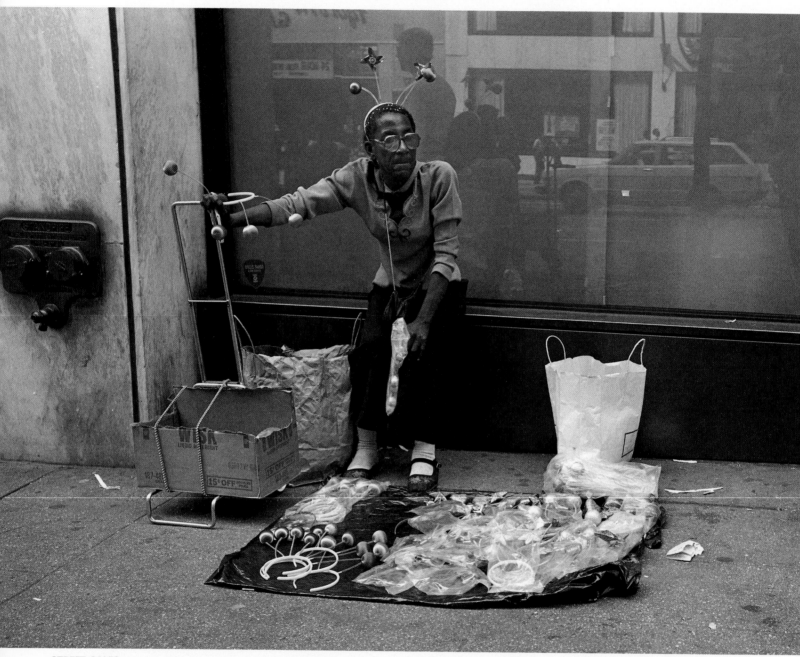

STREET SALES

Fads always sell well when they first happen — ballpoint
pens, hula hoops, glasses with funny noses. This lady
is having slow business for her deely-bopper hats, a
sci-fi fun fad of the early 80s.

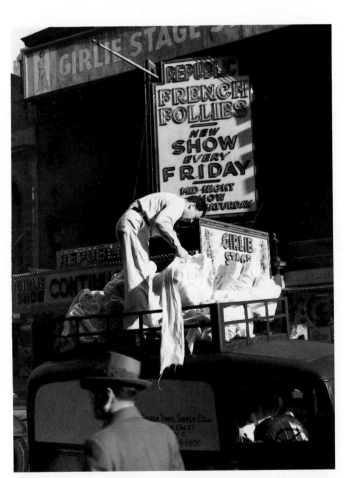

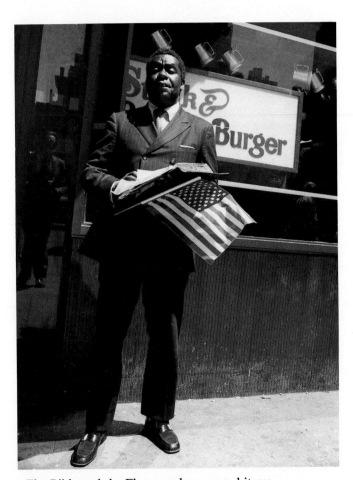

Laundry service was a solidly established business back
in 1940, before paper towels and electric hand dryers.

The Bible and the Flag are always good items.

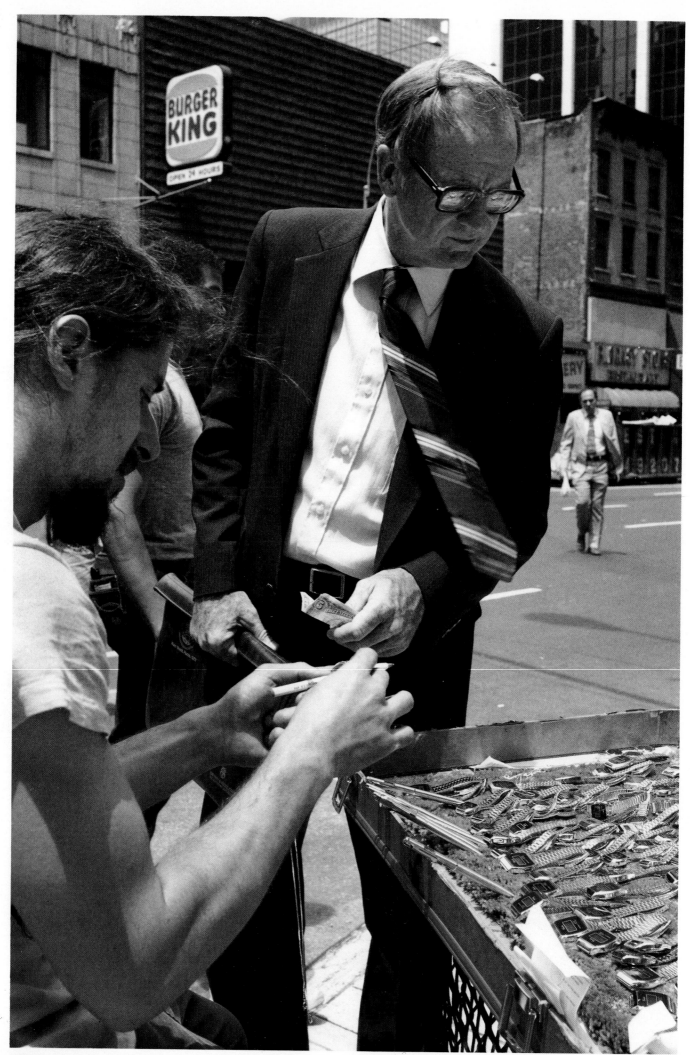

DIGITAL WATCHES

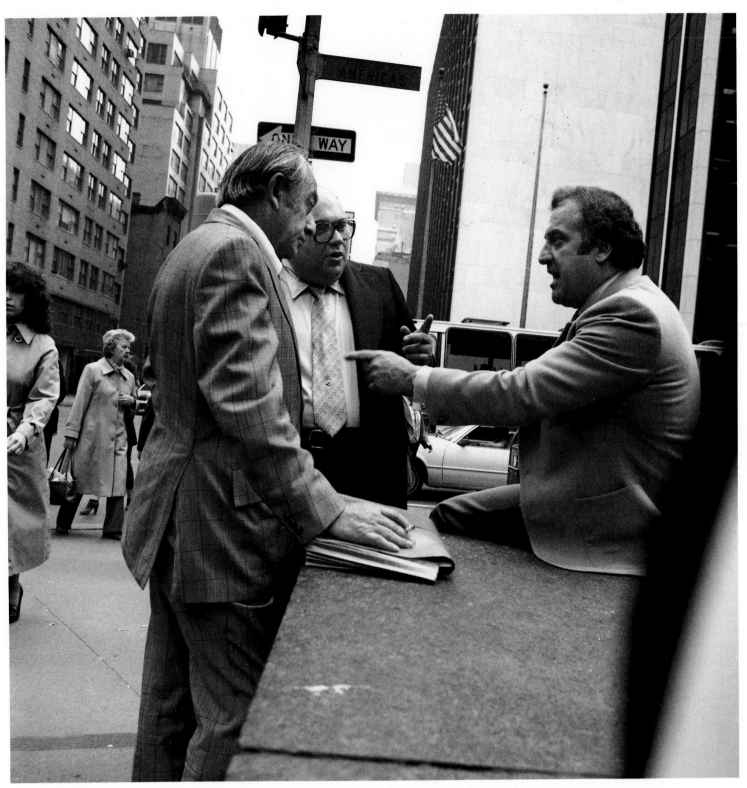

LUNCH BREAK

32

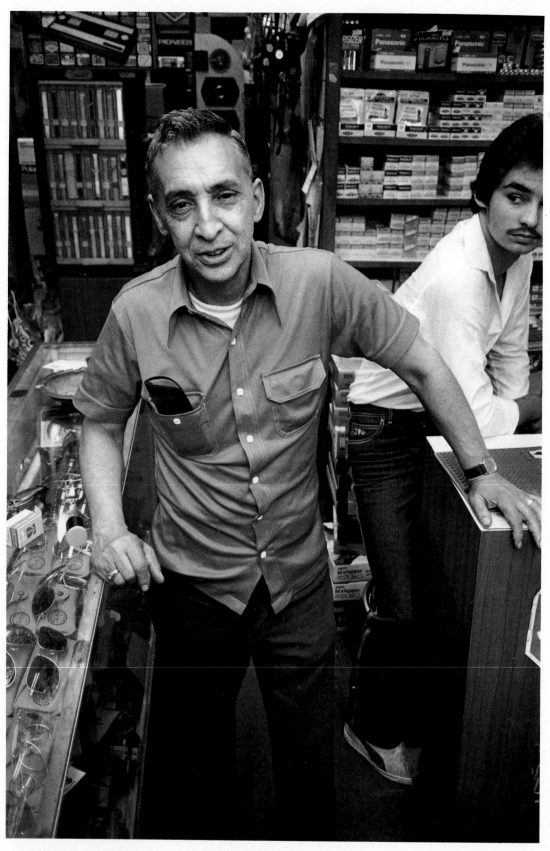

SHOPKEEPER 7th AVENUE

"Crime in Times Square? There isn't any. Maybe out in the suburbs but not in Times Square. Why? There's too many people here. Everybody's watching."

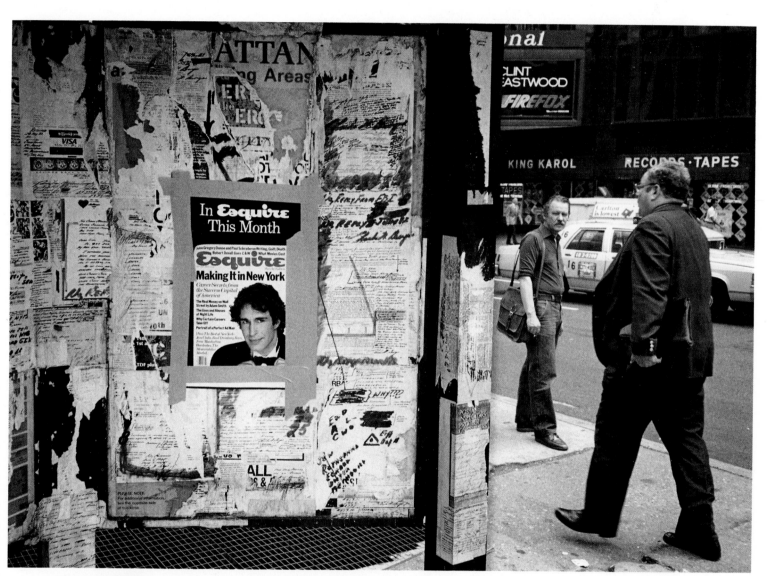

AMERICAN DREAM

The dream of every red-blooded American youngster
has been to make it in New York City. That's where
all the marbles are, at least the biggest, shiniest ones.

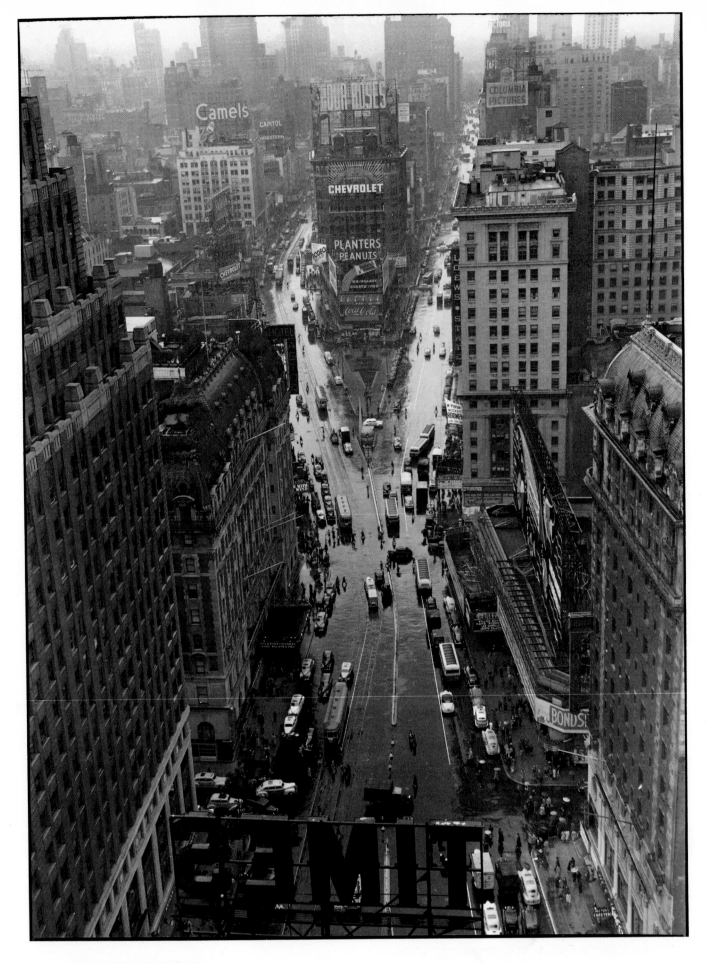

TIMES SQUARE IN RAIN 1940

Making it in New York has been the dream of individuals but also the need of corporations and nations. In 1940 the famous electric signs of Times Square announced Wrigley's, Camels, Four Roses, Columbia Pictures, Bonds Clothing and the great Times Building itself. By 1982, only survivor among these locals was Coca-Cola.

The others were replaced by Aiwa, Canon, Sony, Midori, Minolta, Toshiba and soaring new office buildings. Only the old Paramount Building at left remains stalwart. In place of the great Times sign is a sterile white ledge. The turn-of-the-century elegance of Hotel Astor is replaced by a glassy office building. Banzai!

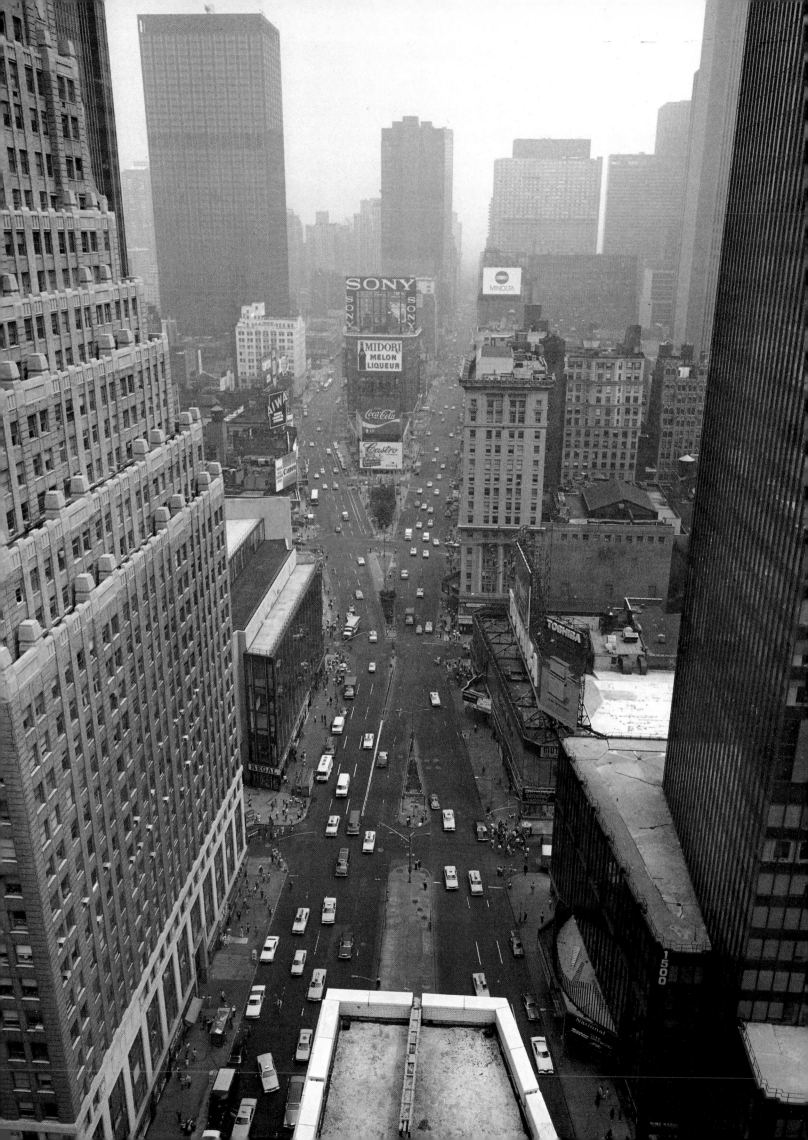

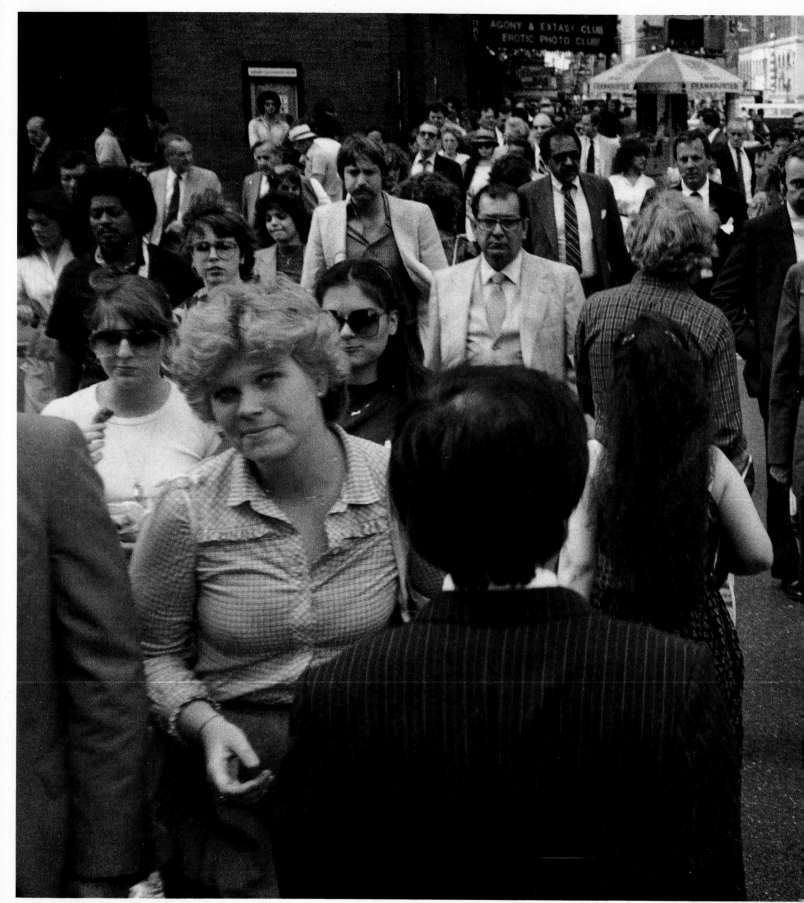

GOING HOME FROM WORK

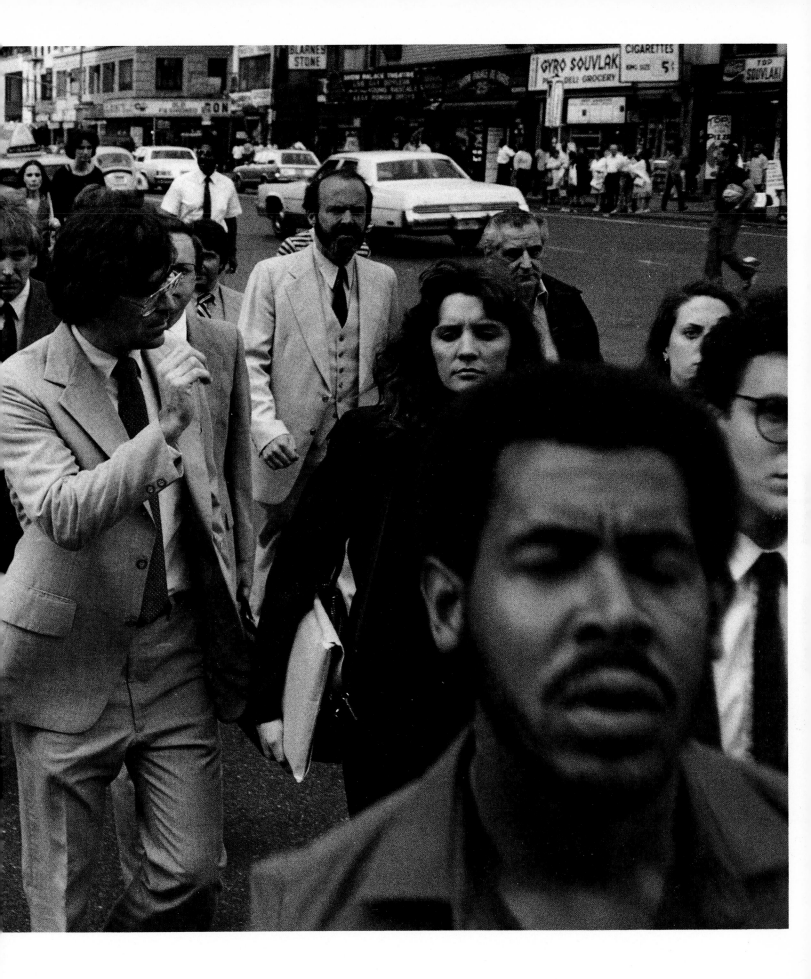

Those who dream by day are cognizant of many things which escape those who dream only by night.

EDGAR ALLAN POE
from Eleonora

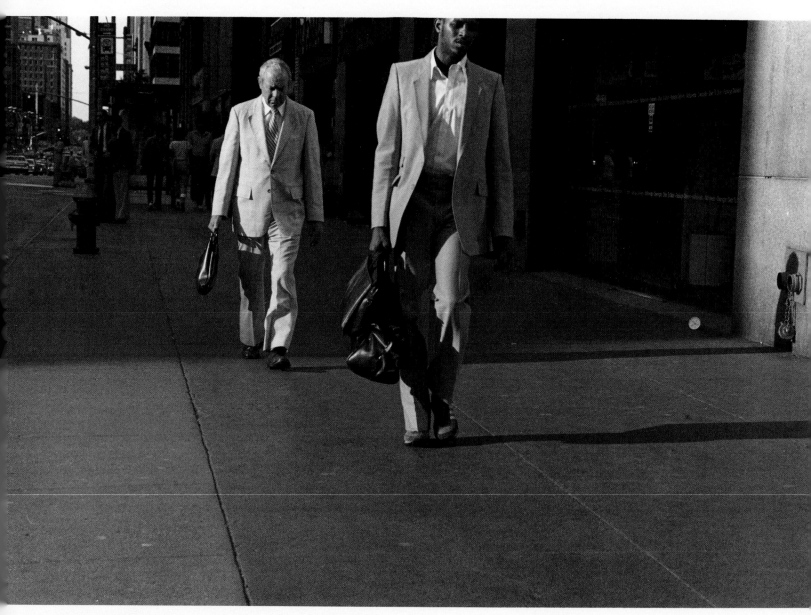

WORK DAY'S END

It can be a sober time for reflection. Could I have
done better? Suppose they turn down the deal? Never
mind. Soon I'll be with *her*.

3 SEEING IT

They come to see; they come that they themselves may be seen.

OVID (43BC-AD18)
from The Art of Love

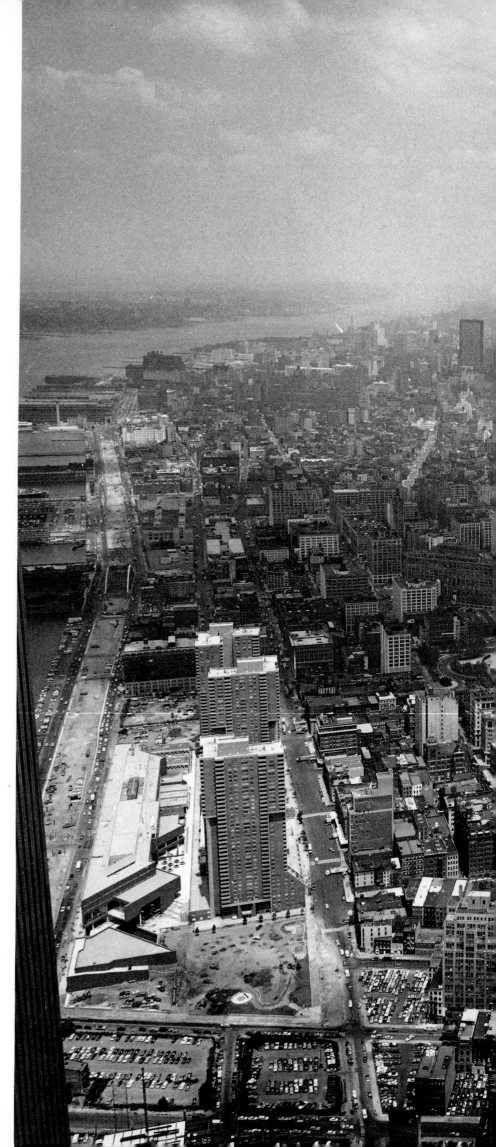

40

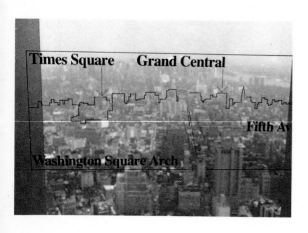

Times Square Grand Central

Fifth Av

Washington Square Arch

A STORM TRAVELS ACROSS MANHATTAN ISLAND AS SEEN
FROM THE 107th FLOOR OF THE WORLD TRADE CENTER

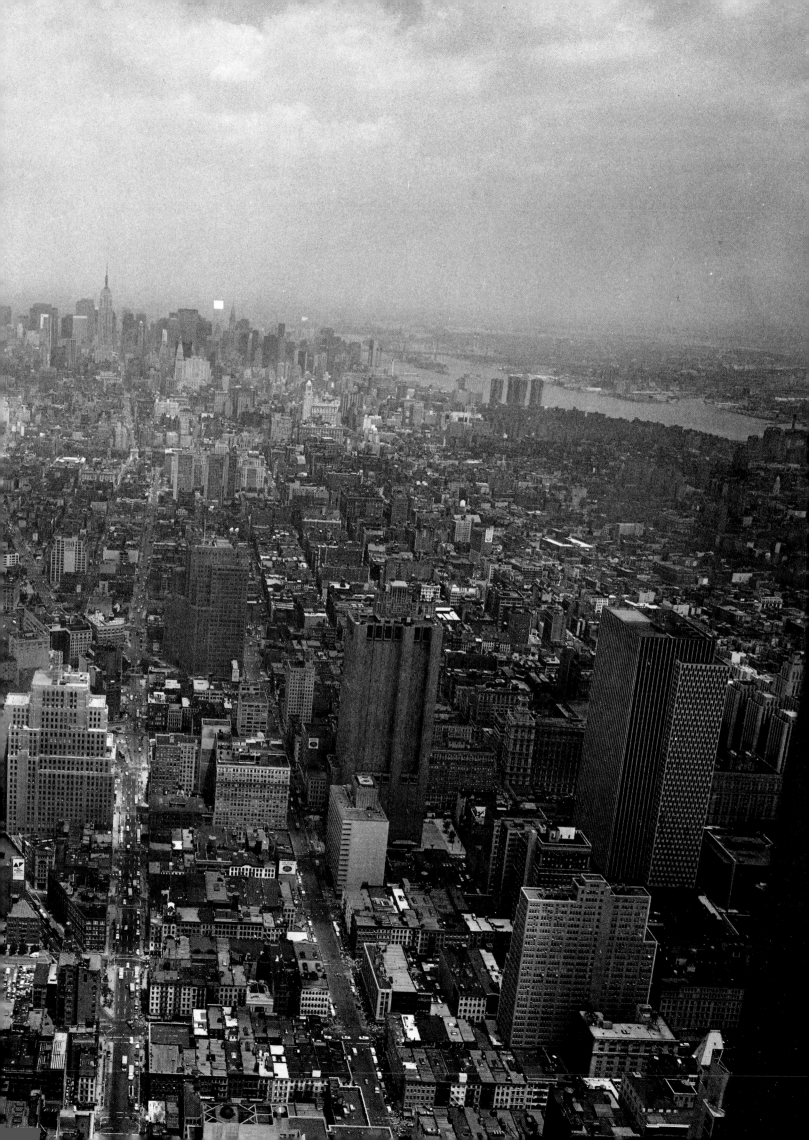

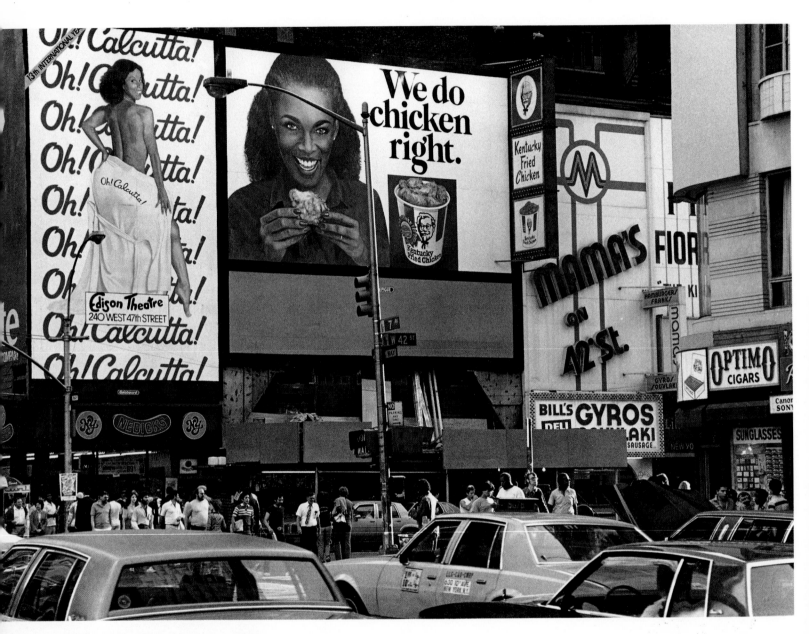

CORNER OF 42nd STREET AND 7TH AVENUE

This has been clocked to be New York City's busiest
intersection.

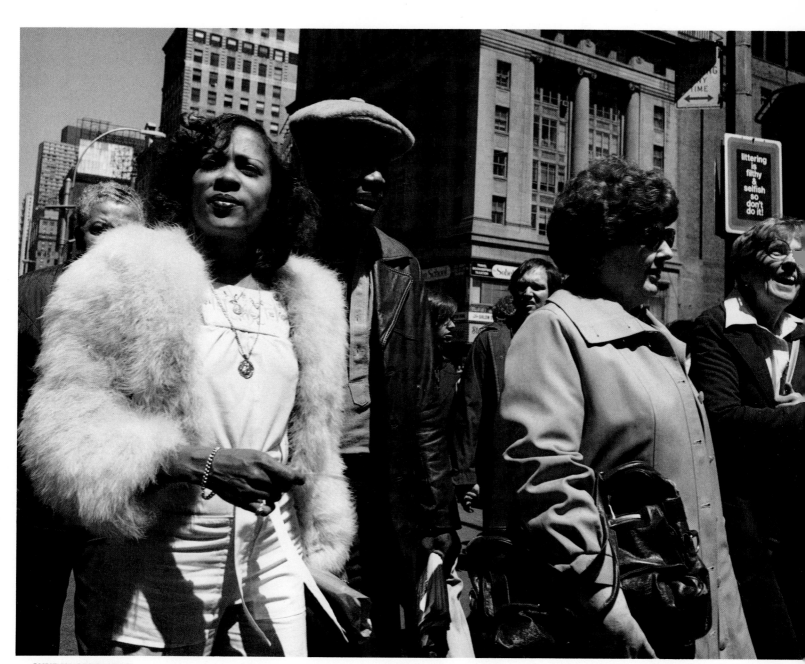

SUNDAY STROLLERS

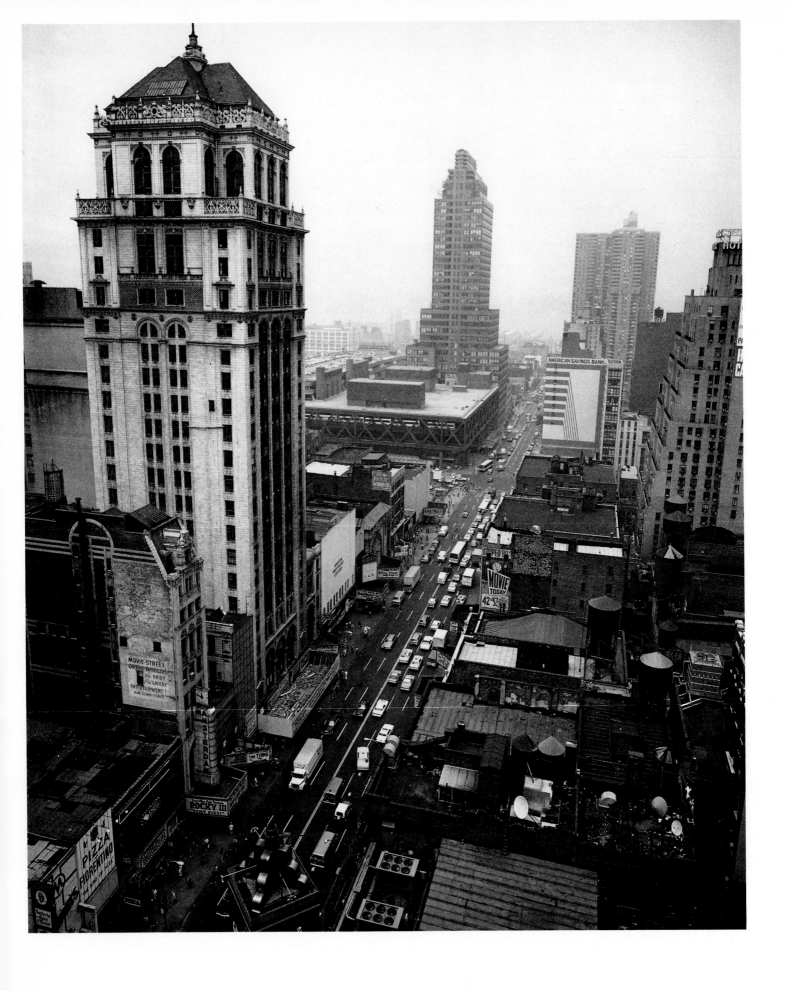

VIEWS FROM ROOF AND UPPER WINDOWS OF NUMBER ONE TIMES SQUARE 1982

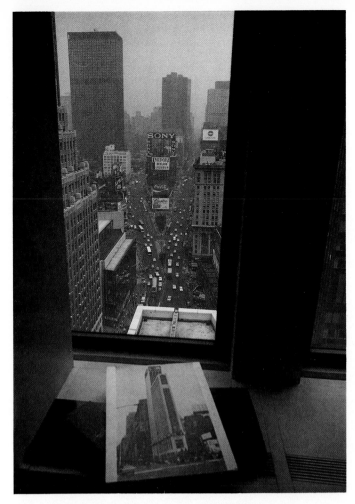

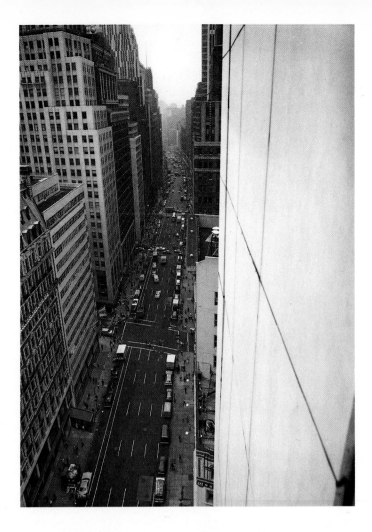

North to Central Park, Museum of Modern Art, the Zoo, Columbia University and Harlem. View is from office of Larry Linksman, president of Number One Times Square.

South to Washington Square, New York University, Wall Street and the Statue of Liberty. I had to lean out pretty far to get this shot.

East to New York Public Library, Grand Central Station, the United Nations Building and the East River.

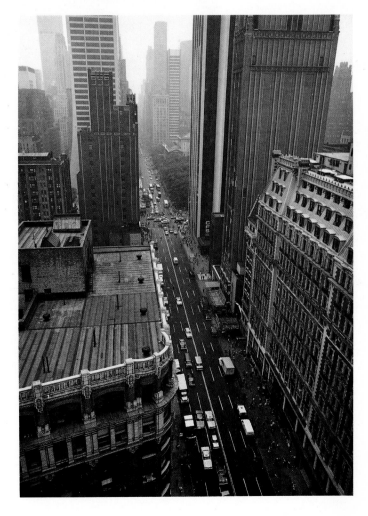

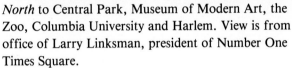

West on 42nd Street, home to sex movies, the dope trade, hookers, hustlers and sellers of stolen goods. Beyond (center of picture) is the architecturally renowned McGraw-Hill Building. Further west are the Embassy of the Peoples Republic of China and the Hudson River.

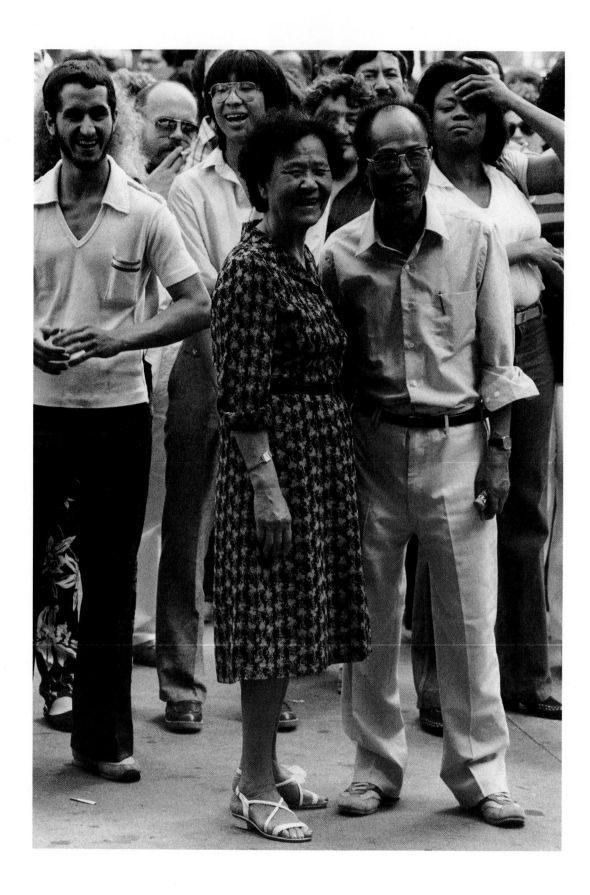

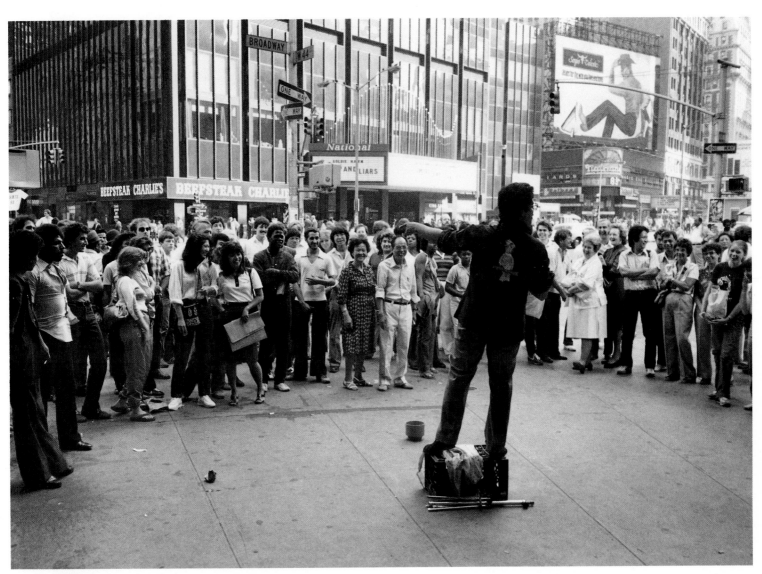

STREET MAGICIAN

*I'm not sure why it's so hard to maintain
some sense of community in the city streets.
Perhaps it is just arithmetic. At a certain
point, numbers make strangers.*

ELLEN GOODMAN
Syndicated Columnist

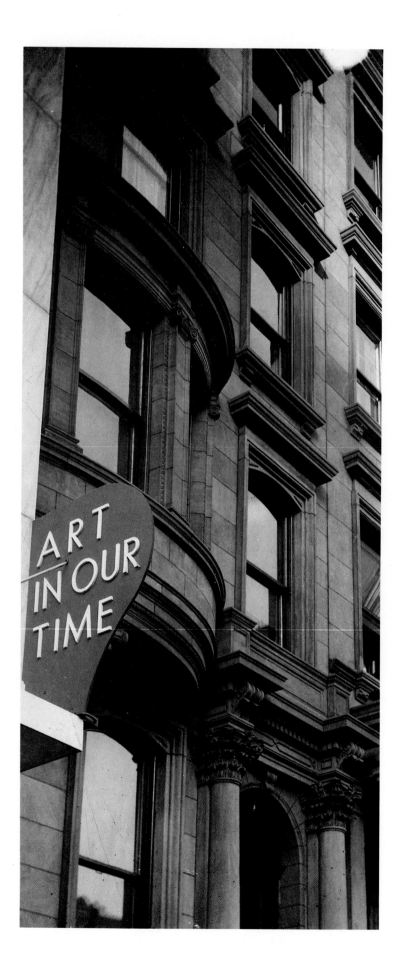

MOMA AND BROWNSTONE 1939

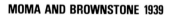

Marquee of Museum of Modern Art announces the very first show in its new home on West 53rd Street. Old buildings on both sides of the Museum have since been engulfed by MOMA's expansion. Sale of MOMA's ''air rights'' for millions resulted in completion in 1983 of a 44-story office and apartment building towering overhead. Meanwhile, the Museum's awesome holdings of ''modern'' art have aged to become classics.

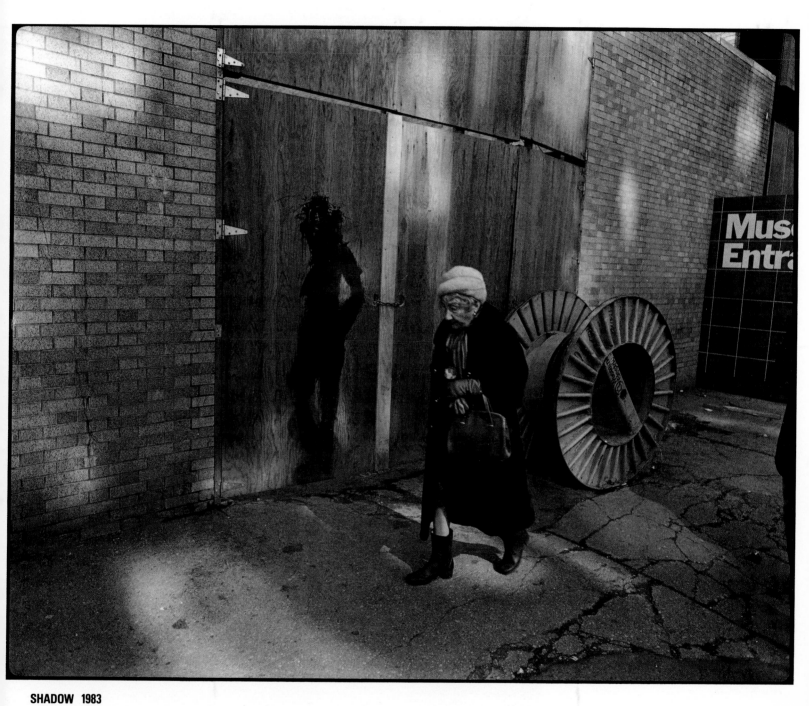

SHADOW 1983

Back gate of Museum of Modern Art during reconstruction.

SEEING IT 1983

8th Avenue at 42nd Street

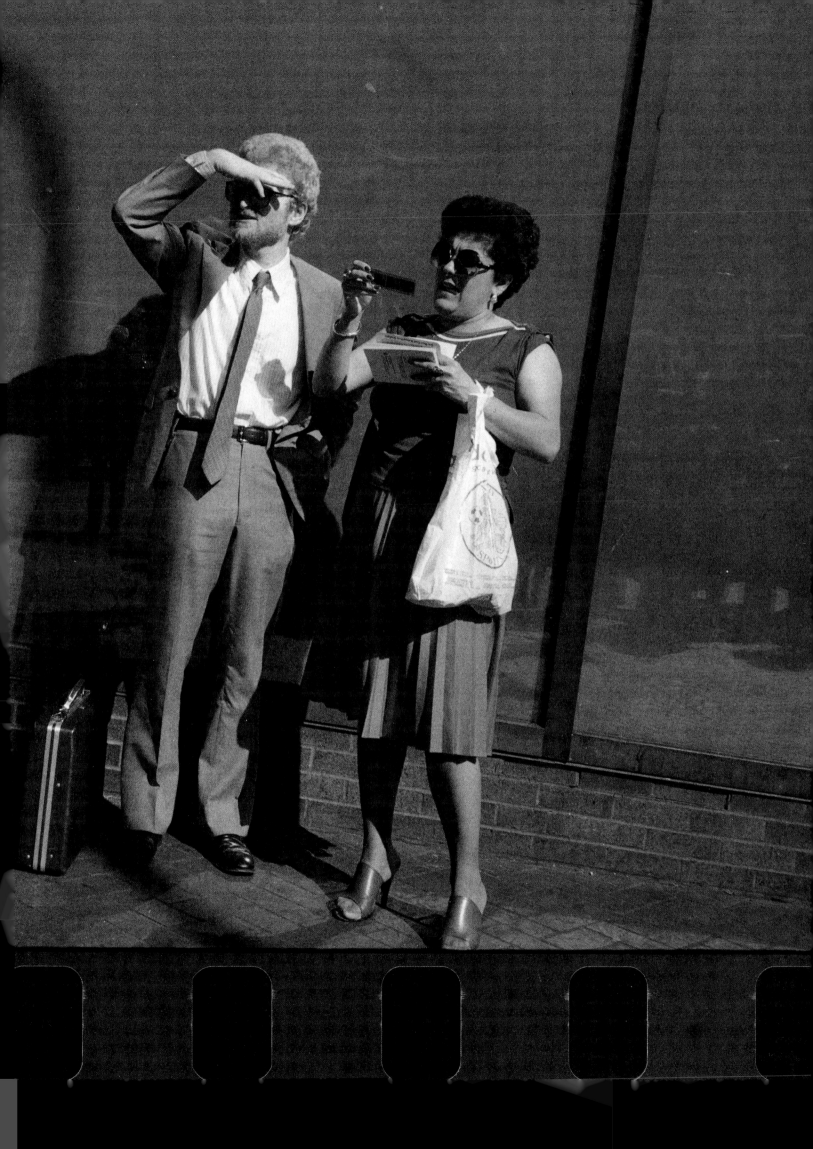

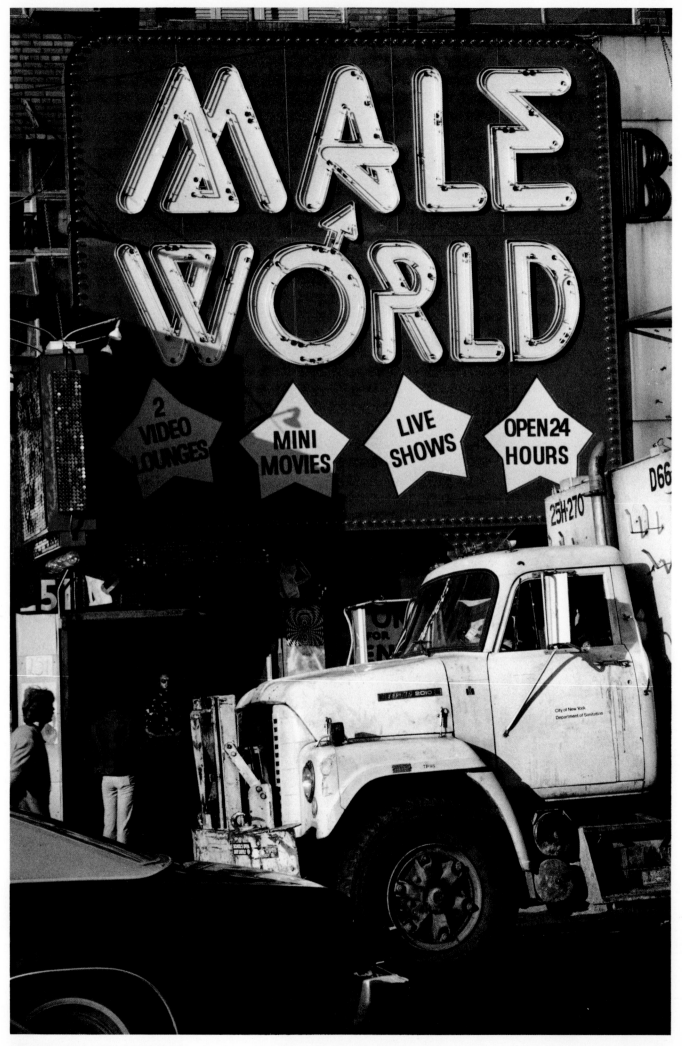

SEX EMPORIUM, WEST 42nd STREET

FOR THE HEAVYWEIGHT CHAMPIONSHIP OF THE WORLD — NO T.V.

AT THE GARDEN FRI. FEB. 23
MAIN EVENT — 15 ROUNDS

MUHAMMAD ALI
VS.
ANY NAME
THE NEW UP AND COMING CHALLENGER

SEATS: RINGSIDE — RESERVED SEATS — 1st BALCONY — 2nd BALCONY

FOR THE HEAVYWEIGHT CHAMPIONSHIP OF THE WORLD — NO T.V.

AT THE GARDEN FRI. FEB. 23
MAIN EVENT — 15 ROUNDS

MUHAMMAD ALI
VS.
ALBE K.O. WALES
THE NEW UP AND COMING CHALLENGER

SEATS: RINGSIDE — RESERVED SEATS — 1st BALCONY — 2nd BALCONY

YOUR NAME IN
HEADLINES

YOUR OWN COPY in 3 MINUTES

★ **EXTRA** ★
THE DAILY TRIBUNE
DARCY & DANNY FLY EAST
BUT SLIP UNITED

Panic In New York:
Menagerie Breaks Loose

★ **EXTRA** ★
THE DAILY TRIBUNE
VES BURTON
HAMMOND !

★ **EXTRA** ★
THE DAILY TRIBUNE
CALLAHAN INDICTED
IN HORSE SWITCH

Panic In New York:
Menagerie Breaks Loose

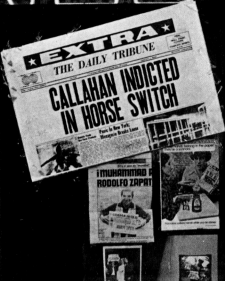

¡MUHAMMAD P...
RODOLFO ZAPAT...

★ **EXTRA** ★
THE DAILY TRIBUNE
ED BAILEY GOES ON W...
LIQUOR INDUSTRY PAN...

Panic In New York:
Menagerie Breaks Loose

★ TRIBUNE
BIRTHDAY-
ES HOLIDAY !

★ **EXTRA** ★
THE DAILY TRIBUNE
HARRY KELLY JR. FINALLY
GETS COLLEGE DEGREE AFTER 22 YEARS
OF NIGHT SCHOOL AND 6 CHILDREN

Panic In New York:
Menagerie Breaks Loose

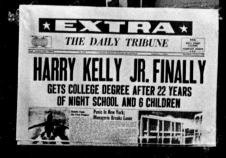

★ **EXTRA** ★
THE DAILY TRIBUNE
IRV GOLDFARB BEAT...
JIMMY CONNORS 6-0, ...

Panic In New York:
Menagerie Breaks Loose

★ TRIBUNE
...ERS ARRIVES IN
...RK - TOWN GOES WILD !

★ **EXTRA** ★
THE DAILY TRIBUNE
MAUREEN & ED OLSZEWSKI
PRESENT THEIR FIRST SMASH HIT "IT'S A BOY"
STARRING JOHN CHRISTOPHER - PREMIERE 10-21-77

Panic In New York:
Menagerie Breaks Loose

★ **EXTRA** ★
THE DAILY TR...
NANCY BRADLE...
BY BROADWAY P...

Panic In New York:
Menagerie Breaks Loose

★ **EXTRA** ★
...DAILY TRIBUNE
...J. SMITH SAYS "NO"
...RAQUEL WELCH

Panic In New York:
Menagerie Breaks Loose

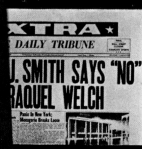

TOUR GUIDE 1940

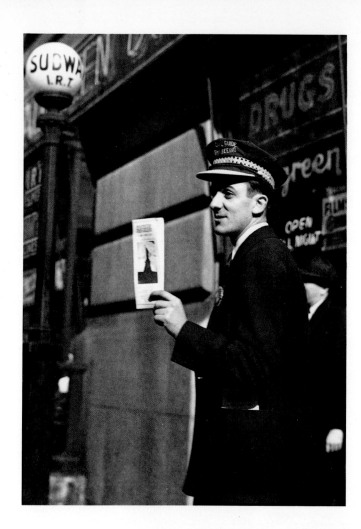

BUS RIDE 1940

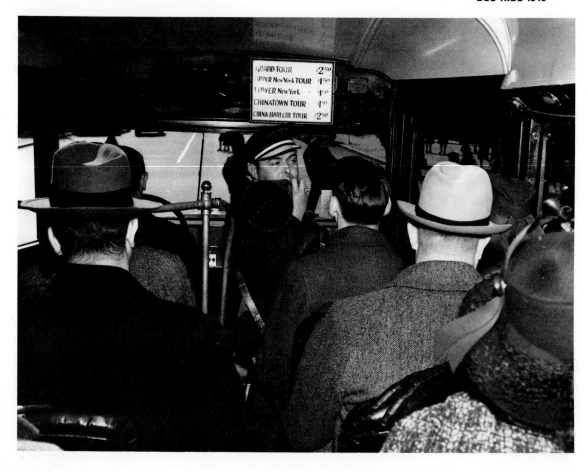

The Statue of Liberty was
a gift to the United States
from the people of France
in 1886.

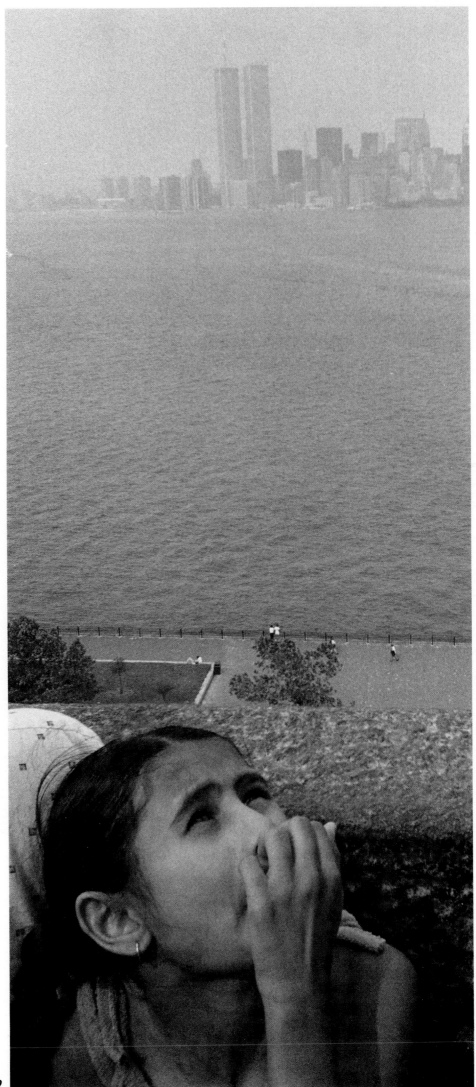

1982

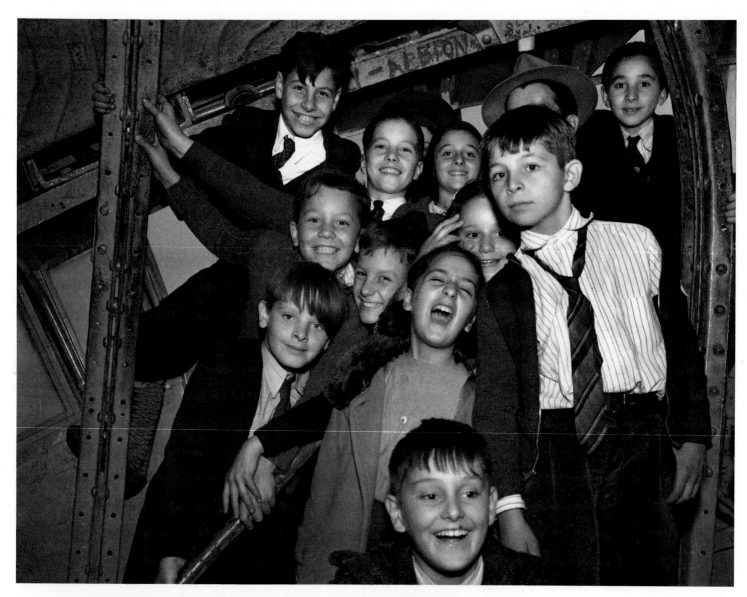

CHILDREN OF PUBLIC SCHOOL #34, THE BRONX, INSIDE HEAD OF STATUE OF LIBERTY 1940

Boys wore neckties those days. The group included
no Blacks, Latinos or Asians.

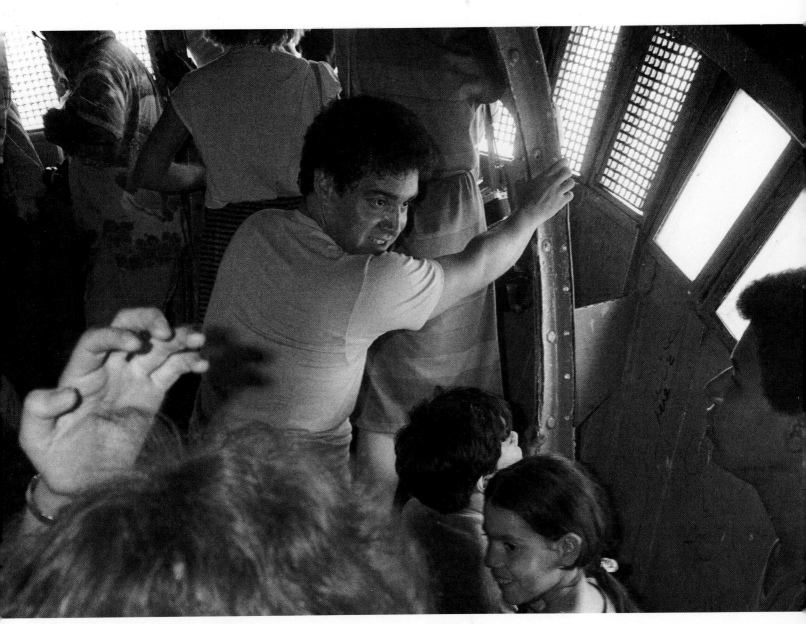

INSIDE HEAD OF STATUE OF LIBERTY 1982

TWO VIEWS DOWN FROM TORCH OF THE STATUE OF LIBERTY 1940

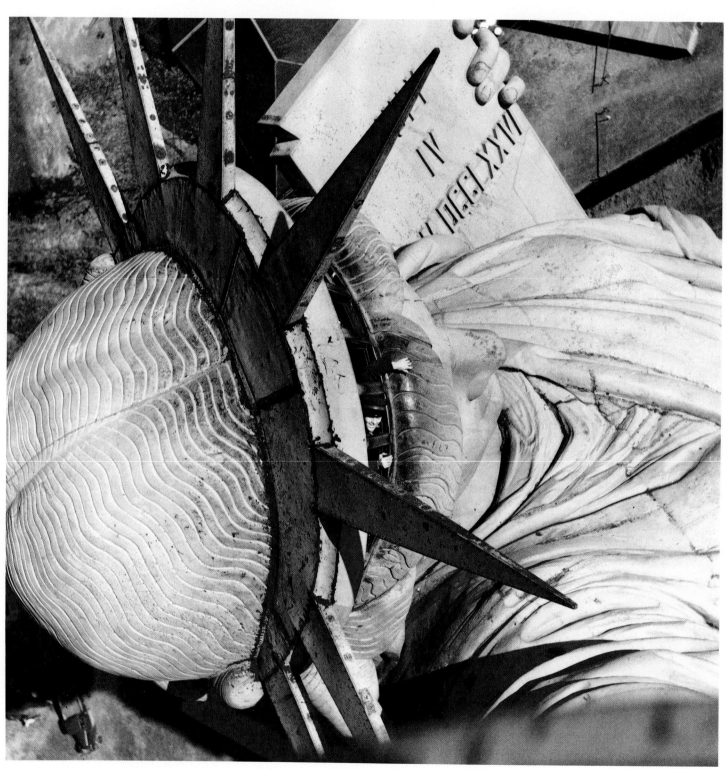

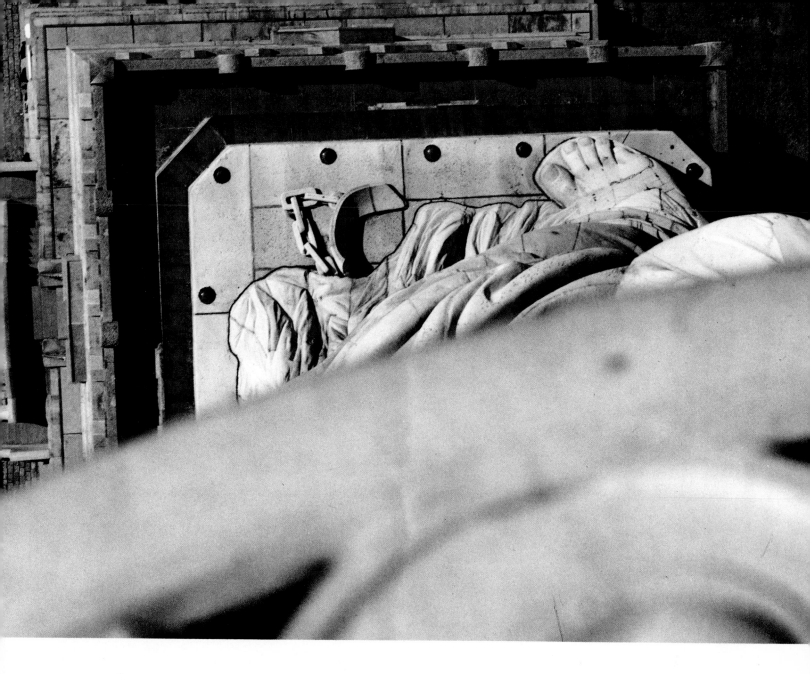

The iron ladder inside the raised arm and hand of
Liberty's statue is less than the width of a man, and
was rickety even in 1940. But the Lady's custodians
listened sympathetically to my plea that I was "doing
a book" about the Statue of Liberty (a con that's now
come true) and gave me permission to take my camera
up to the windy platform around Liberty's torch. It
was scarey and thrilling to lean out and photograph
down onto the head of America's greatest symbol. I
never knew that the tablet in her left hand commem-
orates the American Revolution.

F.A. Bartholdi created his awesome sculpture in
sections in Paris. It was transported to New York
harbor by ship. Its skin is a thin copper alloy hung
over a bolted iron frame similar in engineering to the
Eiffel Tower. One detail of Bartholdi's conception that
few have ever seen is this view down from the torch
where chains and shackles can be seen broken from
Liberty's feet.

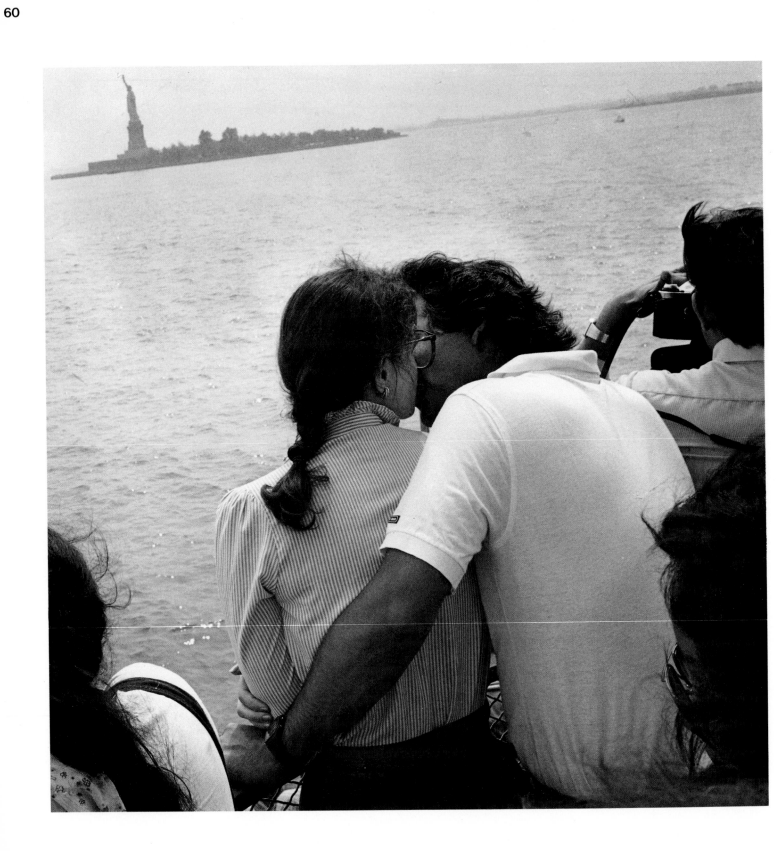

4 SIGNS OF THE TIMES

It sometimes happens that, wearied with public affairs and sated with opulence, amid the ruin of religious belief and the decline of the state, the heart ... may by degrees be seduced to the pursuit of sensual enjoyments alone ... while the road to mighty enterprise is closed.

DE TOCQUEVILLE
from Democracy in America (1835)

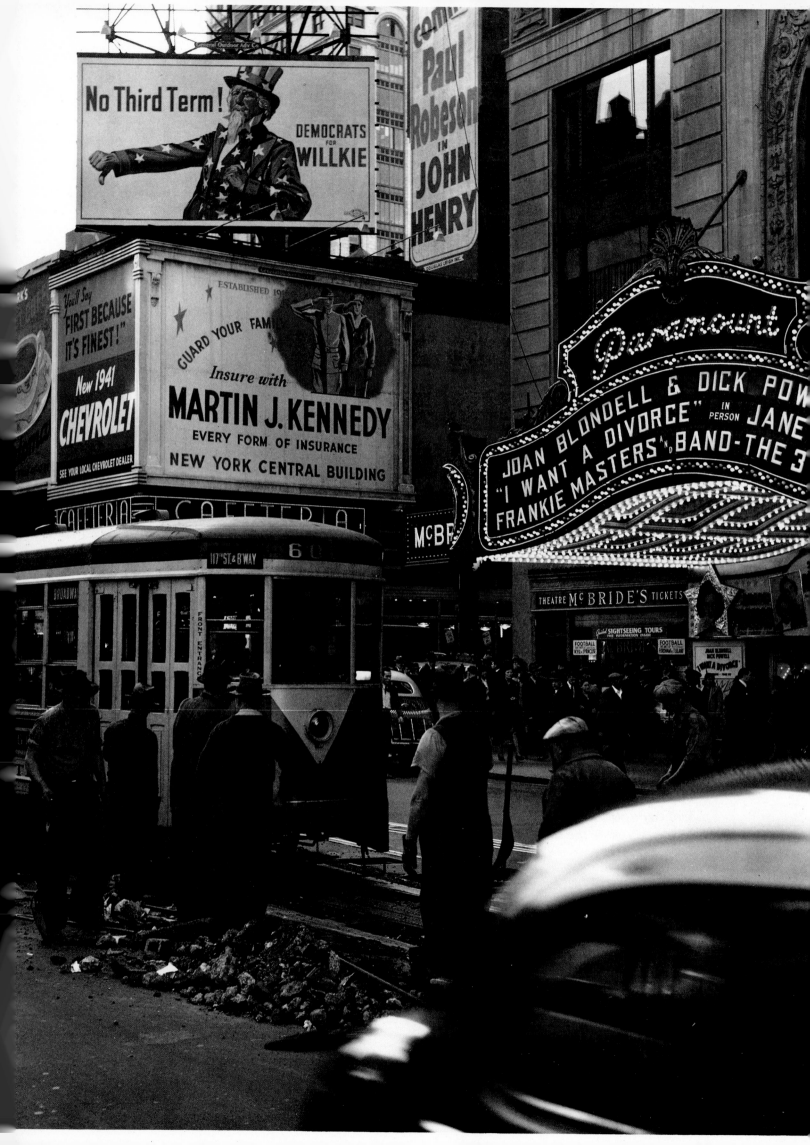

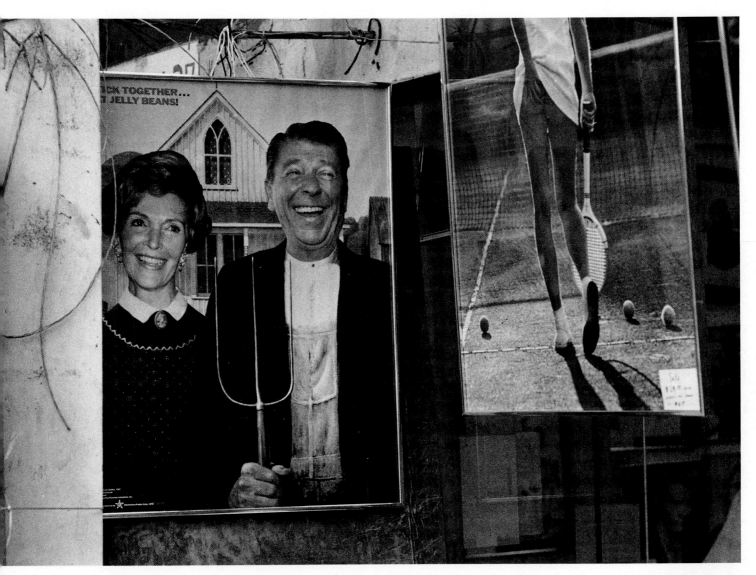

POSTER SHOP 1982

ELECTION YEAR 1940

Republican Wendell Willkie ran against Roosevelt.
Trolley cars ran in Times Square. The streets were
torn up for repairs, as they still always are today.

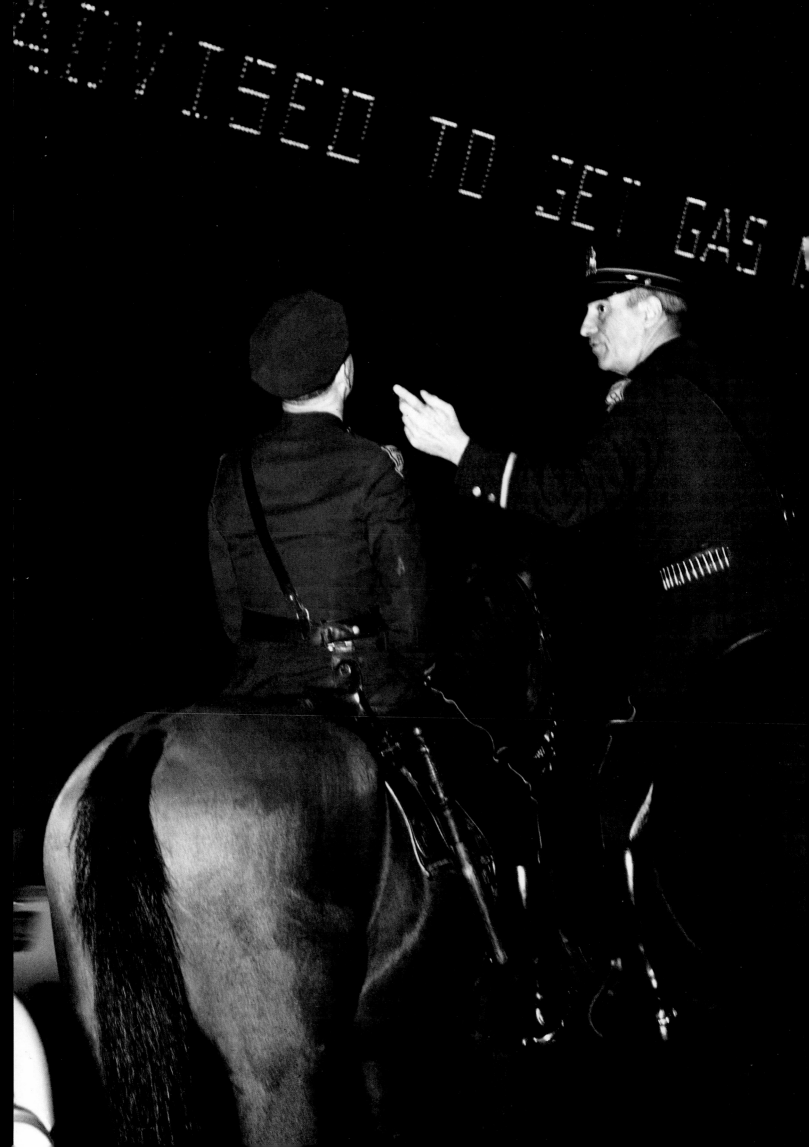

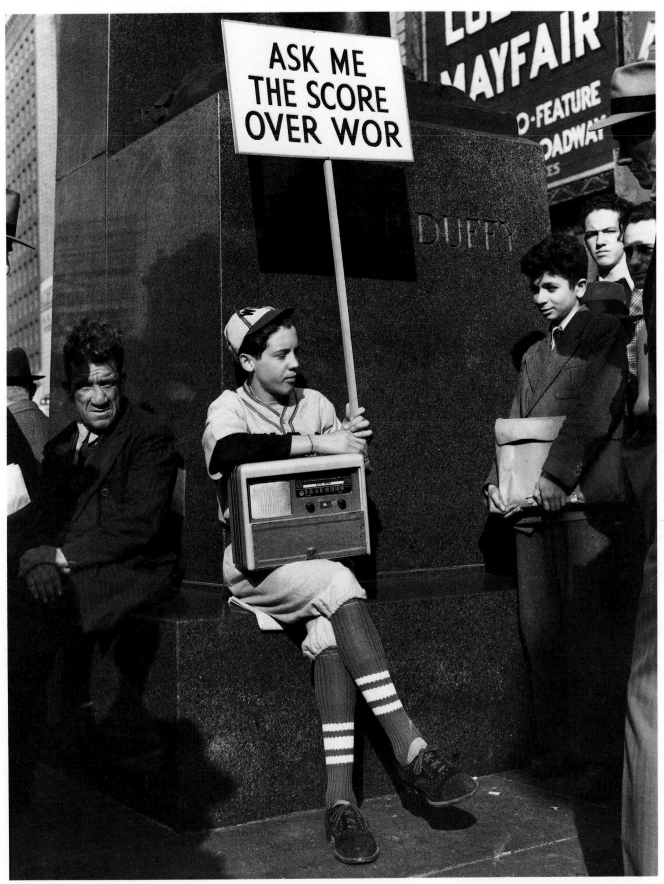

MEANWHILE, BASEBALL

Portable battery-operated radios were rare in 1940.
WOR got itself appreciated by sending a boy with
such a radio to Times Square so the big ballgames
could be heard by passersby.

TRAVELING SIGN ON THE TIMES BUILDING

It was the English in 1940 who were advised to get
gas masks. Hitler was dropping bombs on Britain, but
poison gas was never used in World War Two—except
in the Nazi extermination camps.

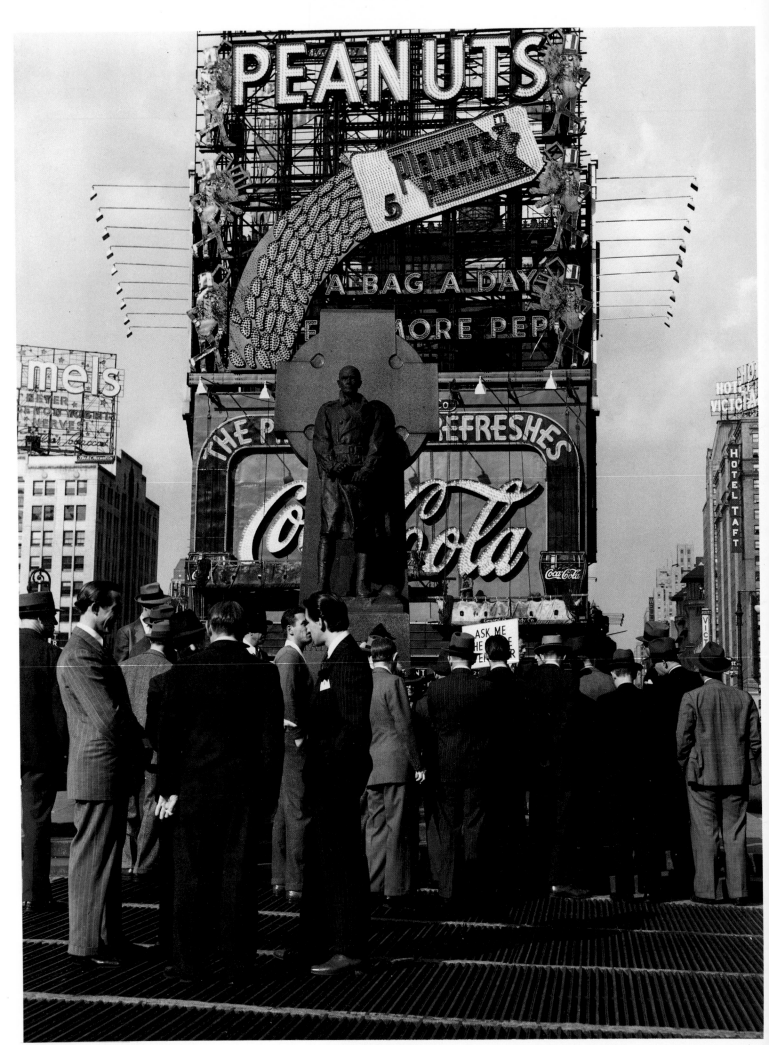

LISTENING TO THE BALLGAME 1940

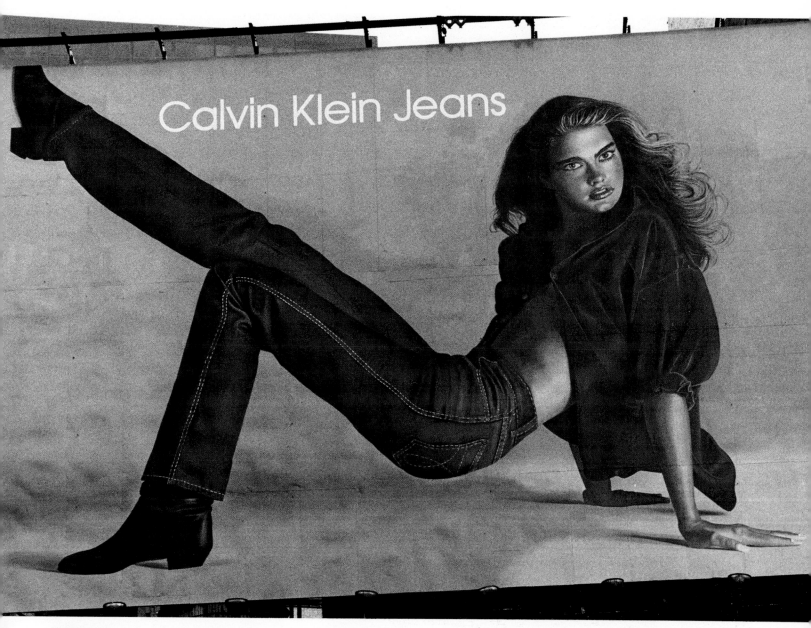

PANTS 1981

Teenage sex symbol Brooke Shields reigned as queen
of Times Square billboards for some months. Then
Calvin Klein changed his demographics. Brooke was
replaced by a slightly older model.

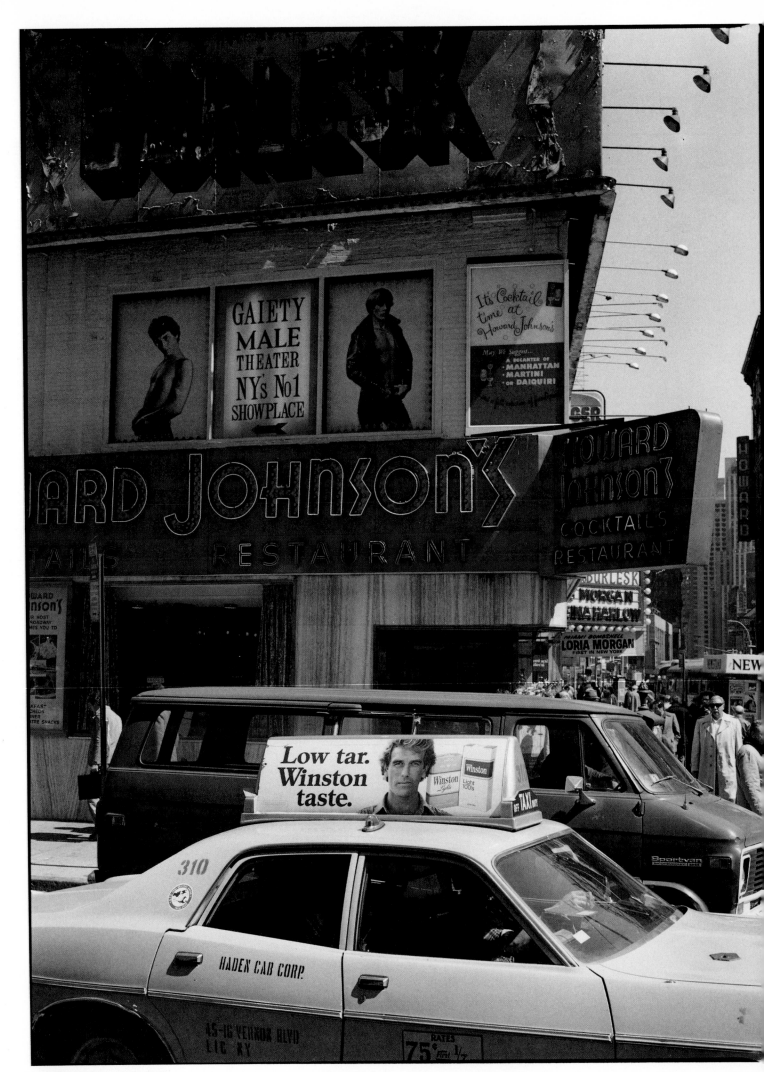

SIGNS OF THE TIMES 1979

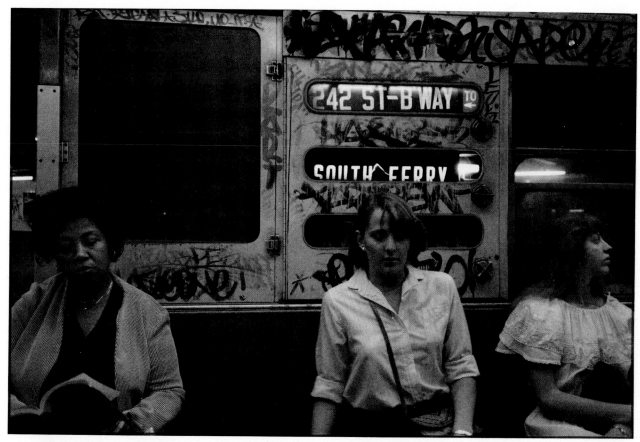

UNDER TIMES SQUARE 1982

In 1940 I had to use flashbulbs in the subways.
Modern films and lenses are faster, so I try to work
now with only environmental light. This is important,
because street photography is like a science-lab
experiment. Adding light changes the natural behavior
of both paramecia and people.

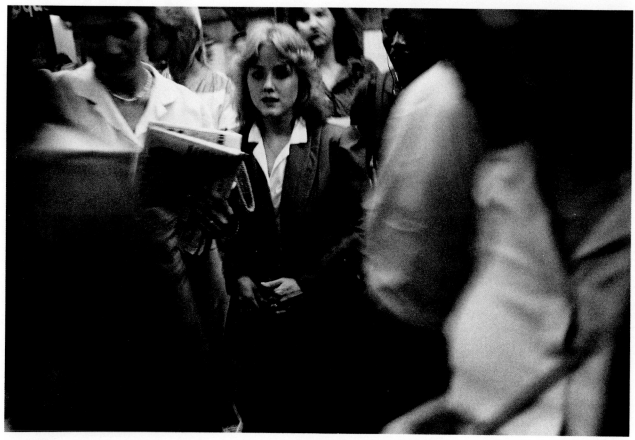

1984

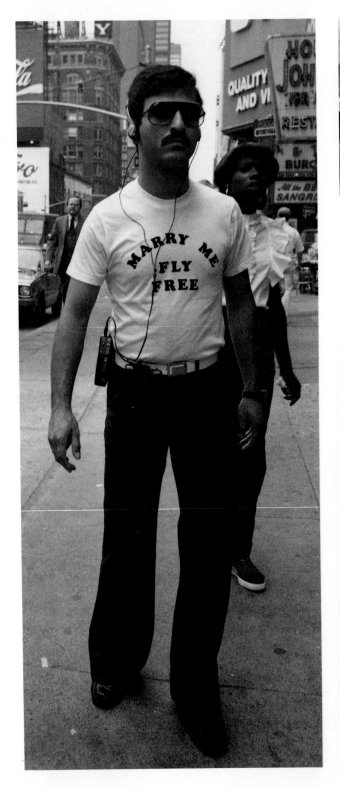

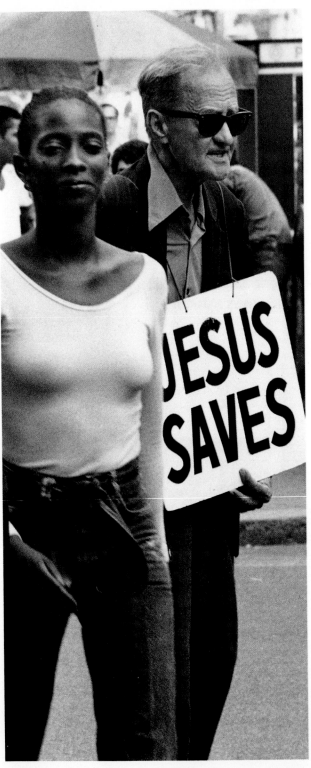

I shall tell you a great secret, my friend. Do not wait for the last judgement. It takes place every day.

ALBERT CAMUS
from The Fall

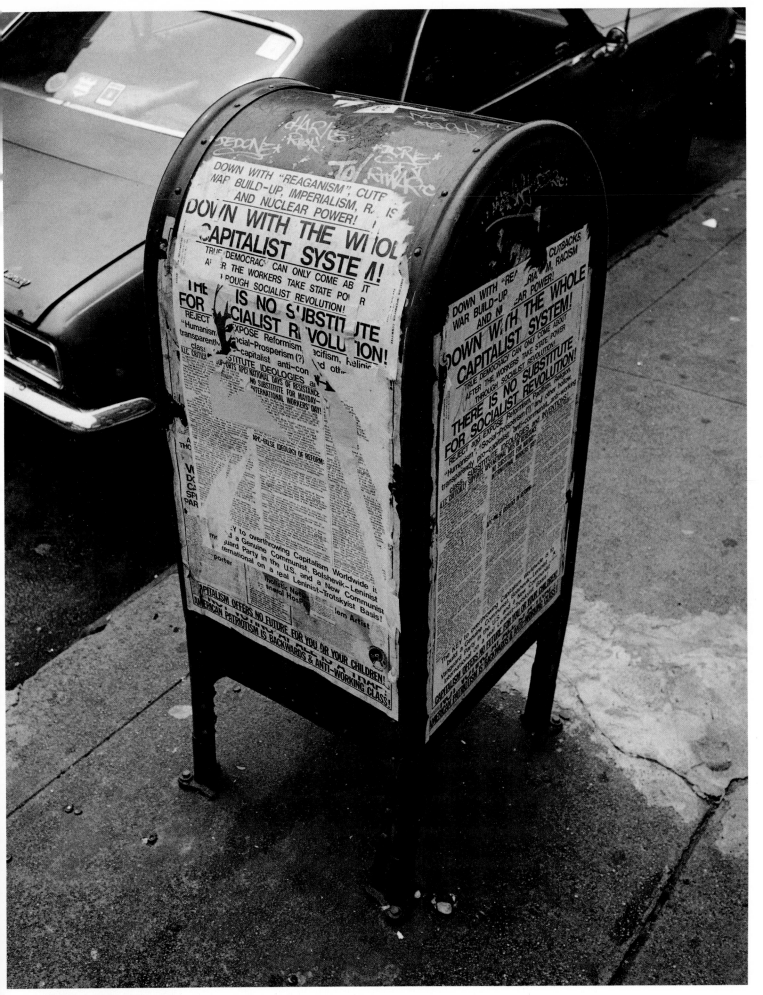

UNITED STATES MAIL BOX

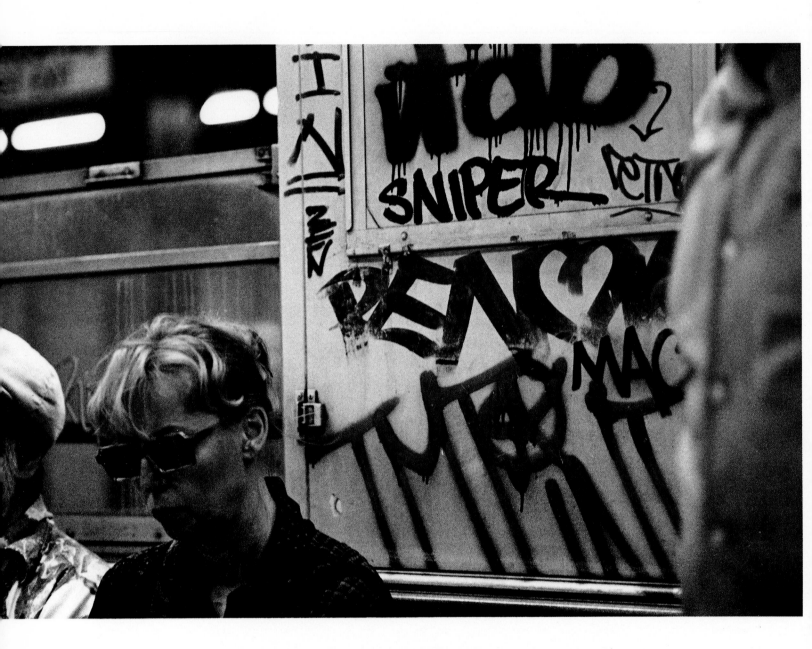

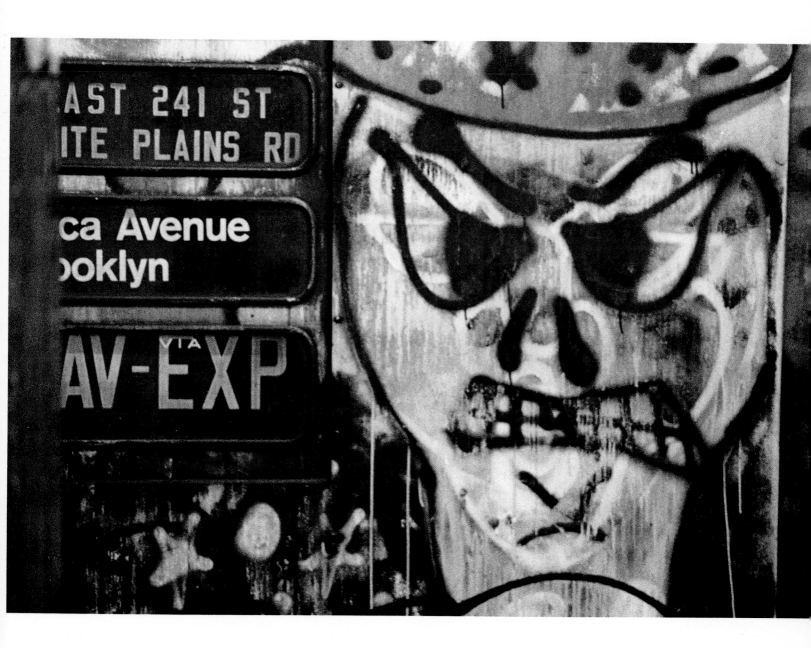

Violence haunts the edge of the New York imagination daily. It rides the mind each apprehensive subway jolt home.

GEOFFREY WAGNER
from Another America

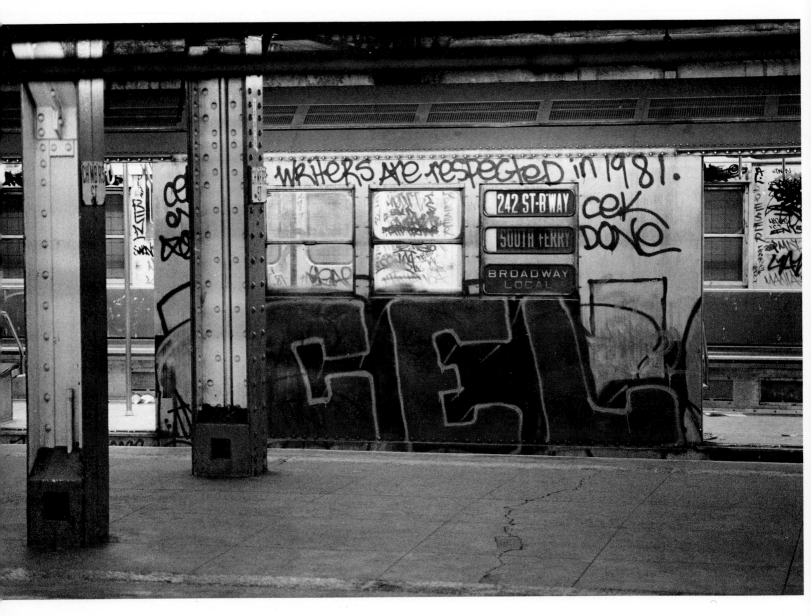

The reference is not to Norman Mailer or Joyce Carol
Oates. New York's graffiti artists call themselves
"writers."

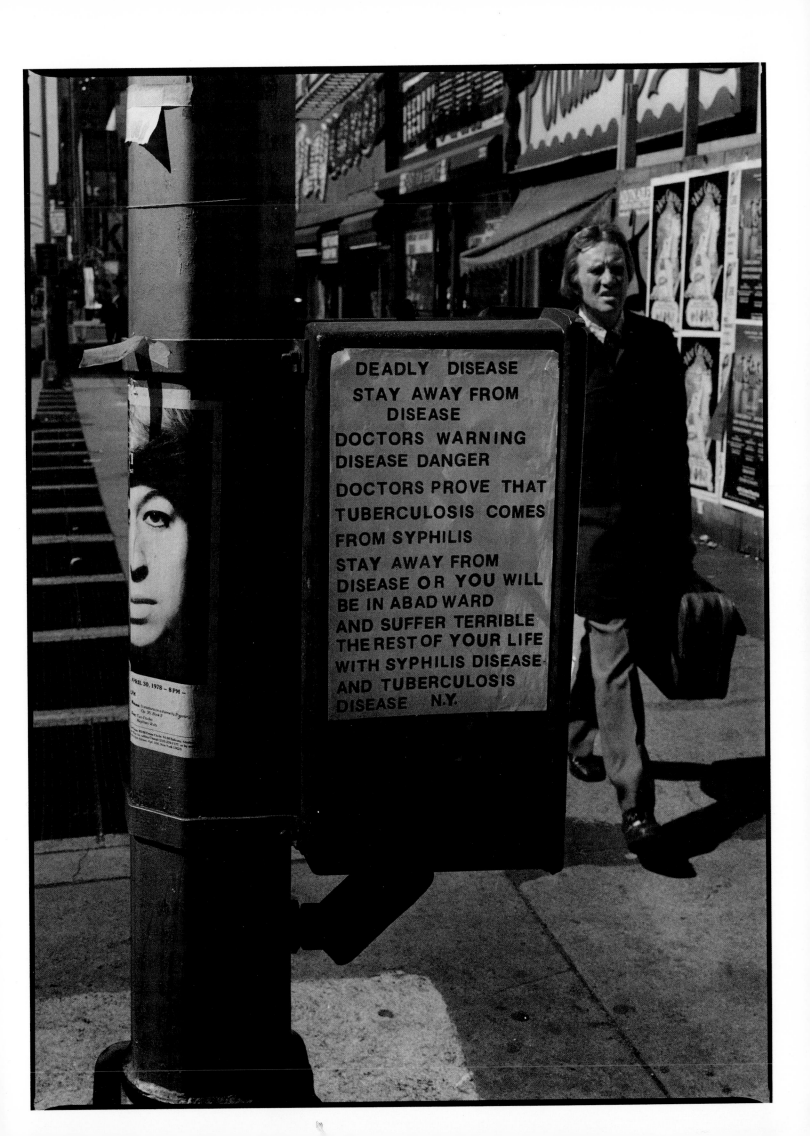

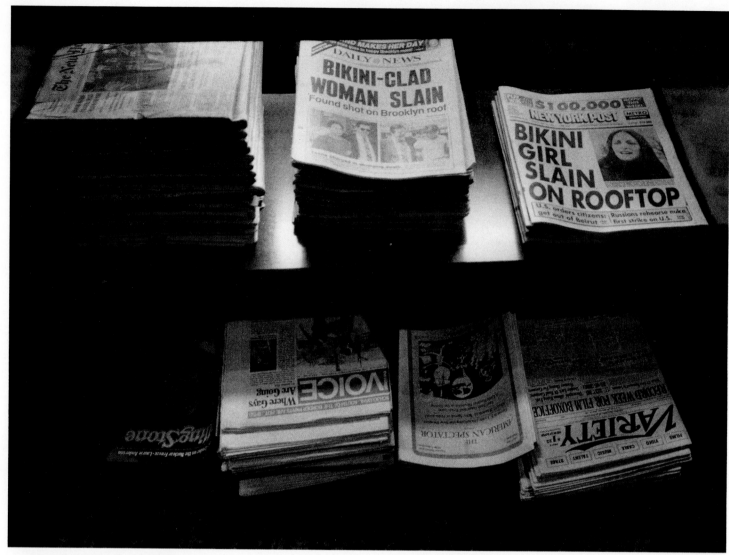

NEWSRACK, HOTEL ALGONQUIN

SPILL (Orpheus and Eurydice)

Could ''accidental'' forms like puddles and
mushroom clouds be God's graffiti?

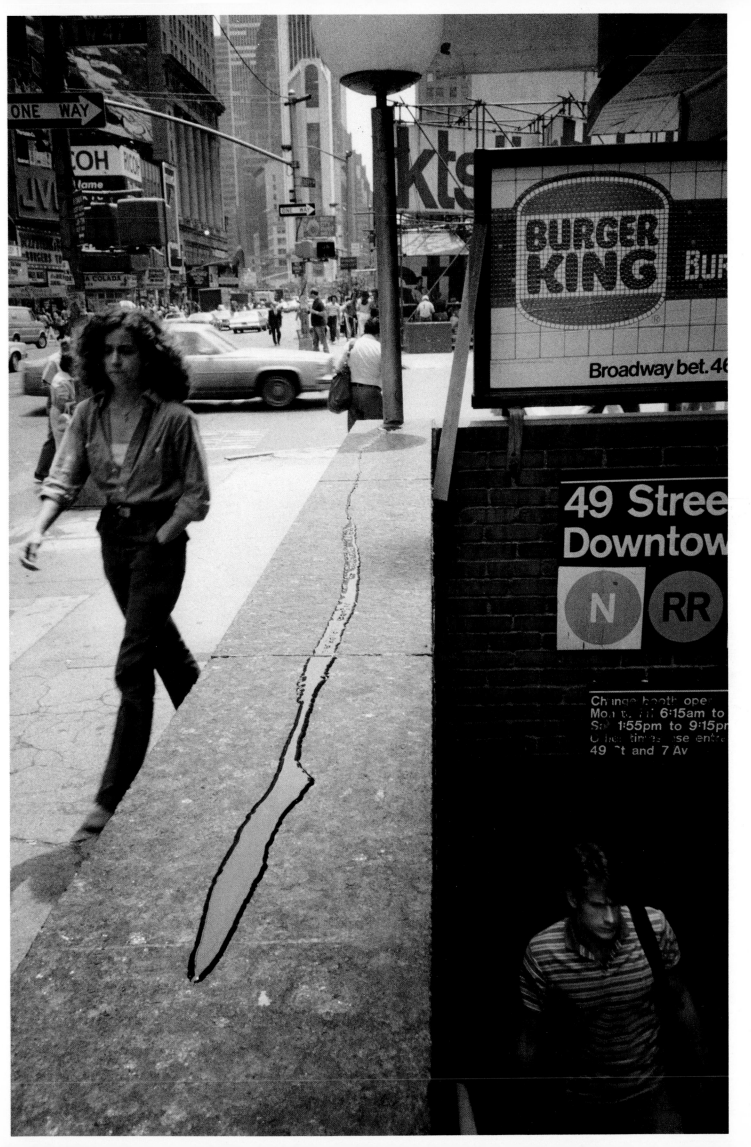

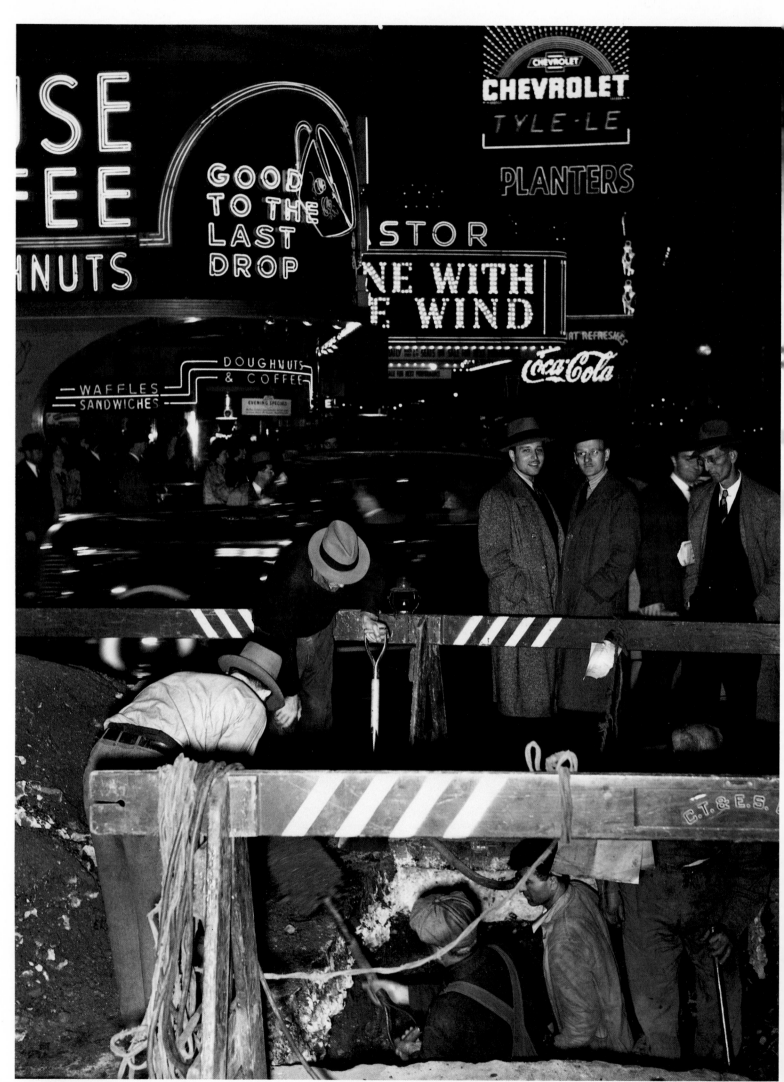

EXCAVATION 1940

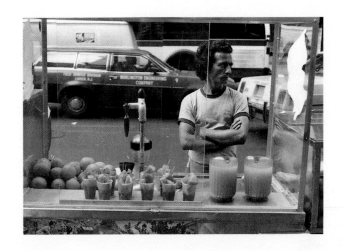

5 ON THE STREET

This is not hell, but a street.
Not death, but a fruit stand . . .
What shall I do now?
Align the landscapes?
Muster the lovers who
turn into photographs?

FEDERICO GARCIA LORCA
from La Poeta en Nueva York

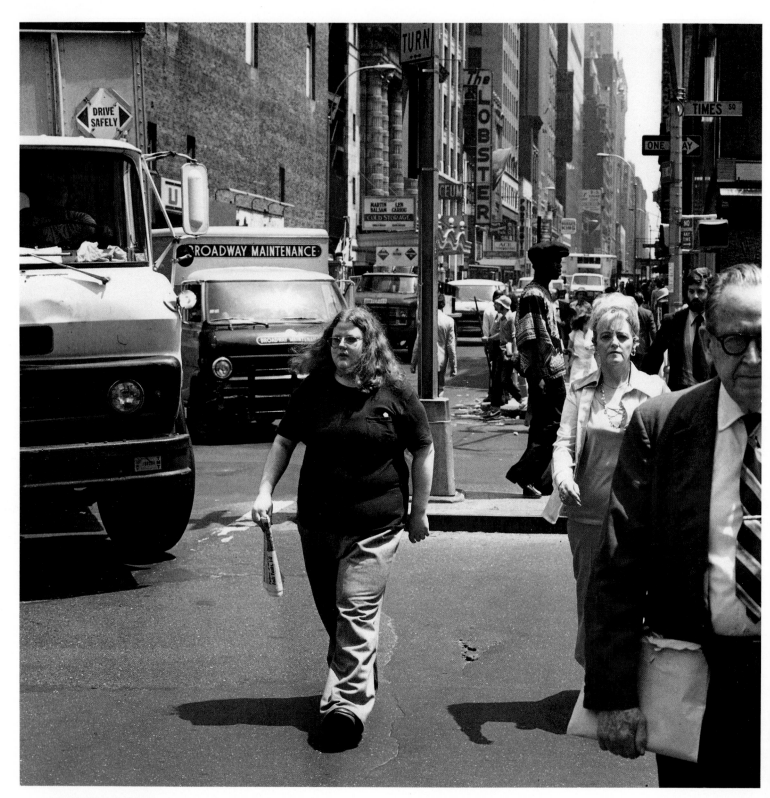

THE PEDESTRIAN WAR

In modern cities a certain tension exists between
pedestrians and motorists. With good reason. A darting
child or a pair of oblivious lovers can cause accidents.
Now and then some nut or drunk drives his Superstud
Special through a red light or down a sidewalk.

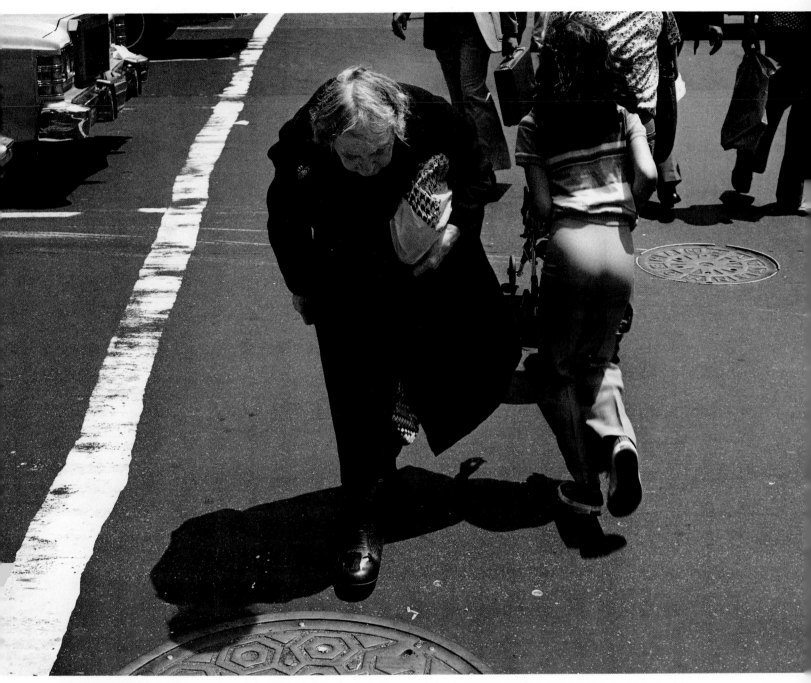

THE GENERATIONS

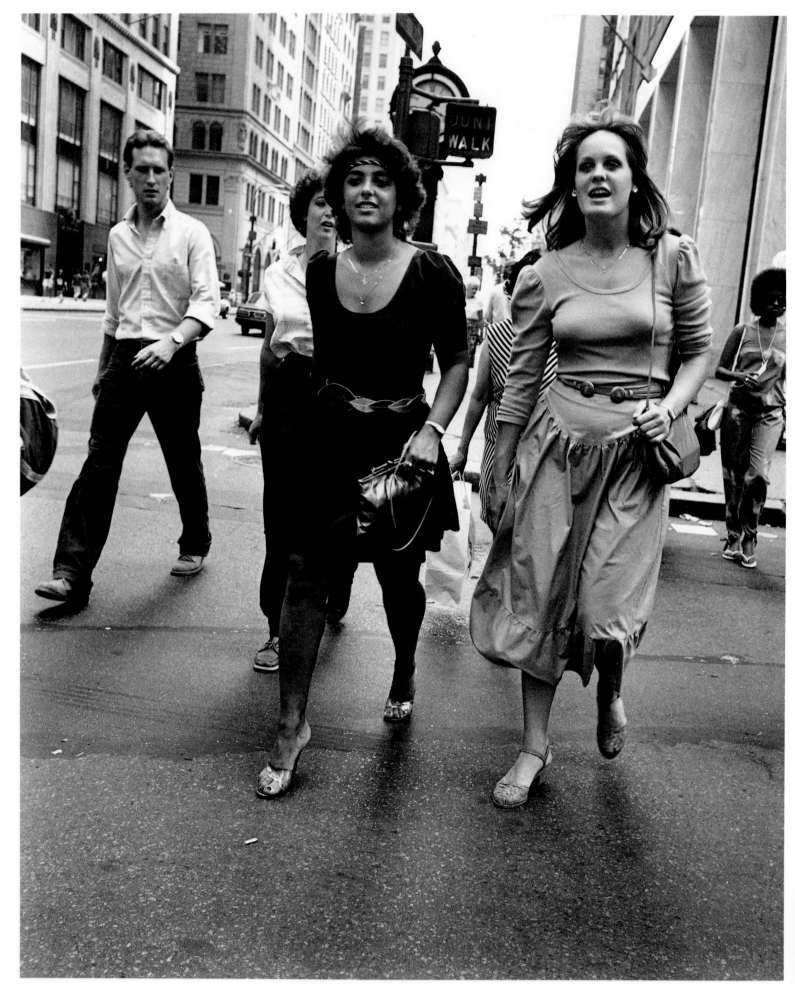

FIFTH AVENUE

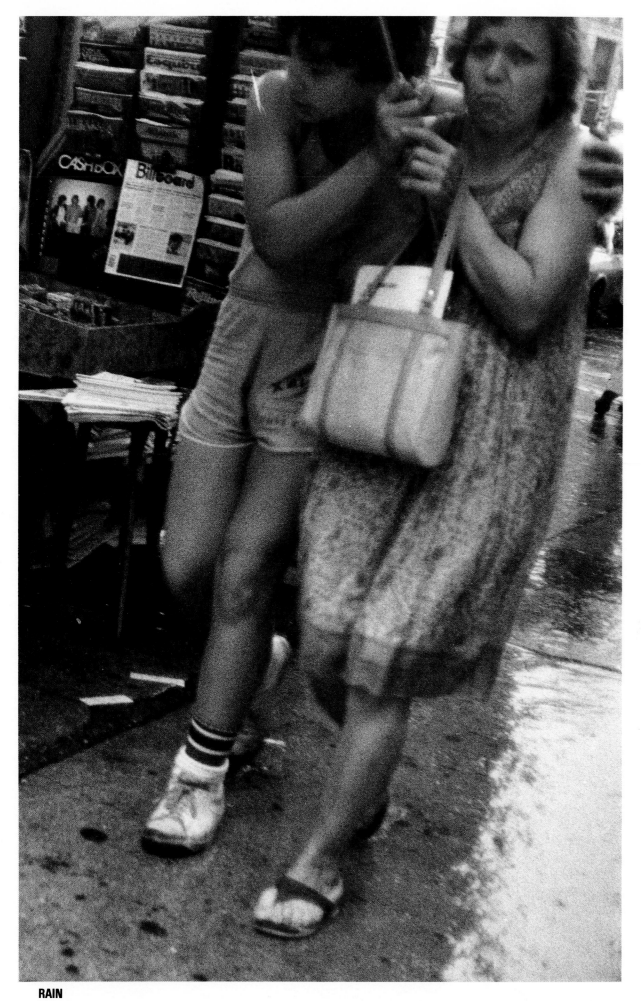

RAIN

It's nice to have a good son.

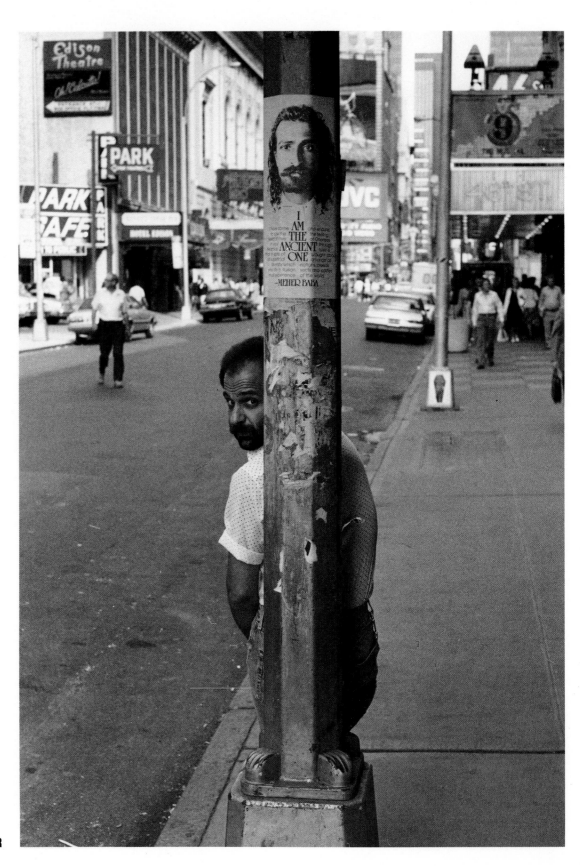

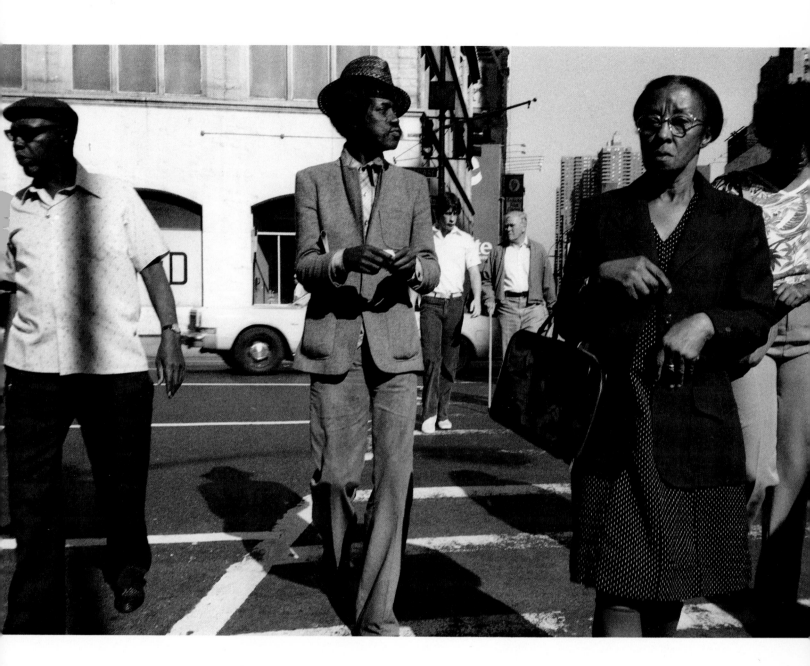

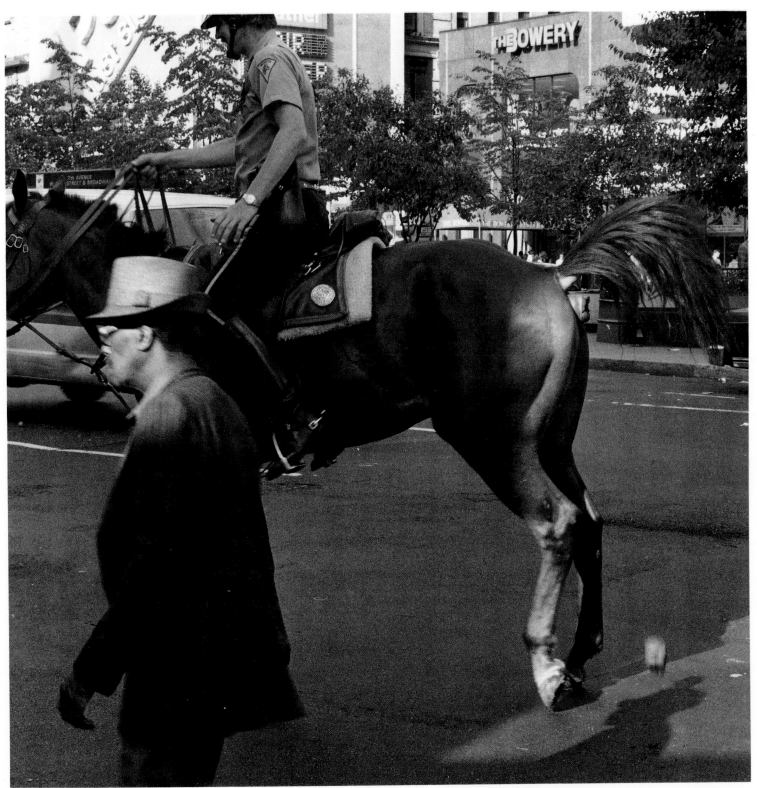

POLICEMAN'S HORSE DROPS GIFT ON SHADOW OF MAN'S HAT

BLIND MAN 1940

He sells pencils for·a nickel. He sports a nice clean
suit. All the ladies those days wore silk stockings
and tried to keep their seams straight.

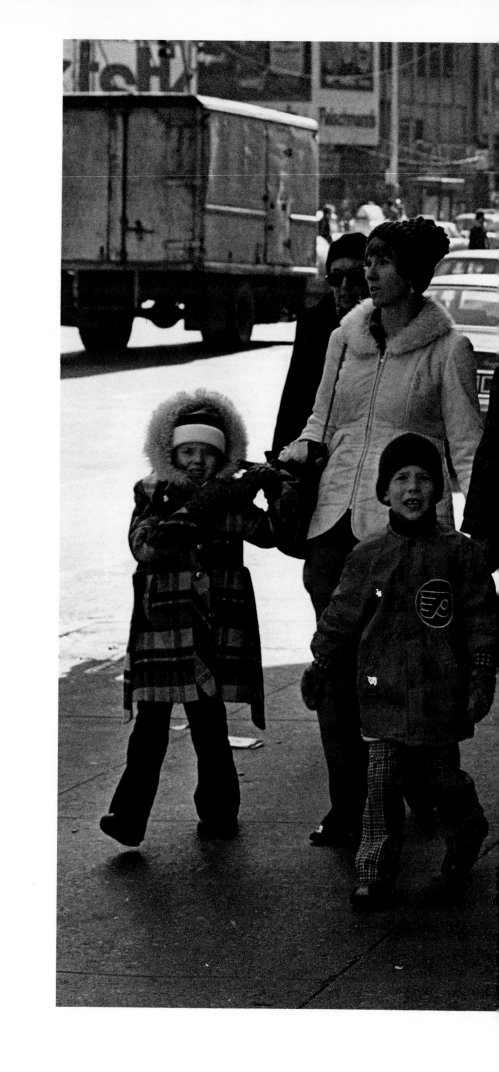

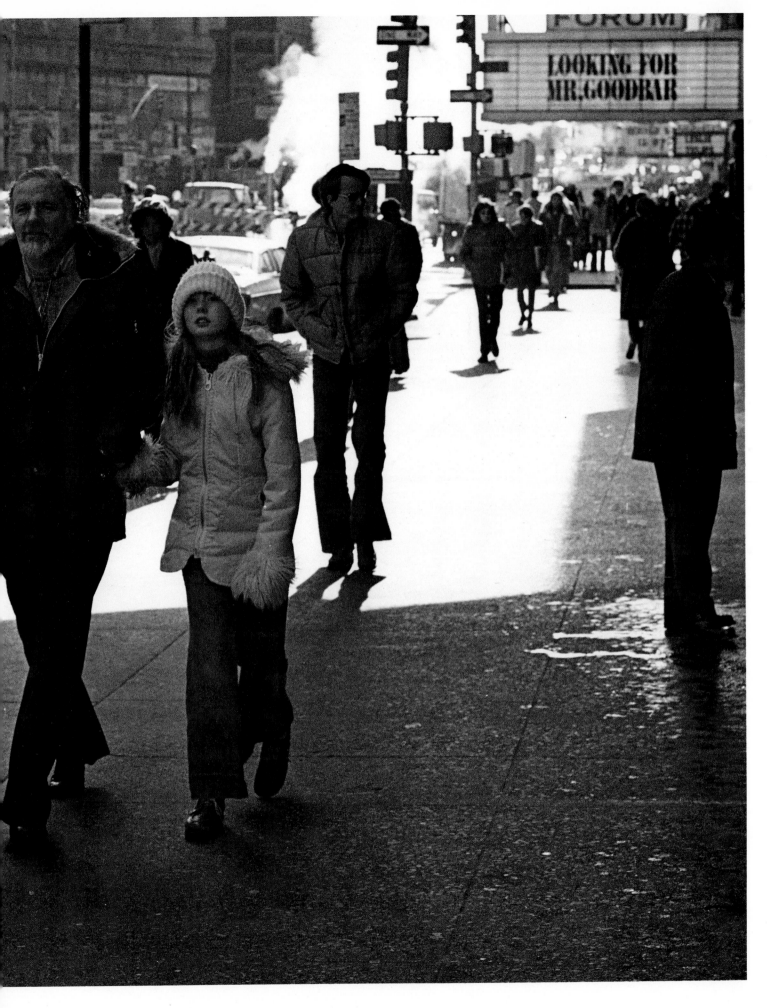

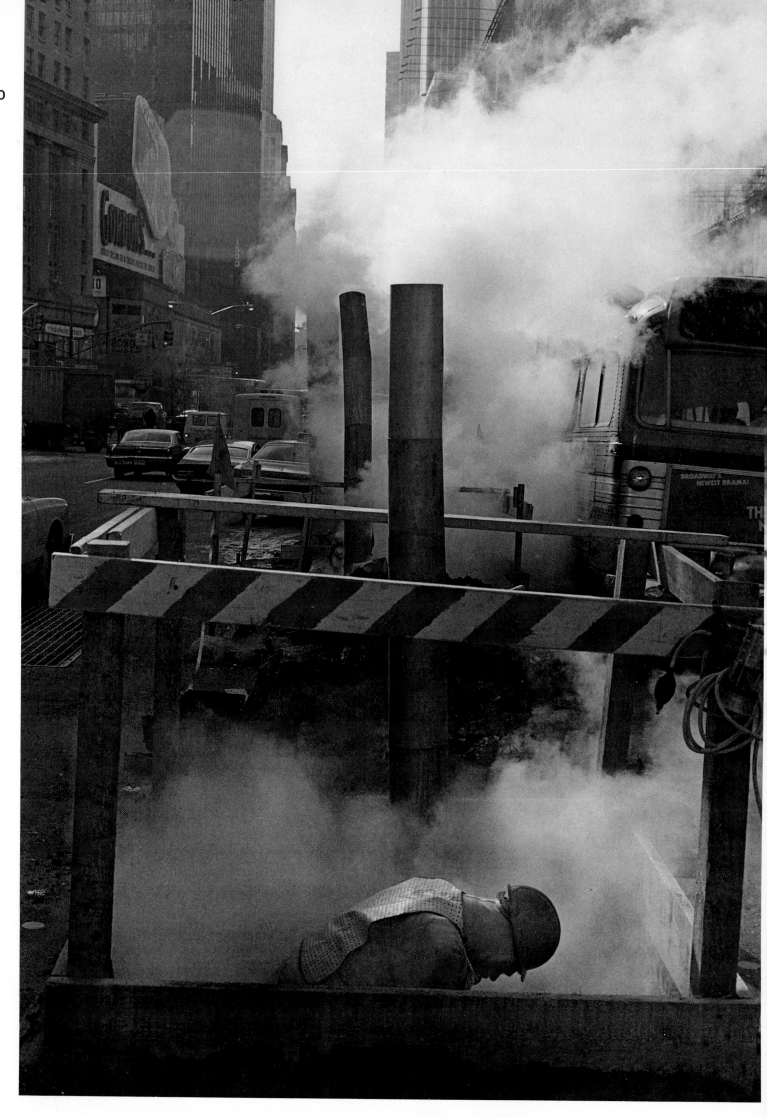

The City of New York has maintained through the
years a special Department responsible for keeping at
least one major dig going in Times Square always,
preferably with steam (see also pages 62, 78, 89 and 95).

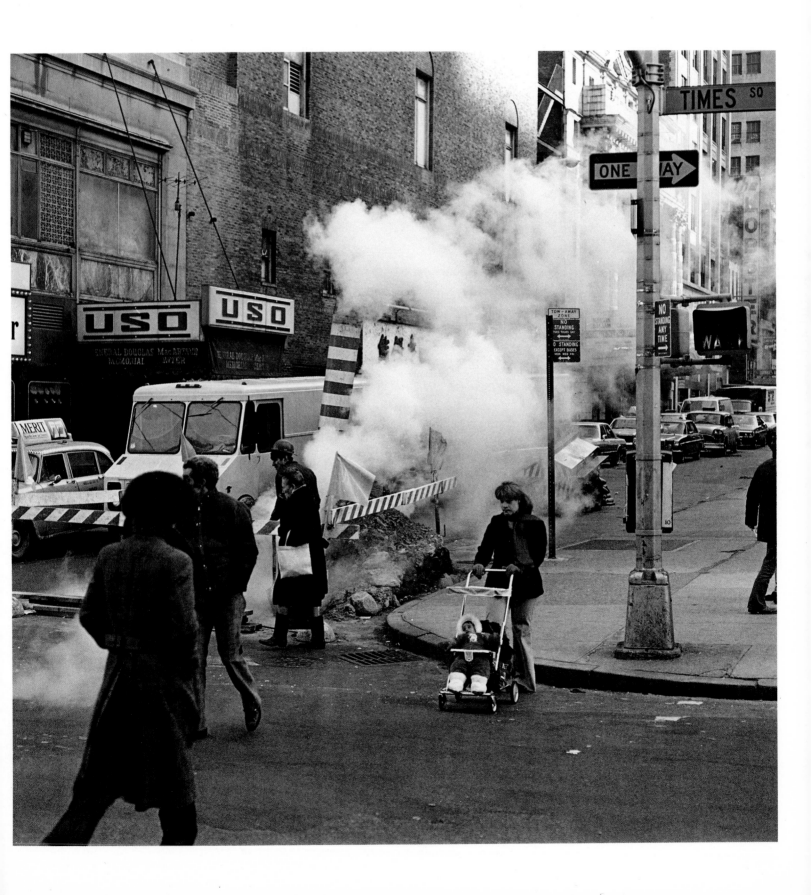

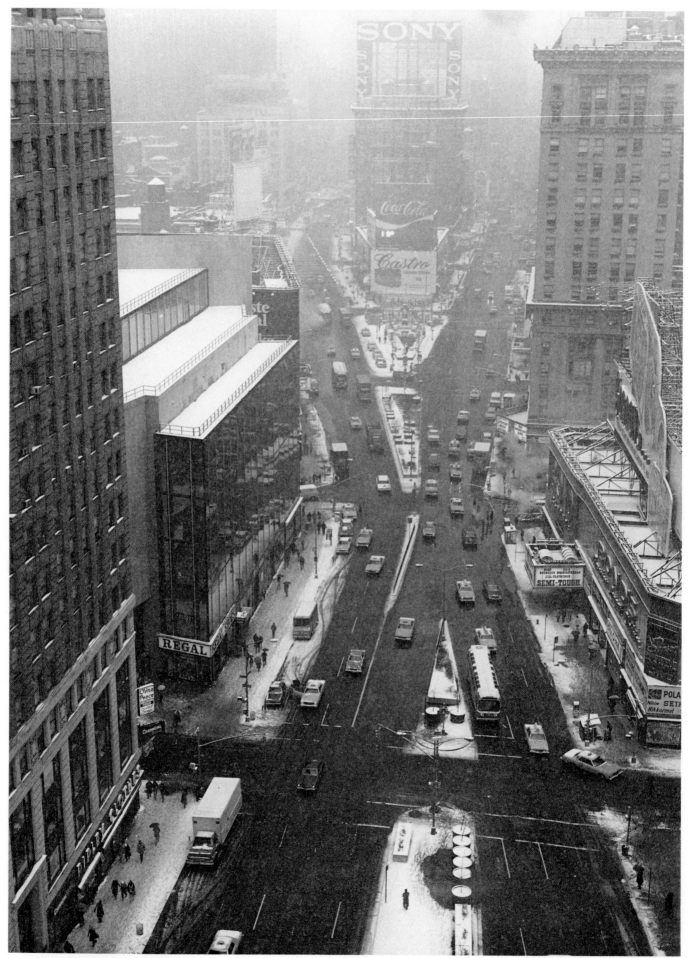

START OF THE BIG 1978 SNOW

Temperature on the Coke sign reads 16°, which
doesn't include the wind chill factor.

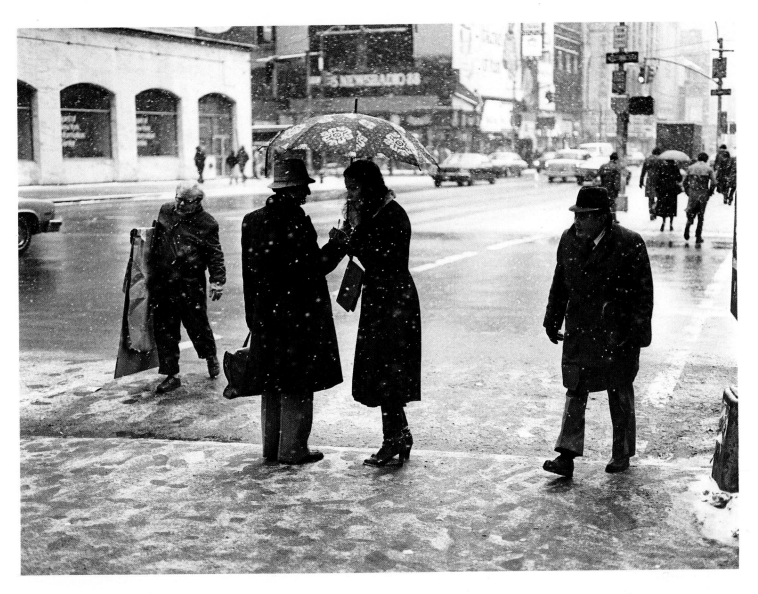

Was it coincidence or chic that the lady's umbrella was
patterned in snowflakes?

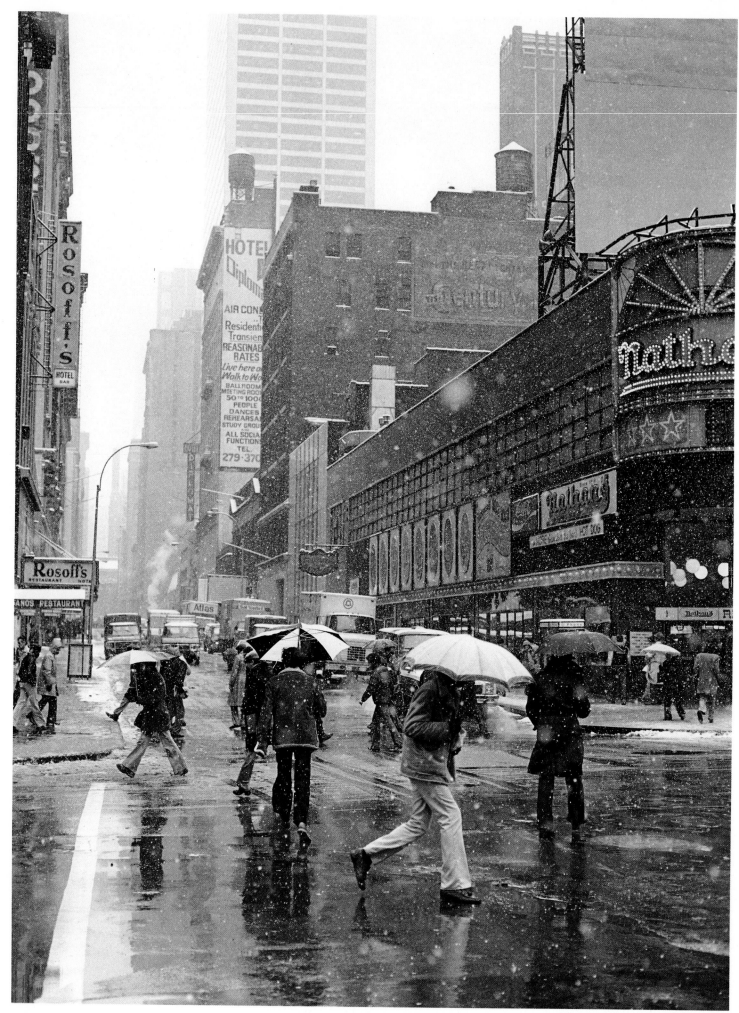

NATHAN'S 1979

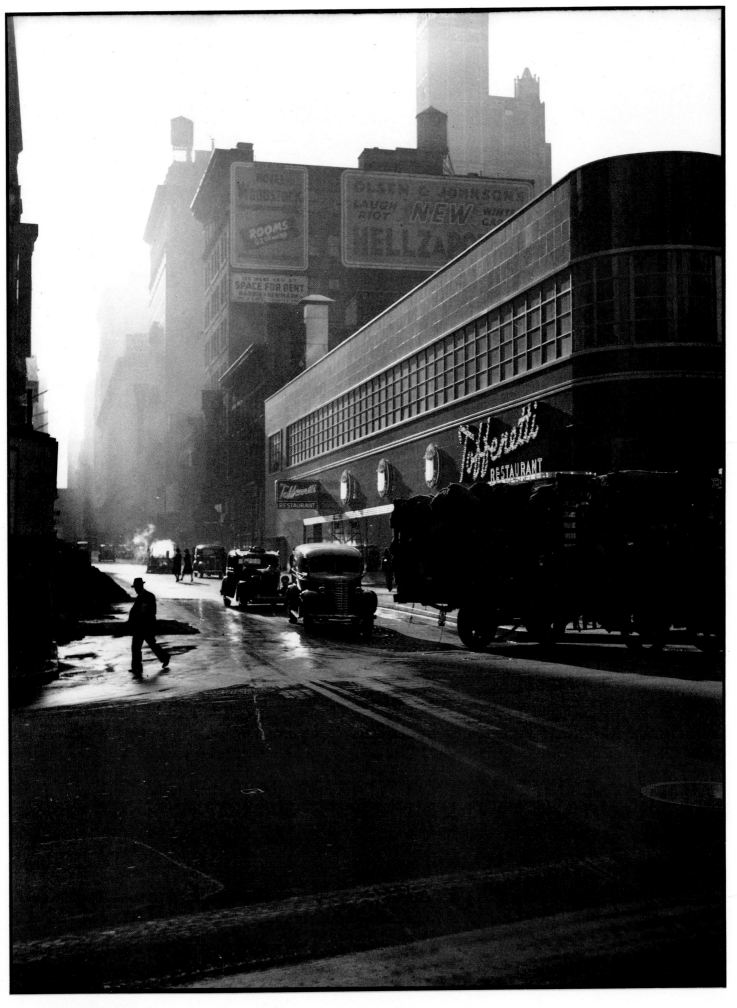

TOFFENETTI'S 1940

Whan that Aprille with his shoures soote
The droghte of March hath perced to the roote...

GEOFFREY CHAUCER (1340-1400)

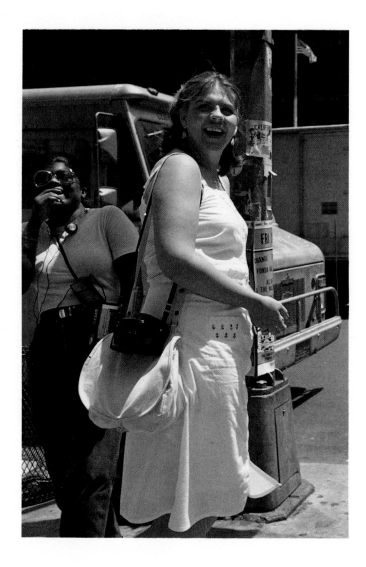

*The Broadway man has a better idea of life
and things in general than any other class of
man in the world. He sees more, meets more
and absorbs more in a day than the average
individual will in a month.*

GEORGE M. COHAN (1878-1942)
Actor-Showman

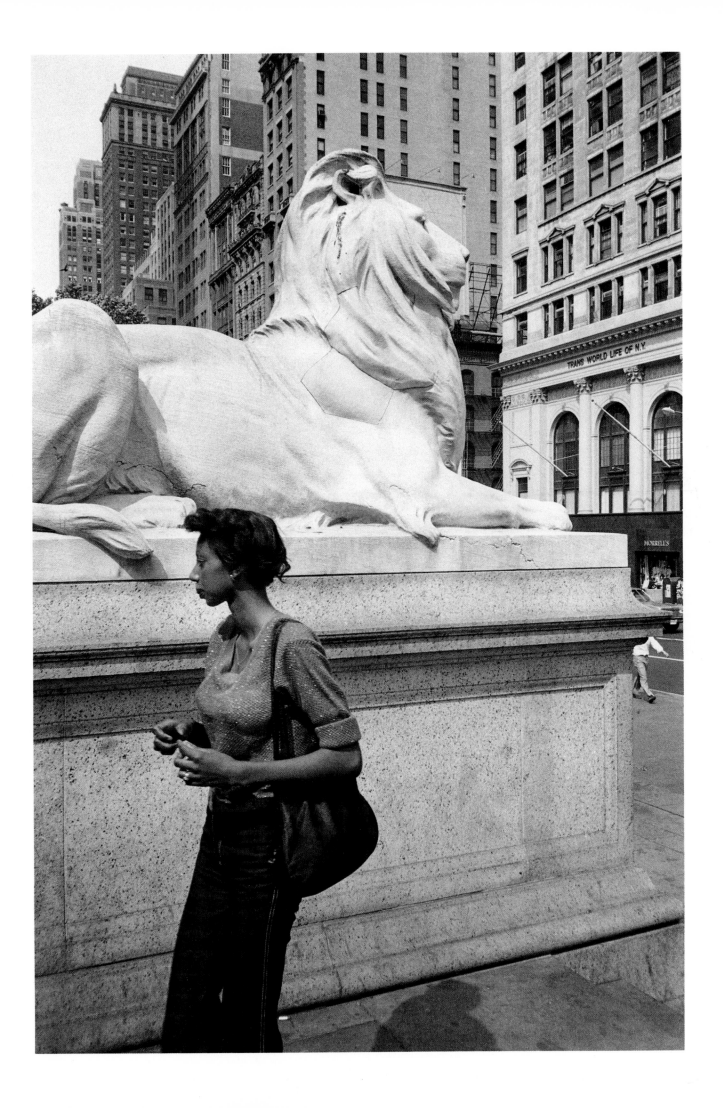

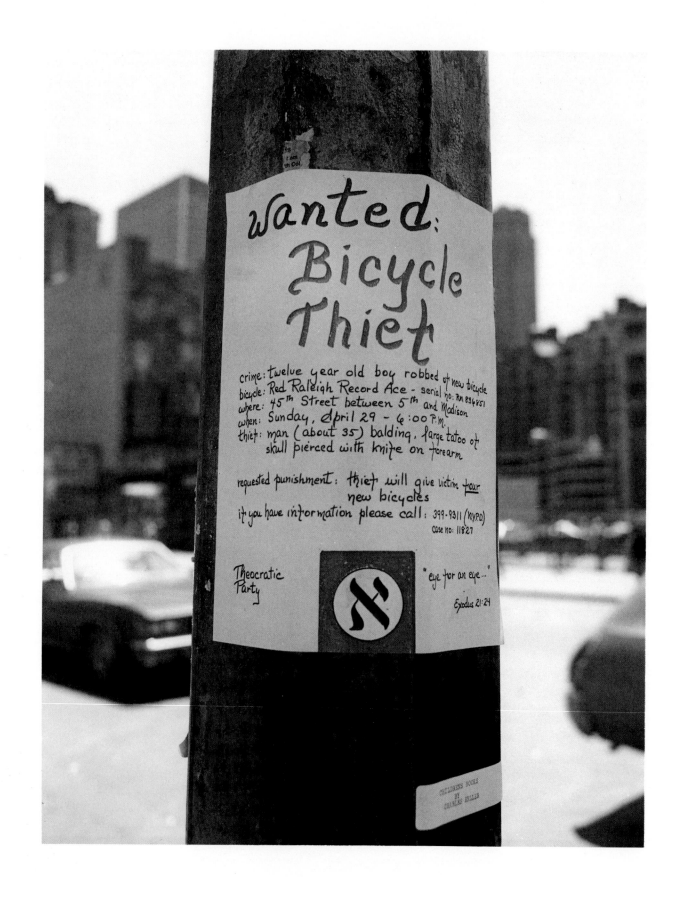

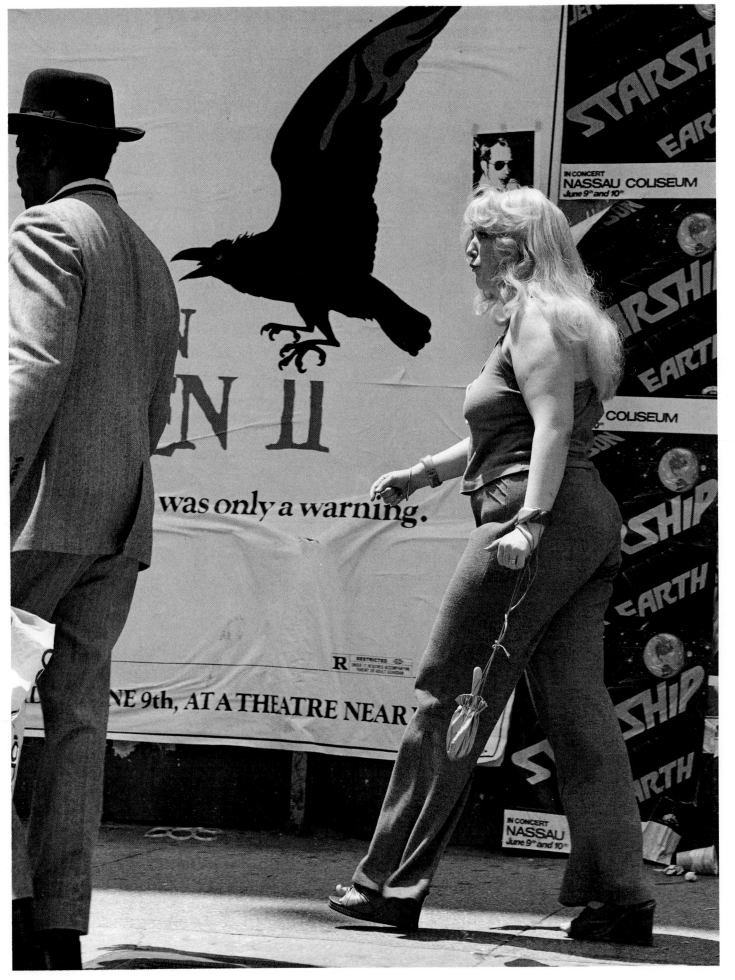

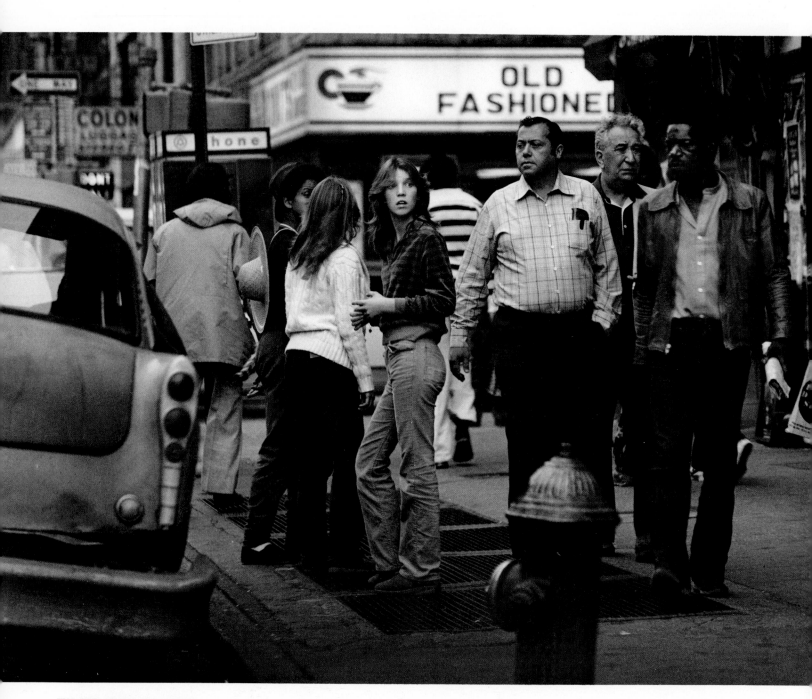

THE CITY PLAYS FOR KEEPS

I saw her and wanted to warn her, "Watch out,
honey, the City plays for keeps." And I wished I were
a few years younger (back about 1940?). All I could
do was make this photograph — in tribute to her
youth, hope and beauty.

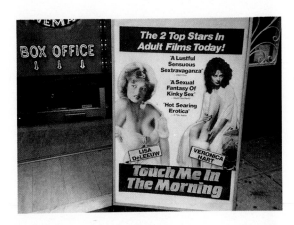

6 ON THE STREET II

*Then I began to think that it is very true
which is commonly said, that the one half
of the world knoweth not how the other
half liveth.*

FRANCOIS RABELAIS (1490-1533)

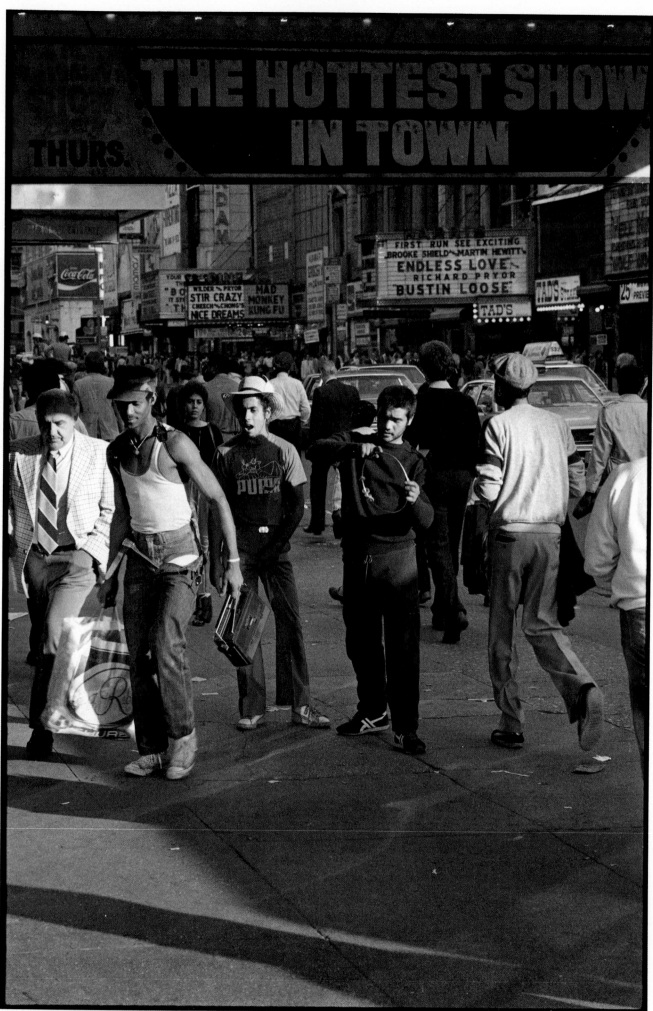

WEST 42nd STREET

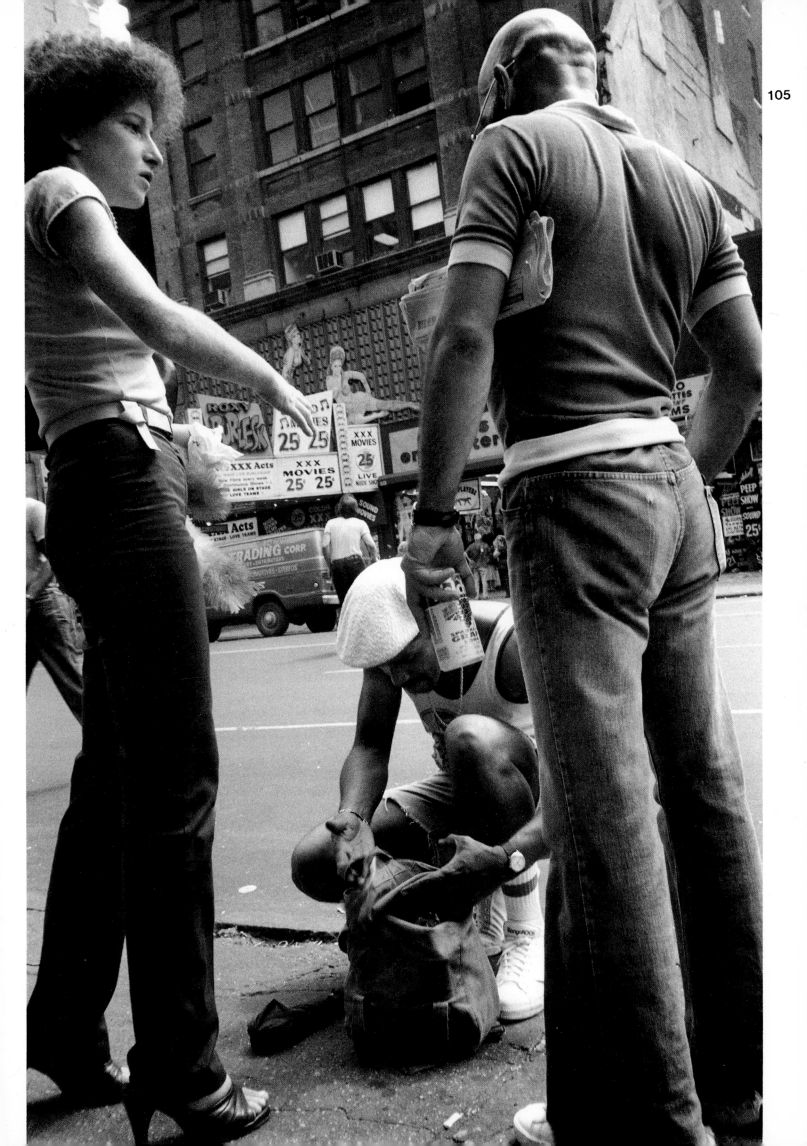

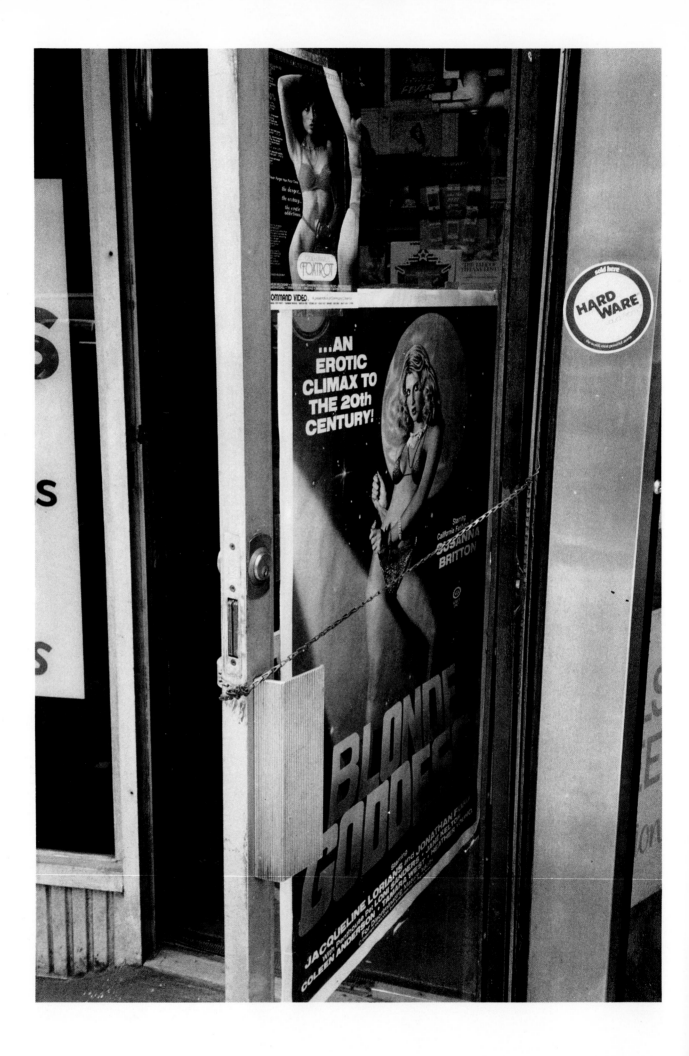

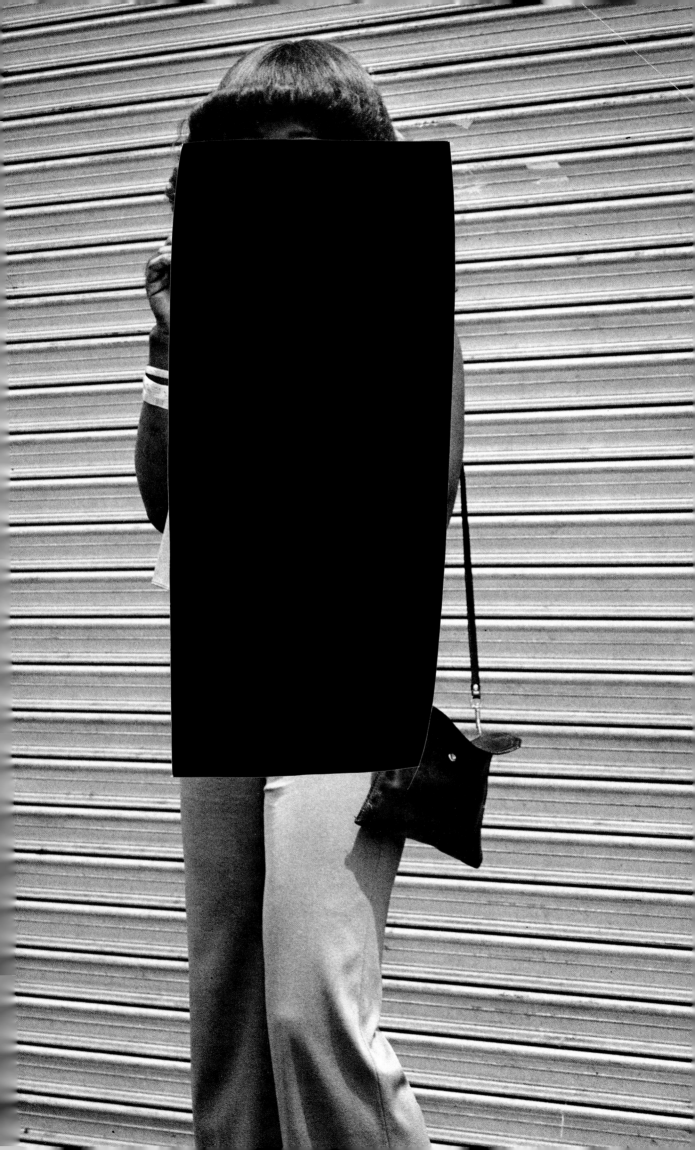

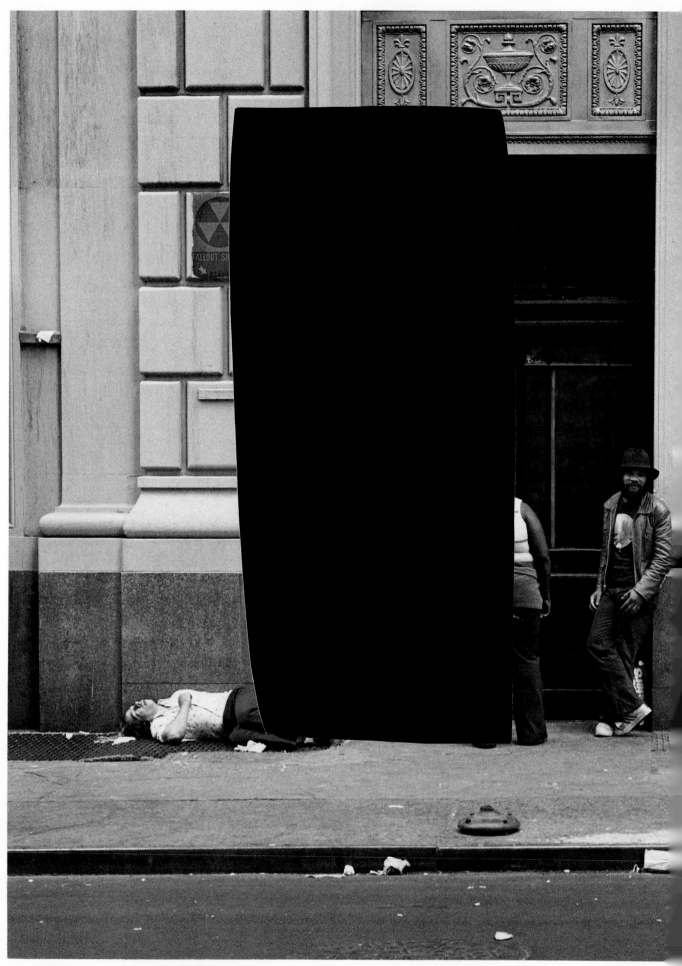

43rd STREET BETWEEN 8th AVENUE AND TIMES SQUARE 1981

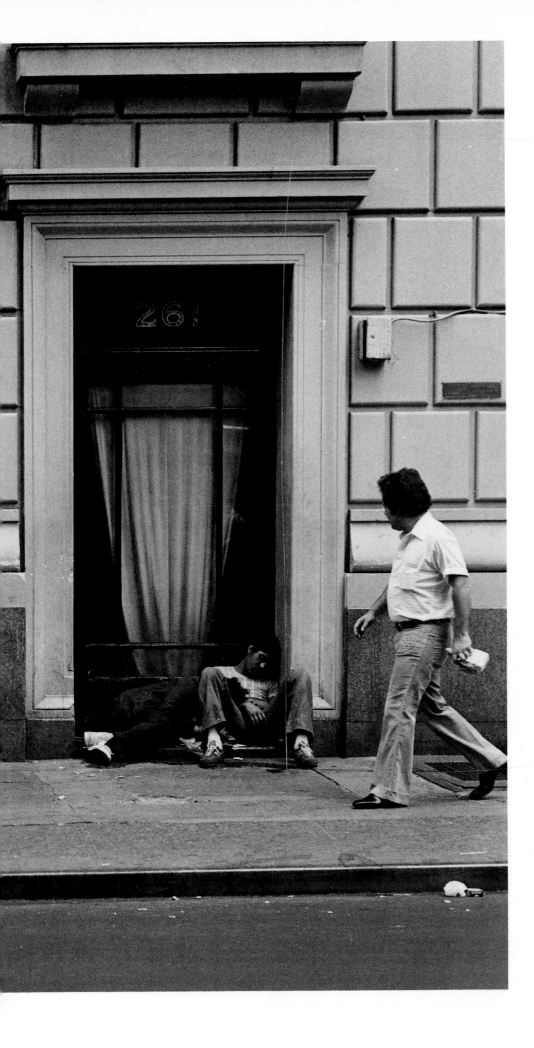

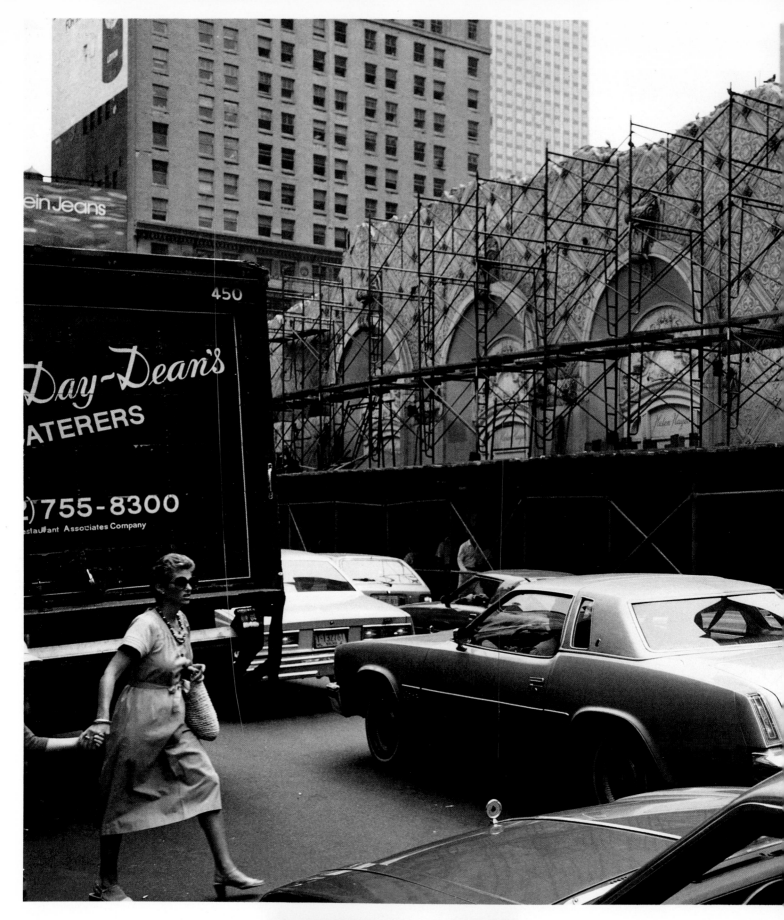
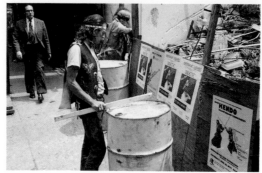

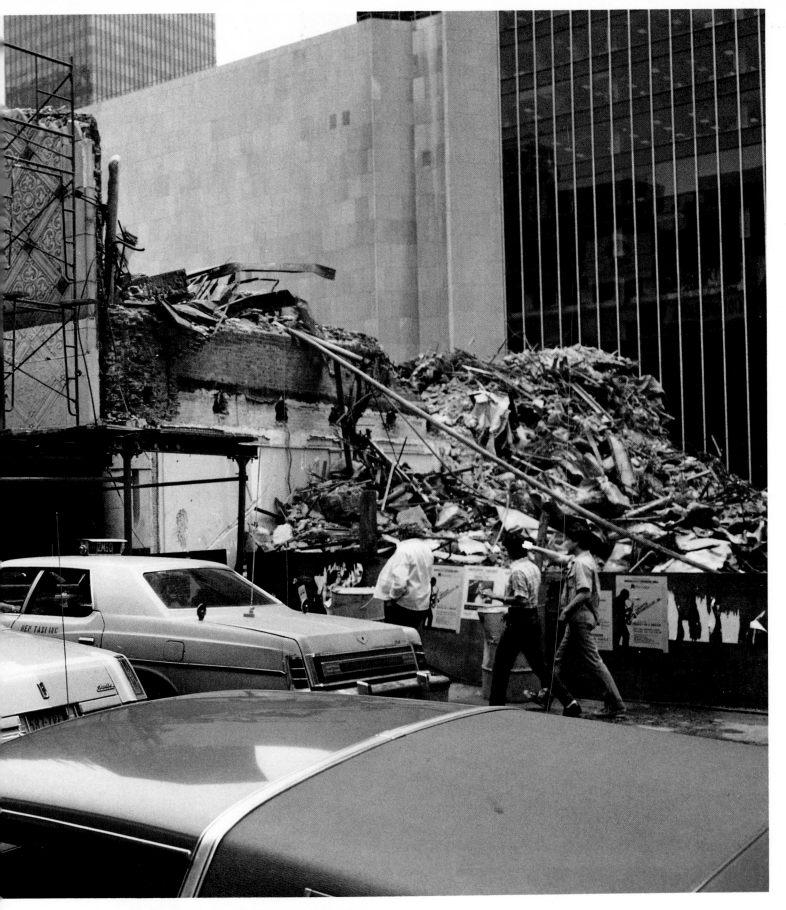

DESTRUCTION OF THE HELEN HAYES THEATER 1982

After photographing the mountain of rubble, I stood by studying the ruins. Next to me was a small American Indian man wearing a beaded headband, a worn leather vest with silver buckles, and levis. He'd taken a stick from the trash and was beating out a simple rhythm on a rusty oil drum. He wasn't doing it to attract attention but drummed softly, meditatively. I realized suddenly it was authentic Indian music.

"Are you doing a death dance for the theater?" I presumed to ask.

He turned eagle eyes on me. Without interrupting his rhythm, he answered: "No, a death dance for my country."

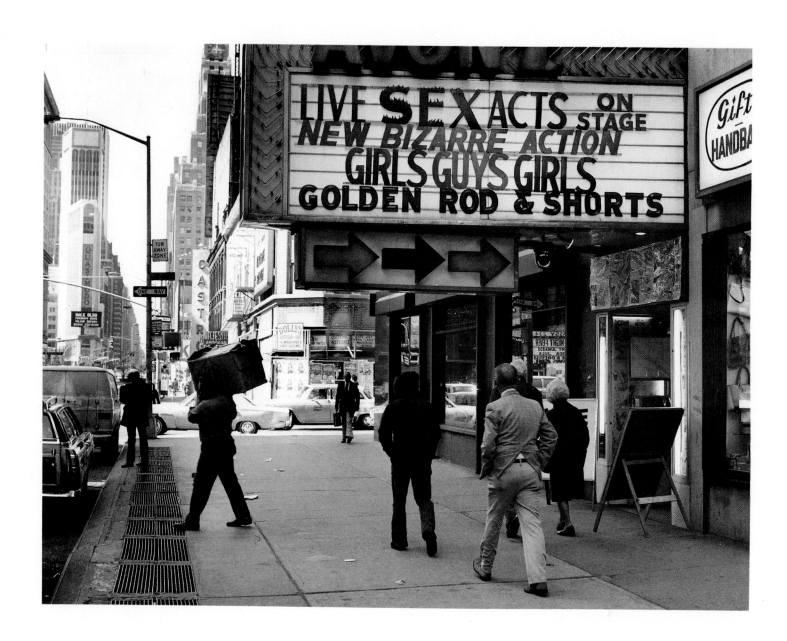

Wonder what's in the box. A body?

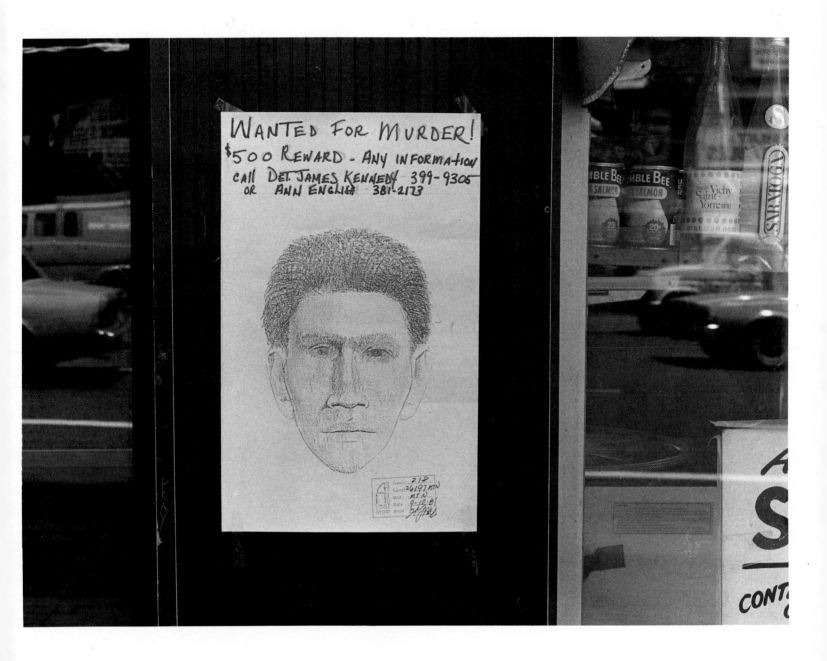

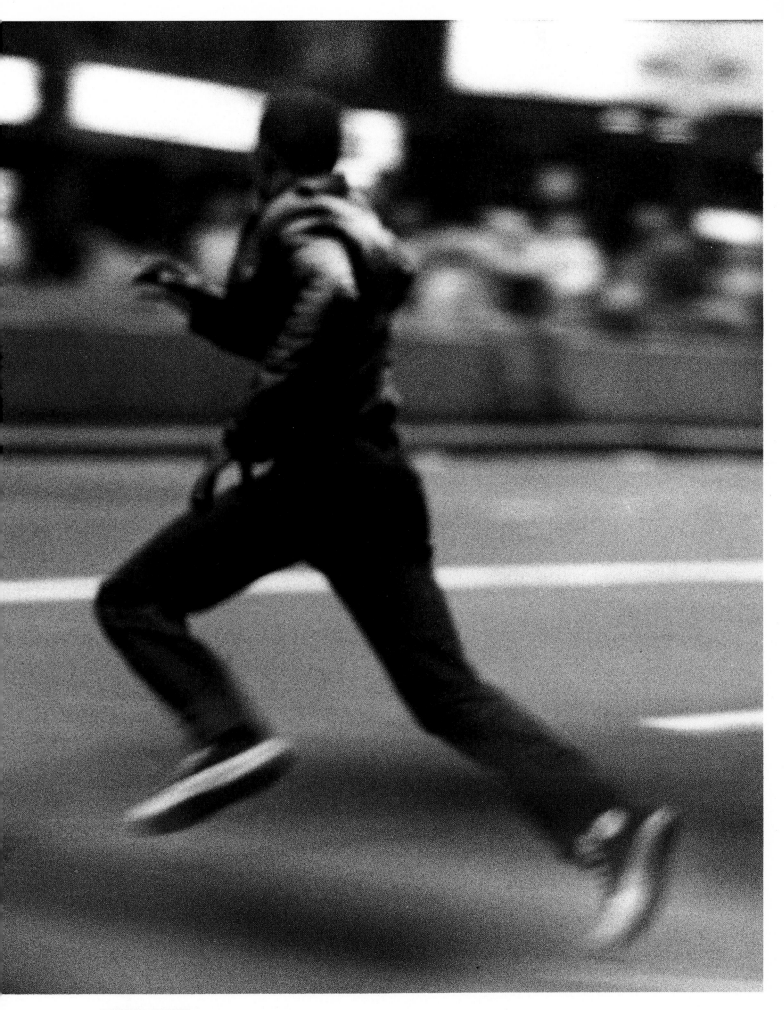

MUGGER ESCAPES

Leather dude knocked over a sidewalk three-card monte game on 7th Avenue near 43rd Street and snatched the money. His victim struggled, got thrown into the street. The whole mugging took maybe ten seconds. The young thief dashed zig-zag across Times Square and got away.

*I think the Big Apple is down to the core.
They've eaten away at the Apple like crazy.
So now where do the criminals go? Jersey,
obviously, is a very nice place to go.*

> *JOSEPH J. DELANEY*
> *Chief of Police*
> *Paramus, New Jersey*

*Times Square as an entertainment district for
the middle and upper class began declining
some years ago, for many reasons: the avail-
ability of television, the closing of night clubs
and of landmark midtown restaurants like
Lindy's, the move to suburbs of many per-
sons and their reluctance to visit "downtown,"
coupled with the widely disseminated if
somewhat inaccurate notion that New York
has an exceptionally high crime rate. . .*

*We do not condone prostitution and vice. We
argue in favor of efforts to redevelop this area
for a more diverse public but do not deny the
obvious fact that there is a strong demand for
drugs and commercial sex. This demand cre-
ates street markets that are not about to dis-
appear simply because we wish them to, or
even because we demand that the area be
saturated with police officers. . .*

*Over the years a handsome profit continued
to be exacted from 42nd Street's rundown
property. A real estate broker described it as
"an ugly cow that gives a lot of milk." He
noted that in 1969 the street's ten grinders
(movie houses) drew 9,000,000 customers
while highly profitable sex bookstores could
easily pay $32,000 a year for a tiny sliver of
street frontage.*

> *from THE BRIGHT LIGHT ZONE*
> *a study by City College of*
> *New York Graduate Center*

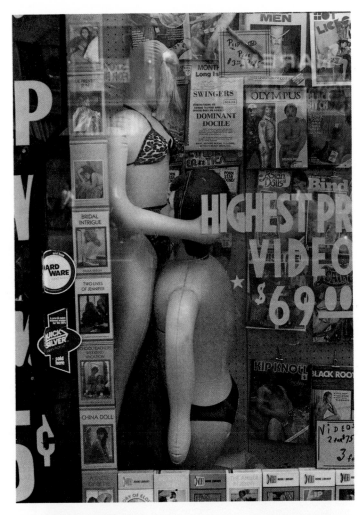

We bring a lot of tourists to this area. If not for us, this town would be dead. How many men would want to come to New York if they couldn't find kids like me? What for — to go see the Statue of Liberty?

> MALE PROSTITUTE

People nowdays have no manners, no morals. Why we have to lock our doors at night. Patron comes in at night has to show his door key. We don't want our desk clerk killed for $40 so some addict can get himself a fix.

> HOTEL CLERK
> Times Square

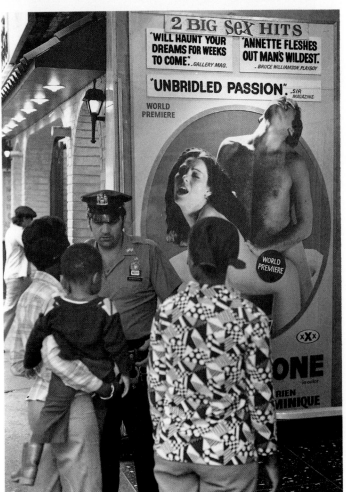

SHUFFLER: *You can win and your money wins too. Pick the red, forget about the black. I'm going home to pick up the slack. Pick the red.*

SHILL:　　*(Puts his money down on the bent card.)*

SHUFFLER: *Almost but not quite. You can win, all you gotta do is play it right. You can win and your money wins too (shuffling as he deals). Pick the red, forget about the black, pick the Queen, forget about the Jack. Pick the red.*

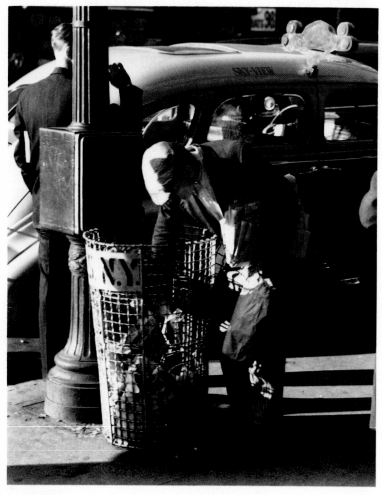

1940

1980

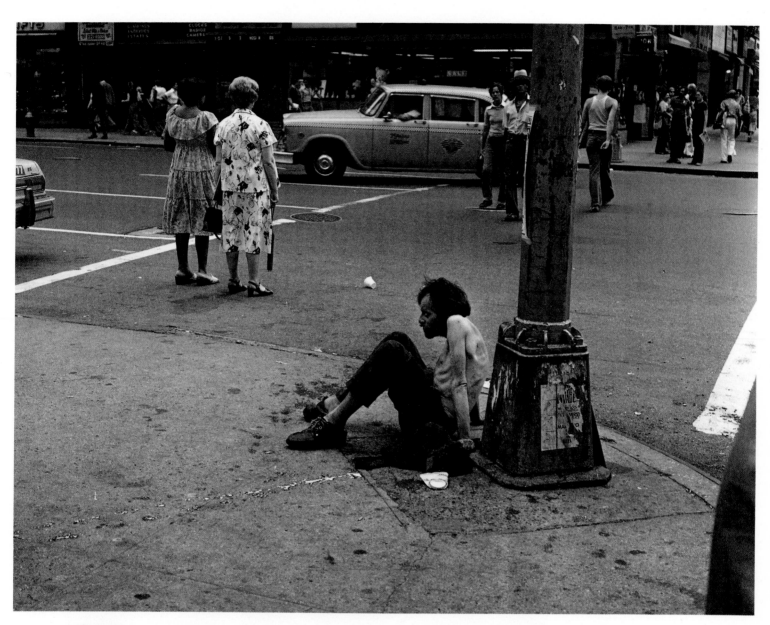

MAN DOWN

Mr. Bones sits in the exact power center of Manhattan
island, the northwest corner of 42nd Street at 7th
Avenue.

He sleeps in a doorway behind a theater. Exhaustion? Drugged? Are those white rectangles empty packets of happy powder? On his chest, a tatooed cross. On his shoulder "Mata," a form of the Spanish word matar, to kill.

Make the experiment I did. Turn this book 90 degrees so the photograph is horizontal. Just a bum in a doorway, right? Turn it vertical again...seems to me the change is spooky. The face of a Goya dwarf emerges. Or is he one of those two thieves hung up there alongside J.C.?

Where does she sleep? What is her existential secret? How does she survive? Is that a sandwich squirreled up under her sweater? She wears the plastic bag scarfed over her shoulders elegantly, a 1930s boa.

Don't know how to say this, other than that I found her beautiful. Despite her chaotic dress and bedragglement, she always walked with grace and purposefulness. I've seen her stop, and stand, feet apart, seeming, like a beat poet, to take in through eyes and ears and scent the sensory overload of the city.

She aged over the four years of our photographic encounters (of which she was never aware). Her face was puffed up, this last time in 1982. Her mouth now twists downward on one side. Was there an illness, a small stroke? Yet Mother Courage's stride down 43rd Street the last time I saw her was as erect and proud as ever.

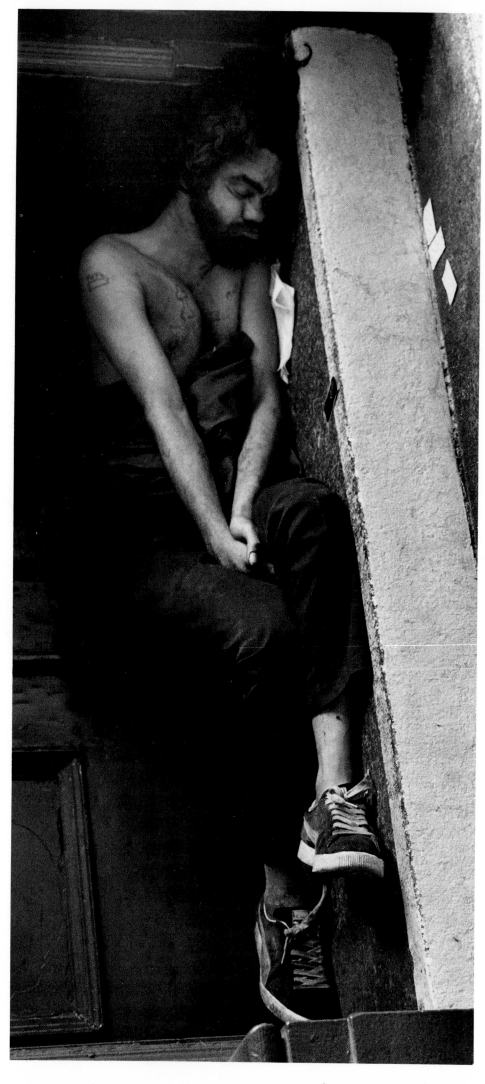

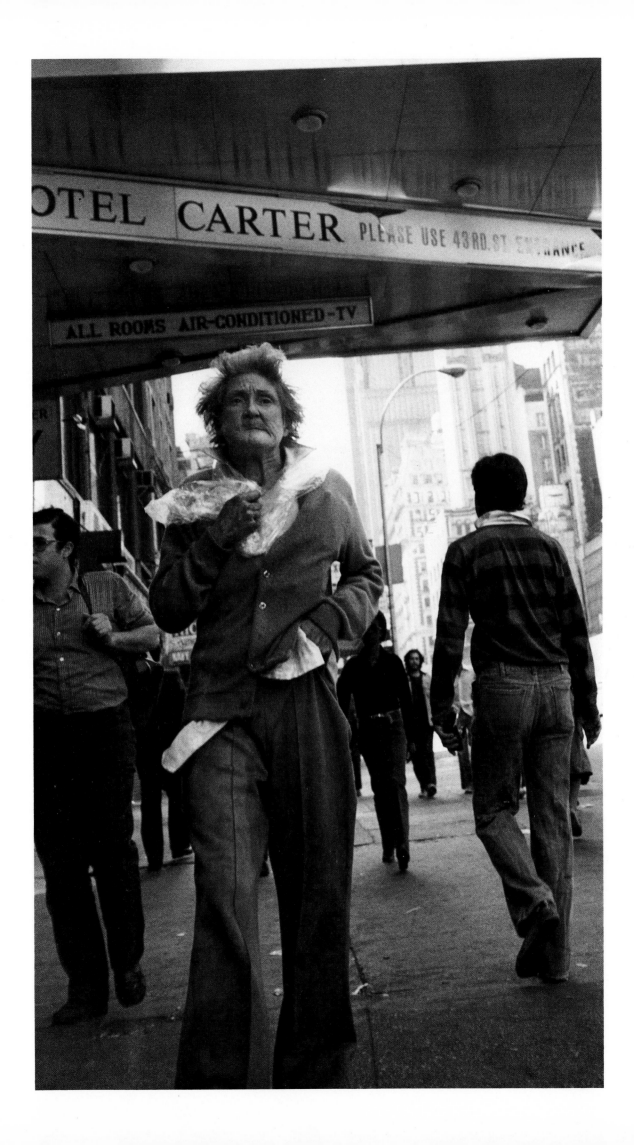

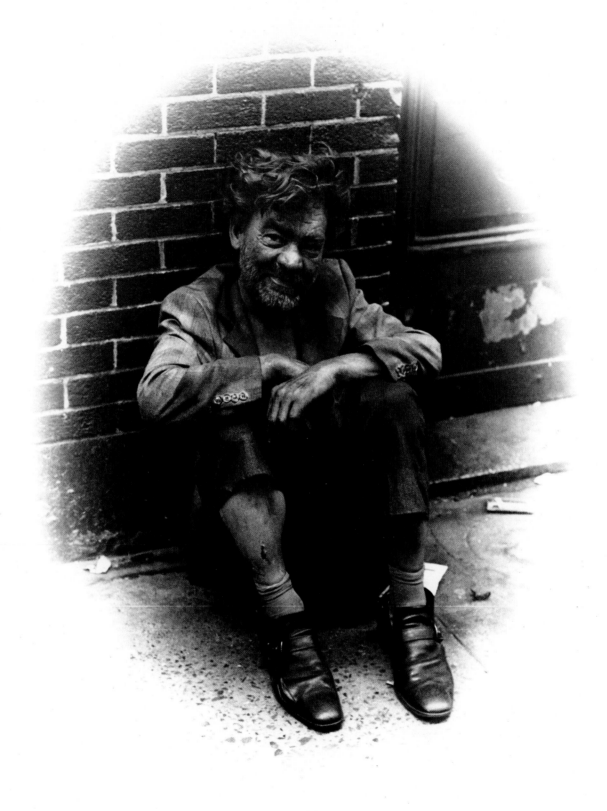

New York attracts the most talented people in the world in the arts and professions. It also attracts them in other fields. Even the bums are talented.

EDMUND LOVE
from Subways Are For Sleeping

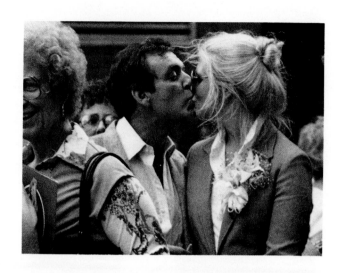

7 PRIVATE MOMENTS

I love the idea of there being two sexes, don't you?

JAMES THURBER
cartoon from the New Yorker

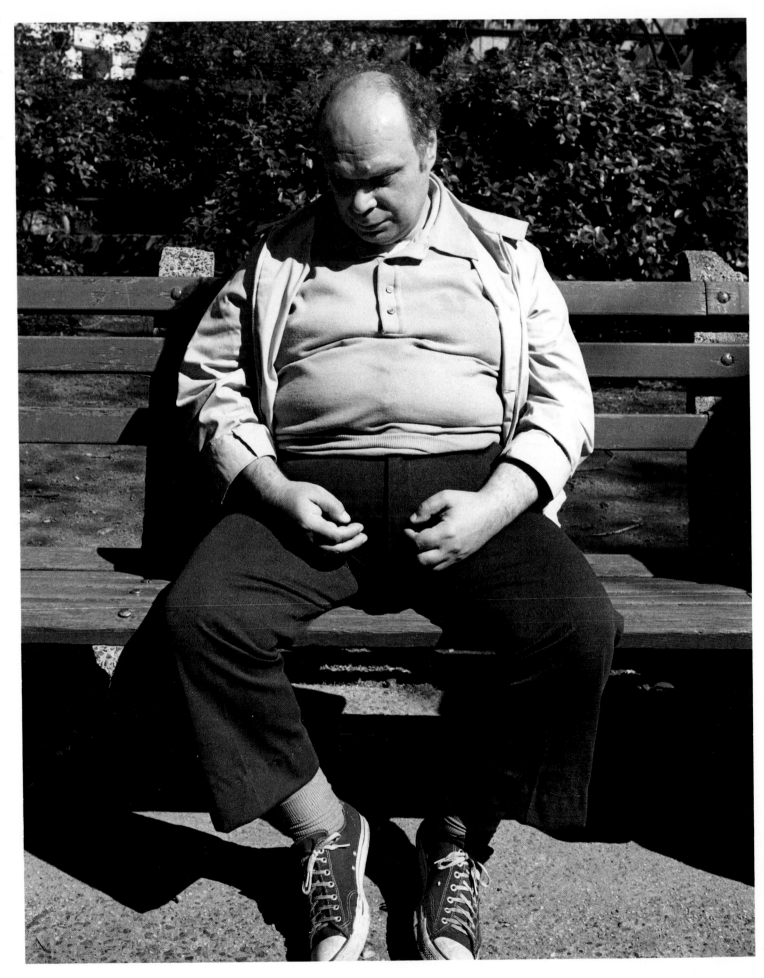

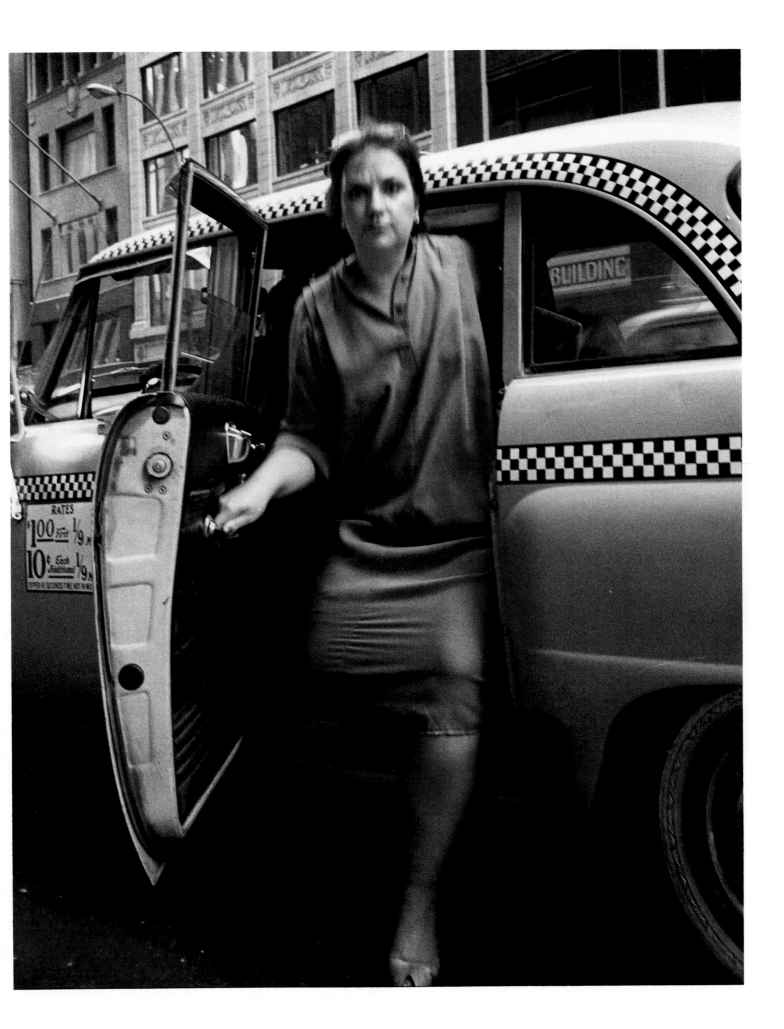

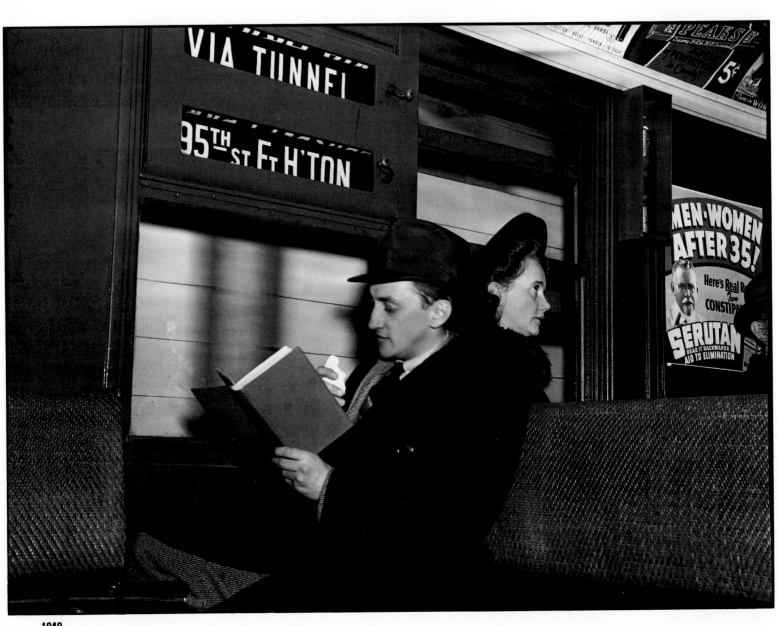

1940

TALKING IT OVER 1982

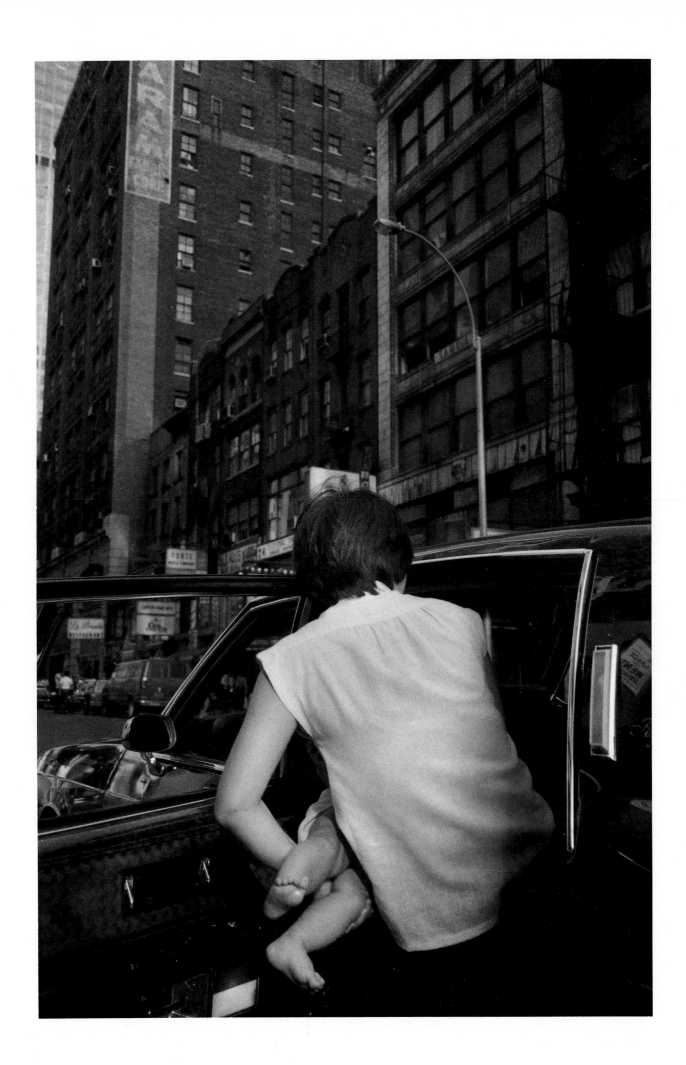

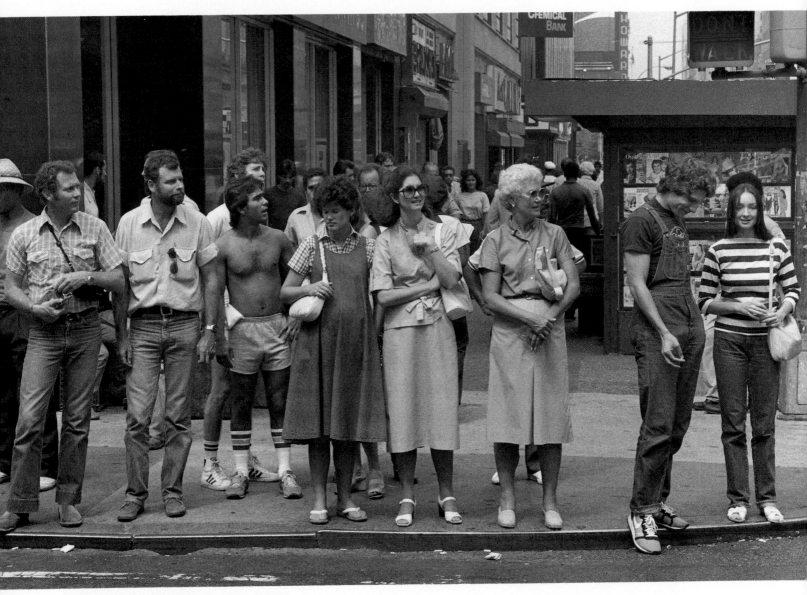

WAITING FOR THE LIGHT TO CHANGE 1982

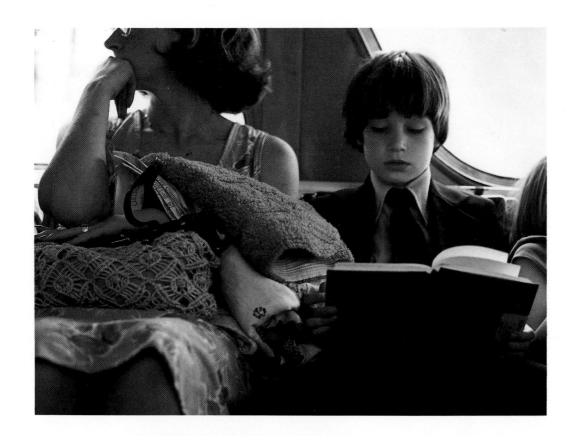

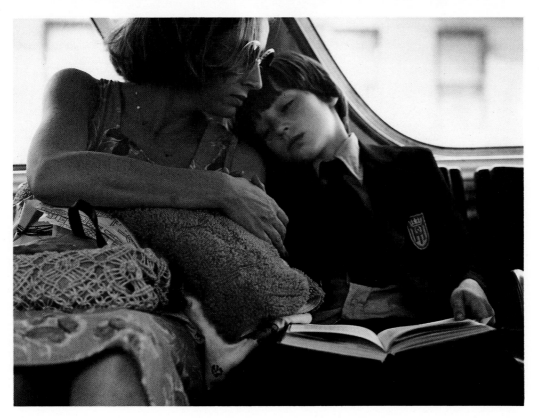

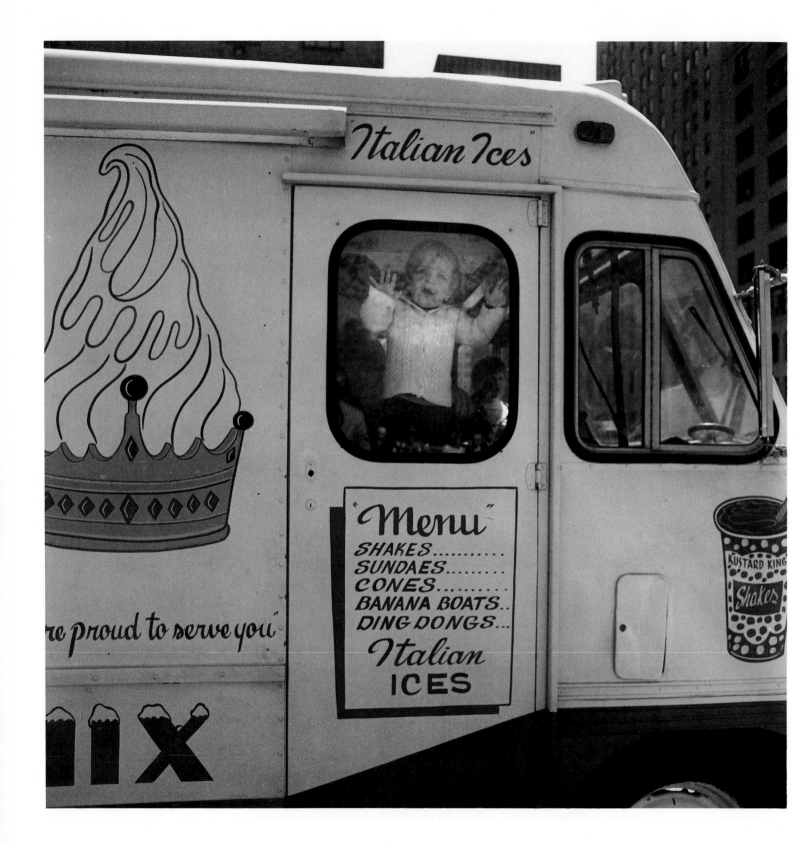

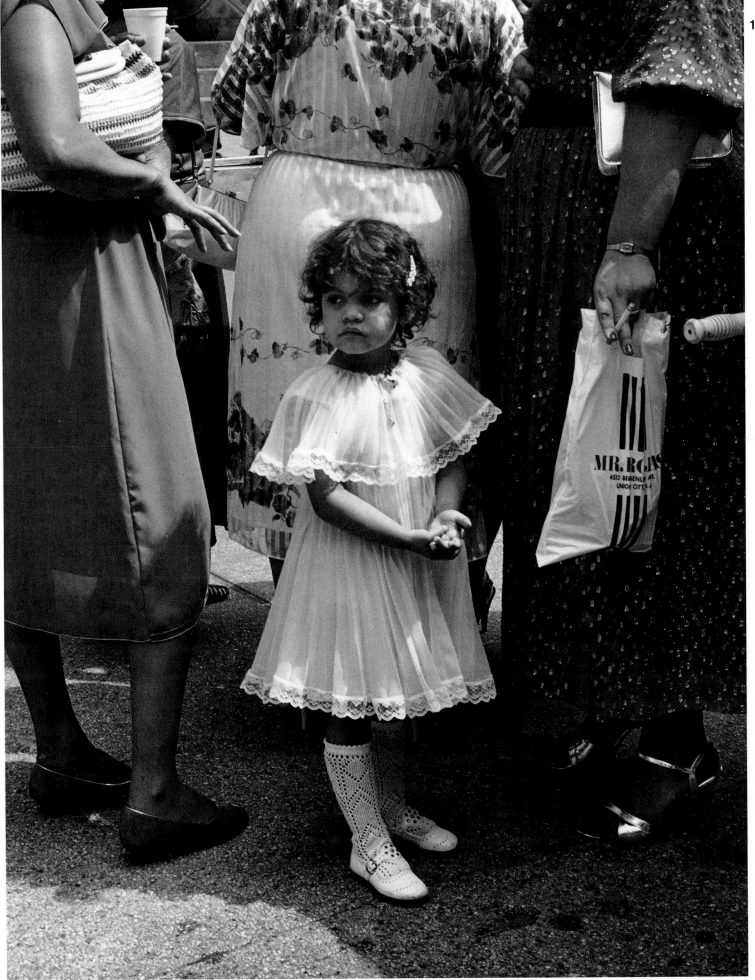

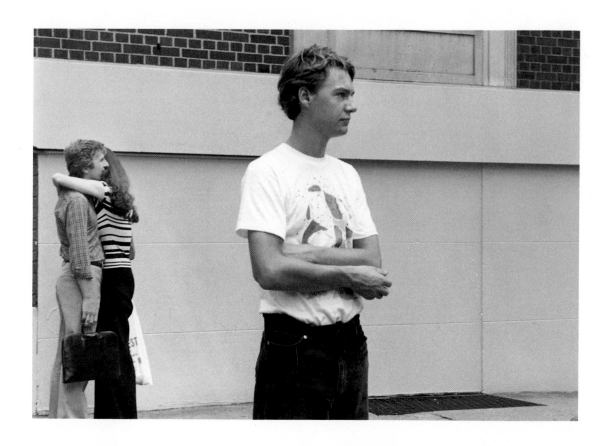

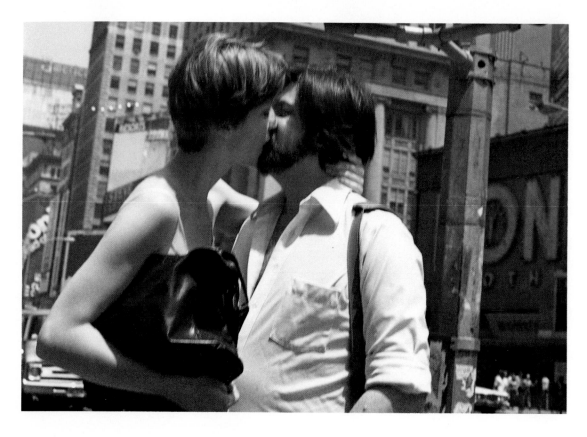

"The Times They Are A Changin'"
BOB DYLAN

"Girls Just Wanna Have Fun "
CYNDI LAUPER

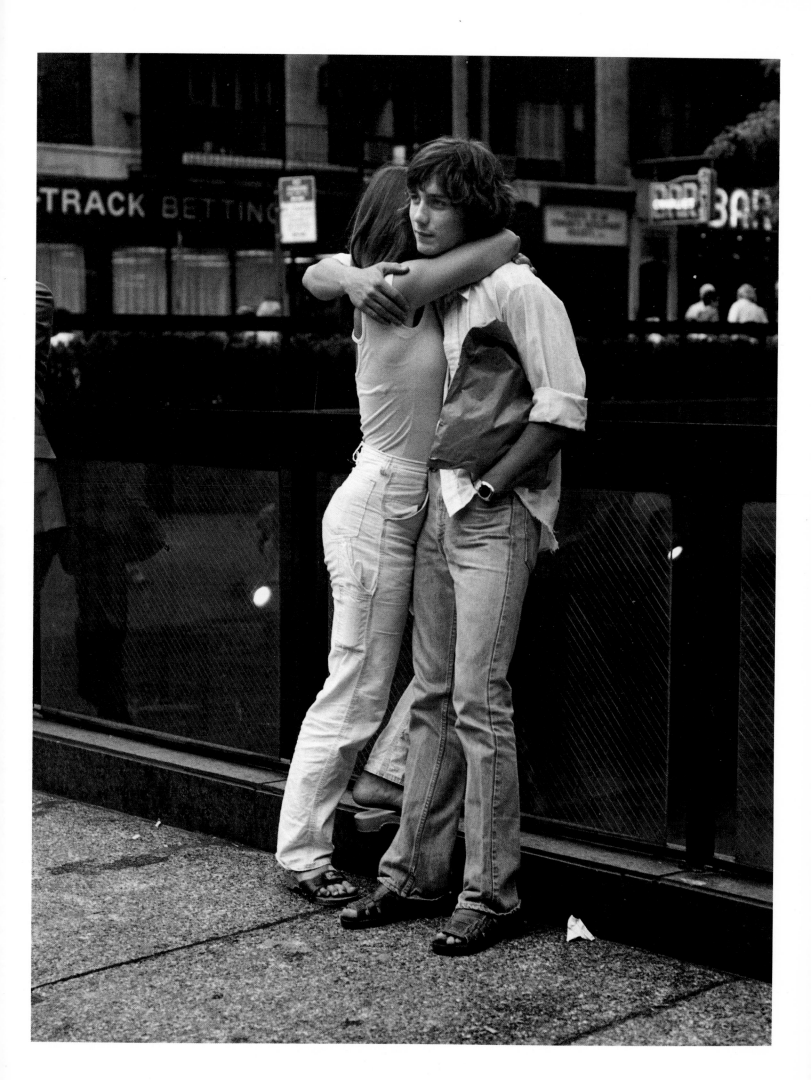

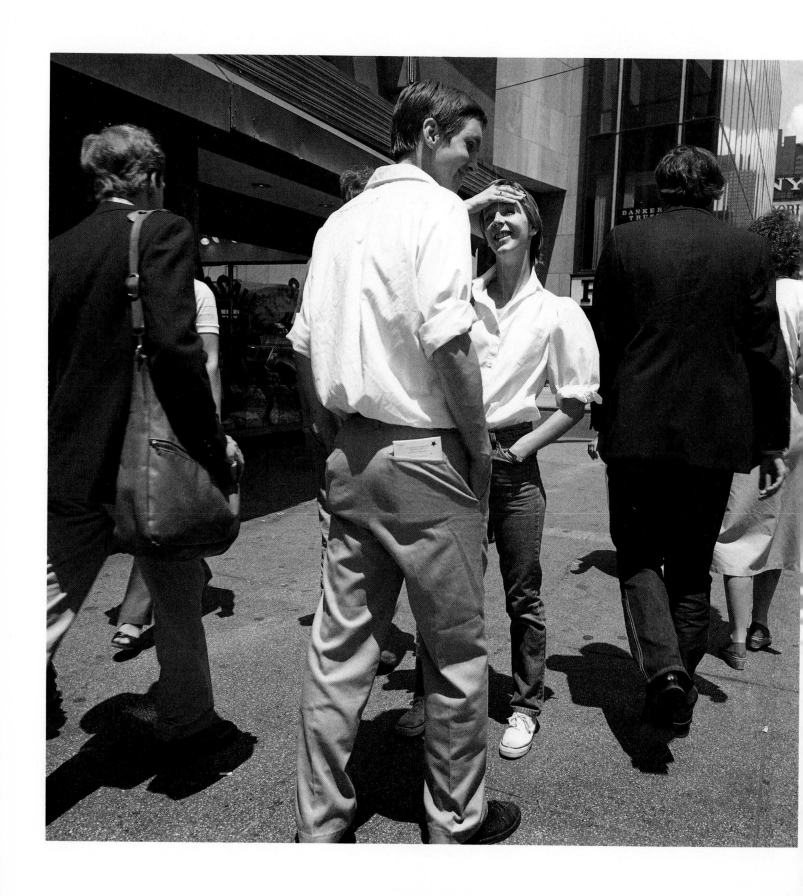

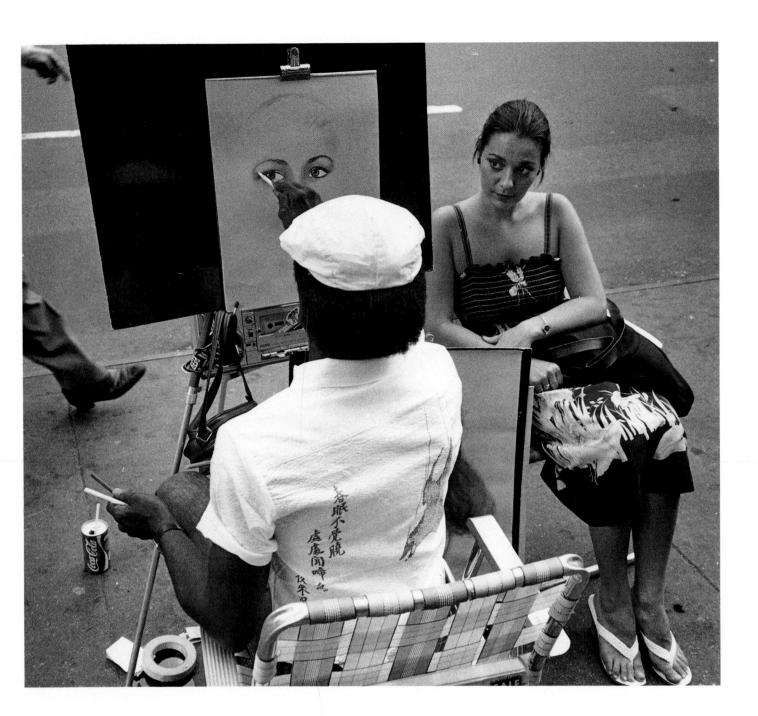

138

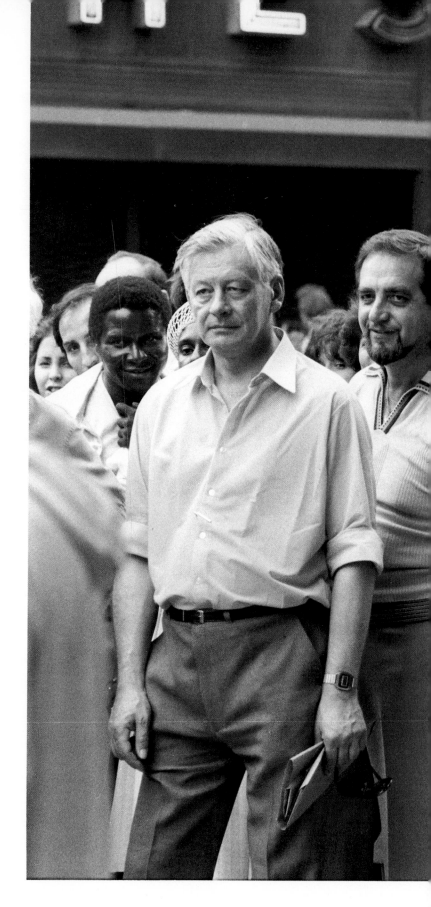

A man gradually identifies himself with the form of his fate; a man is, in the long run, his own circumstances.

JORGE LUIS BORGES
from El Aleph

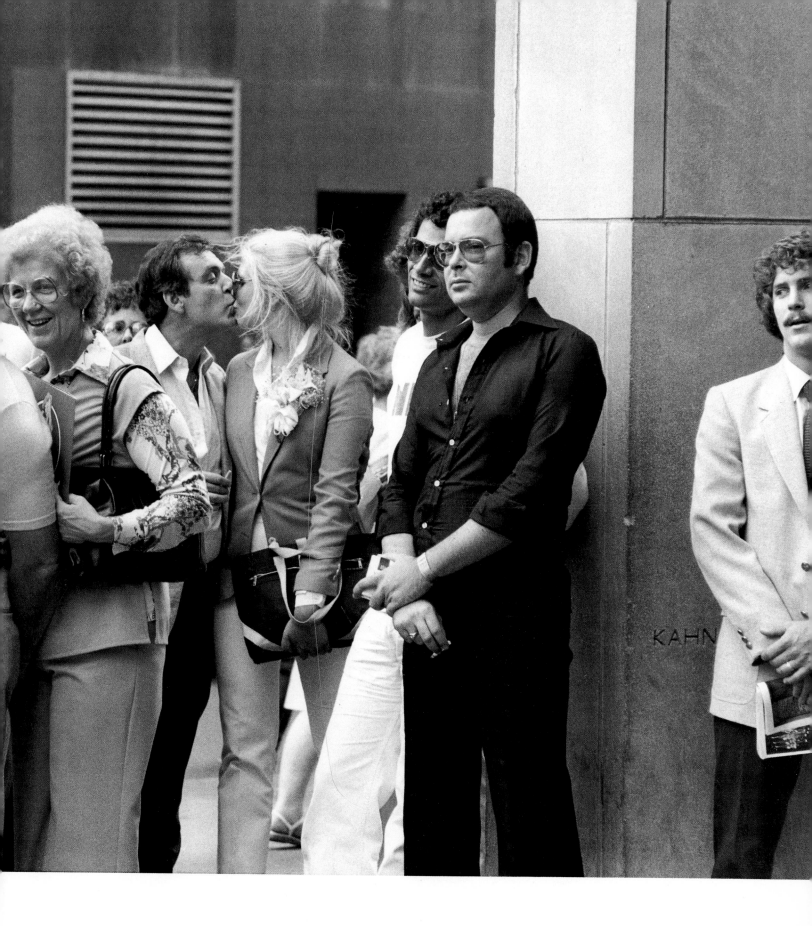

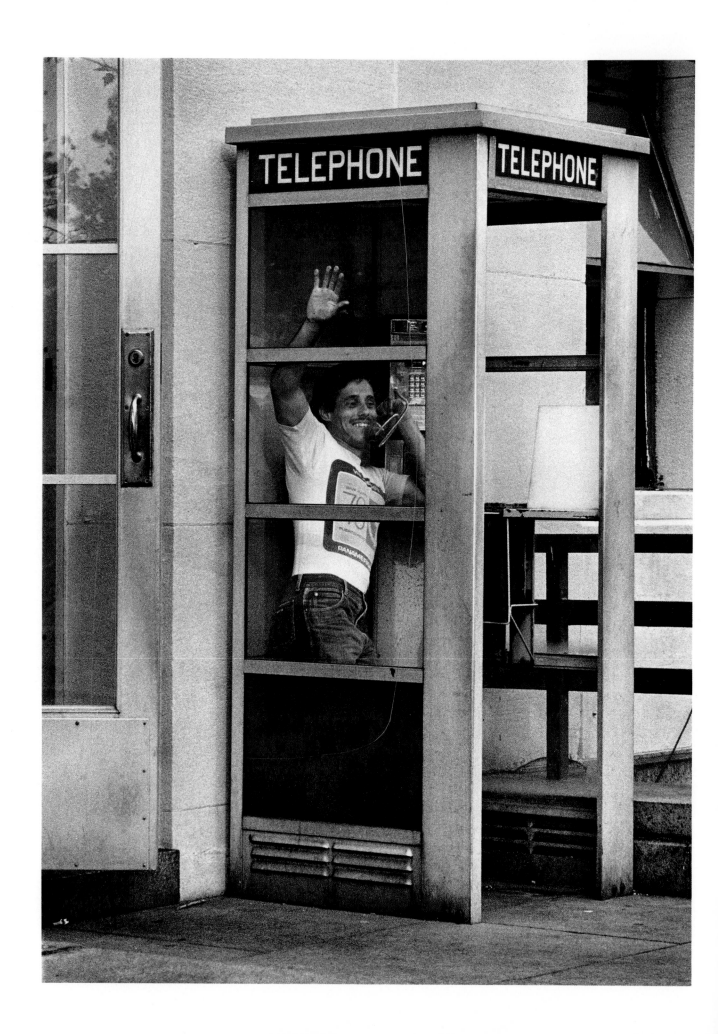

MOVIE TICKETS

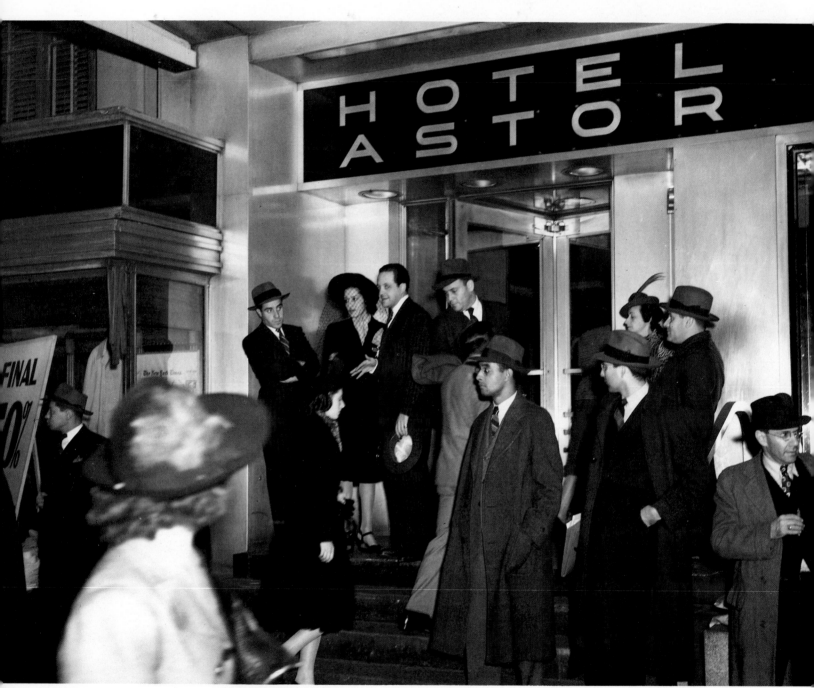

WAITING FOR THEIR DATES ON HOTEL ASTOR STEPS 1940

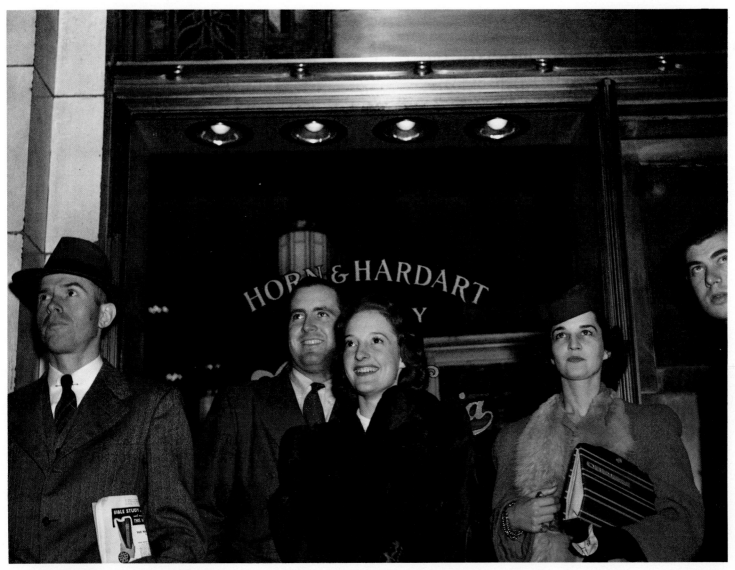

WATCHING THE ELECTRIC SIGNS 1940

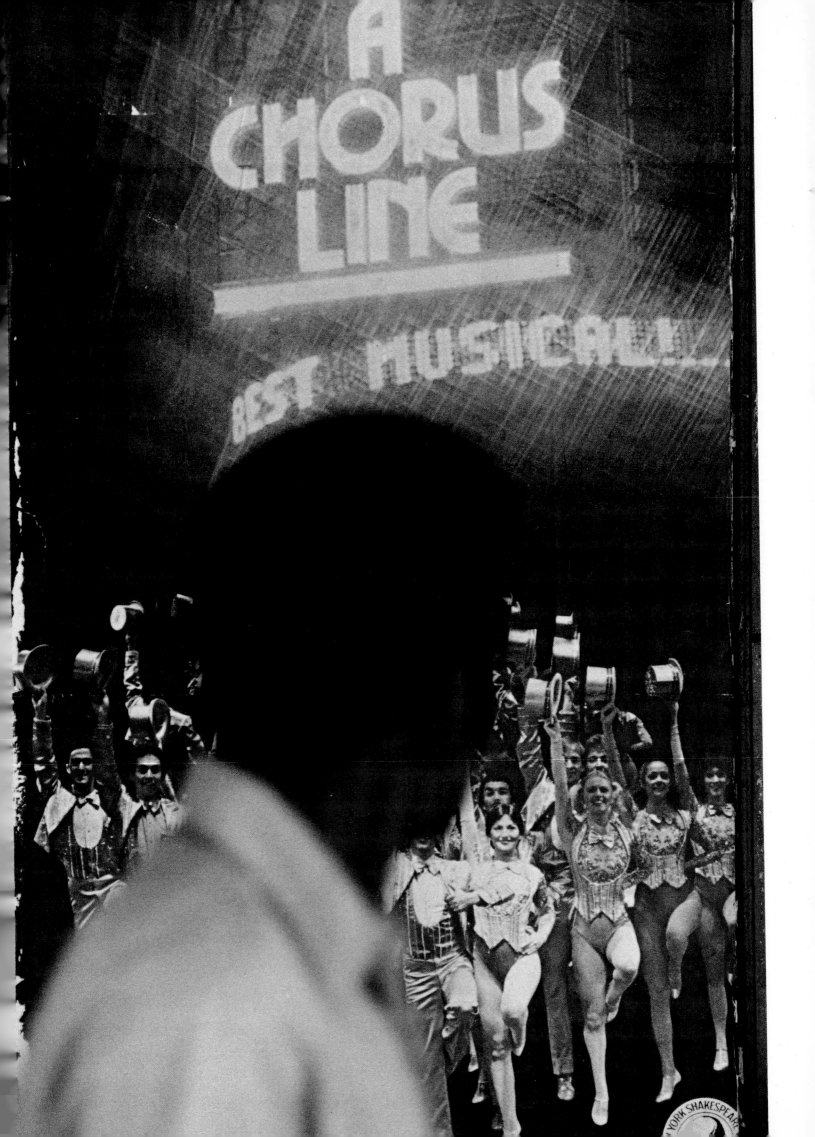

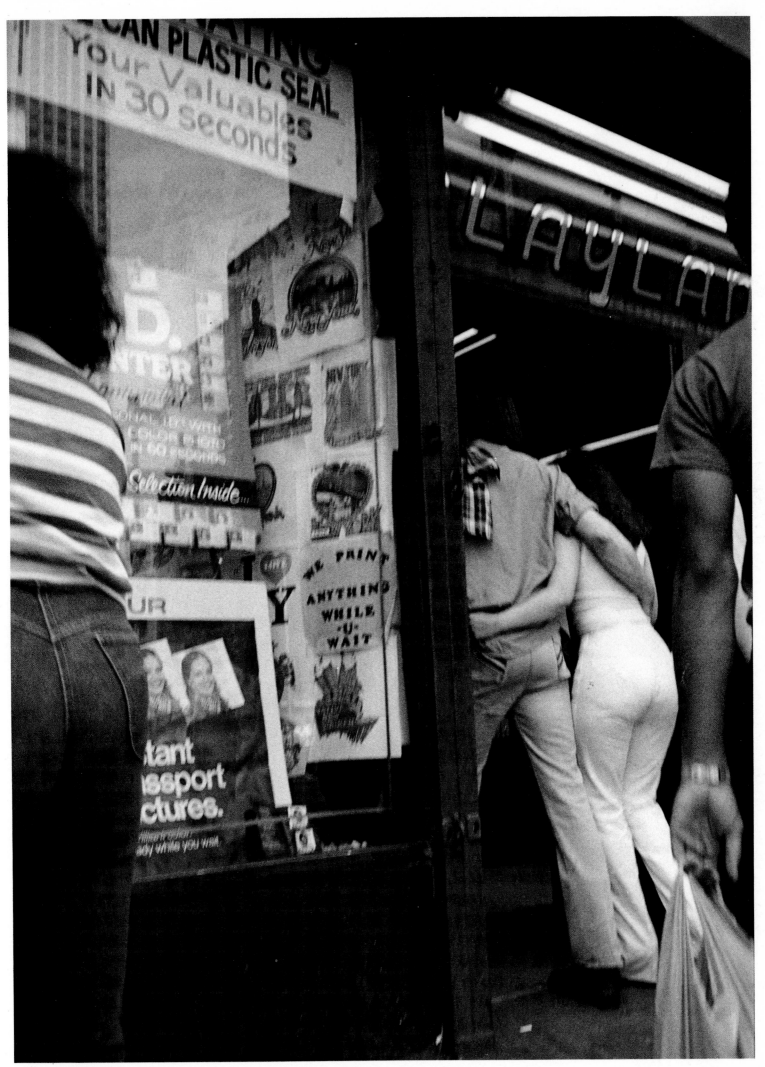

PLAYLAND 1982

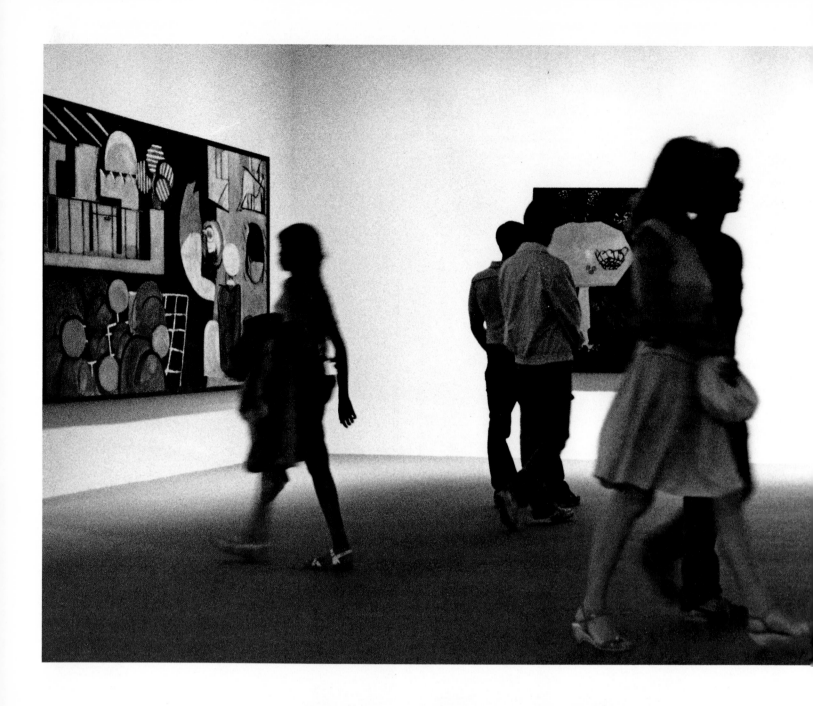
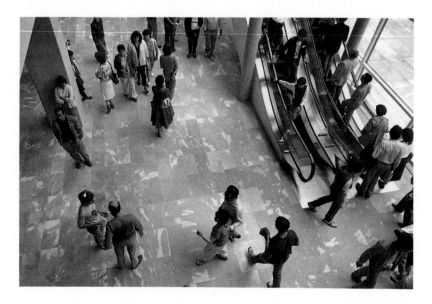

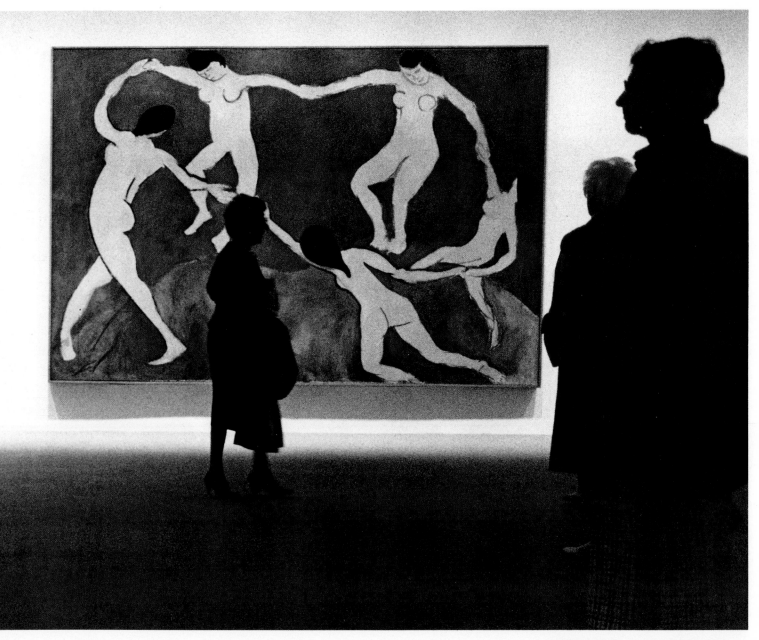

OPENING SHOW IN NEW MOMA 1984

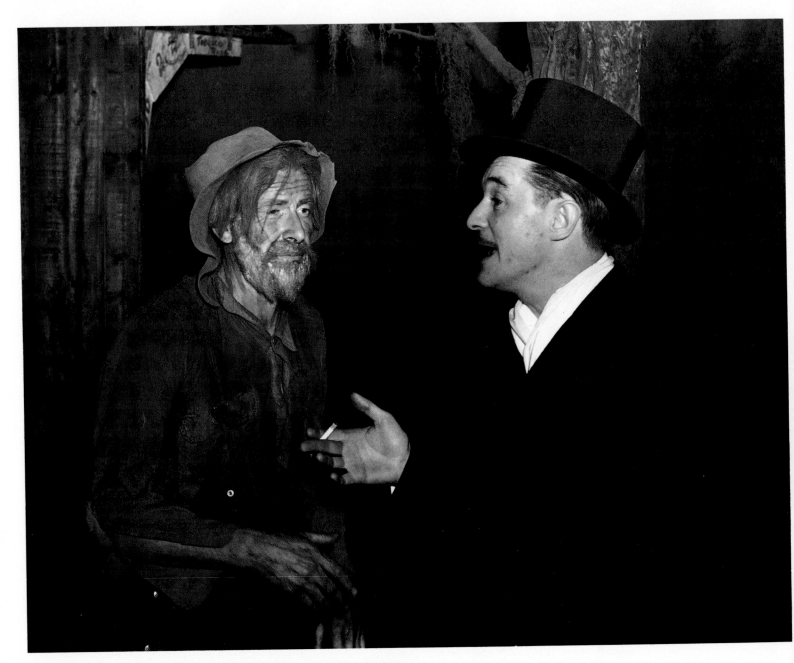

BACKSTAGE AT NINTH ANNIVERSARY PERFORMANCE OF TOBACCO ROAD

In 1940, young Will Geer was made up and costumed
for the role of old Jeeter Lester. Forty years later, in
the 1980s, he didn't need as much makeup to look like
TV's old Grandpa Walton.

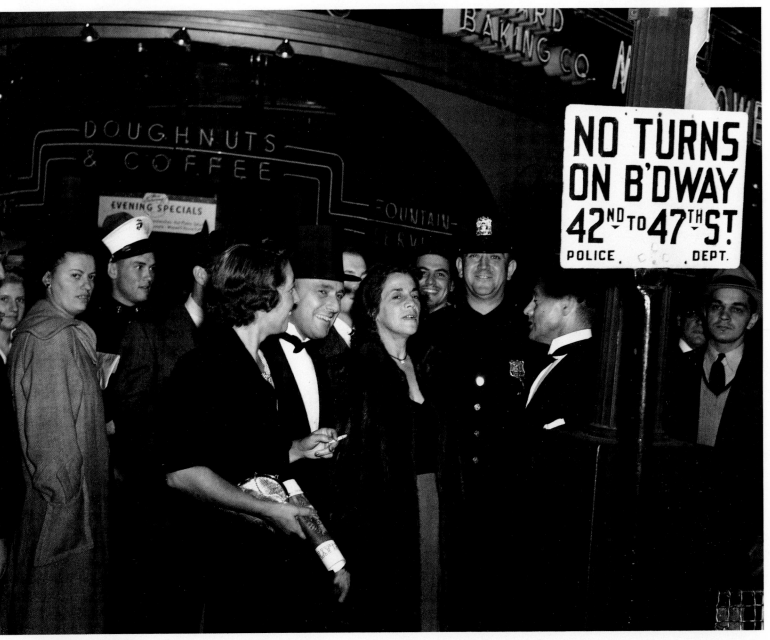

AFTER THE THEATER

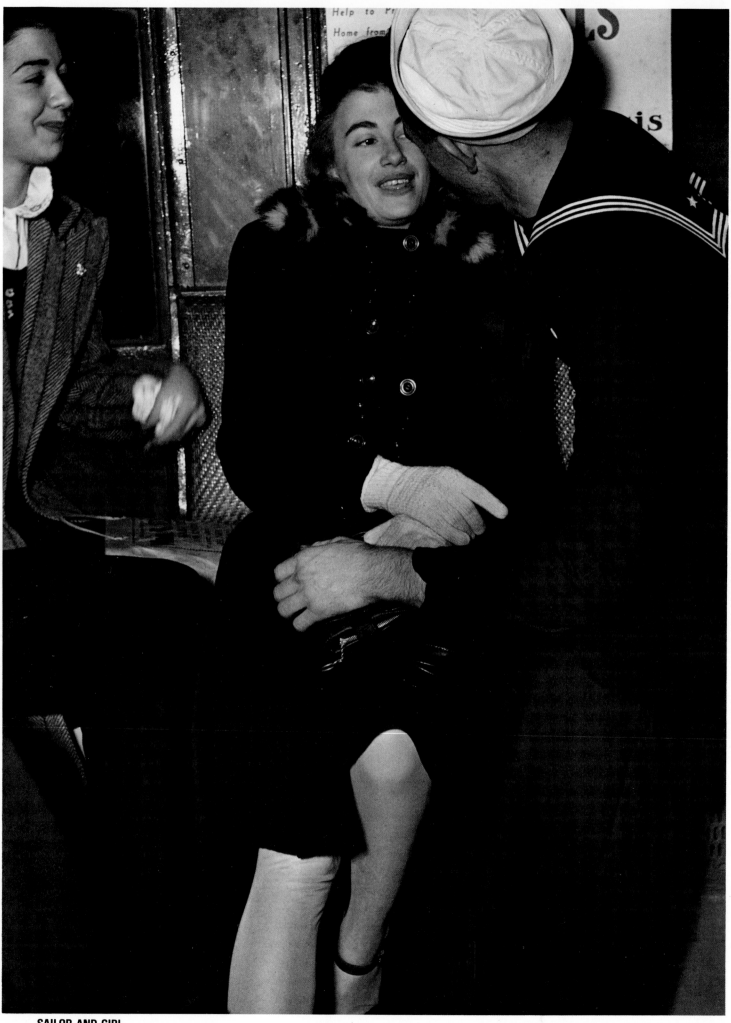

SAILOR AND GIRL

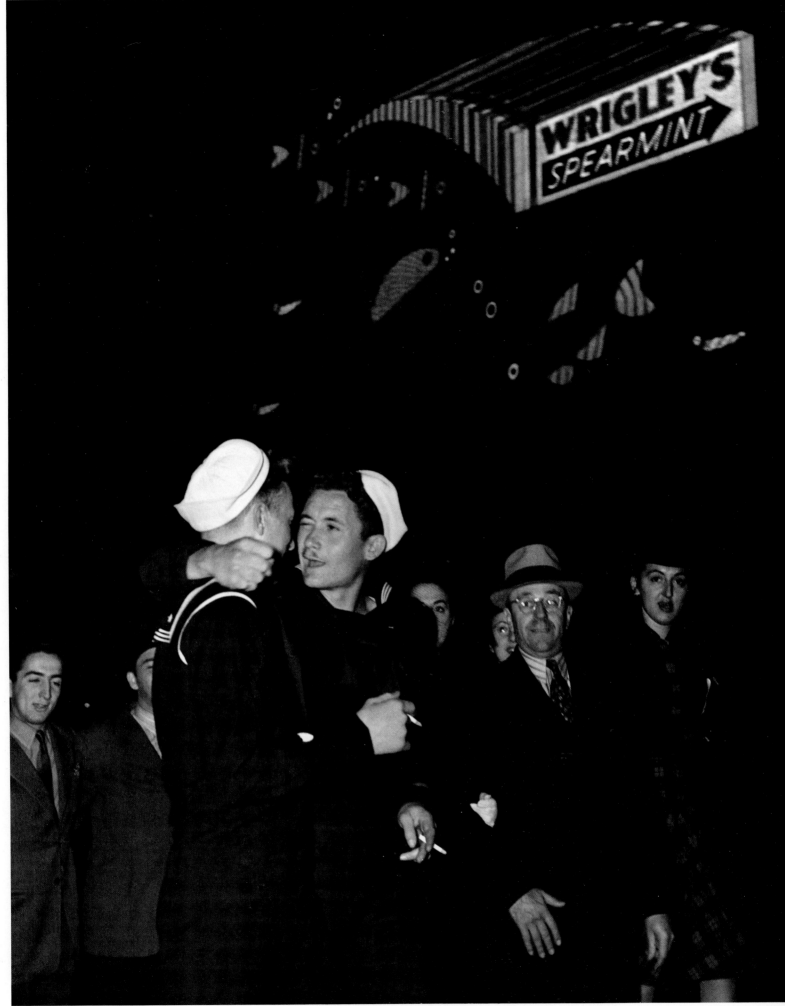

SHORE LEAVE

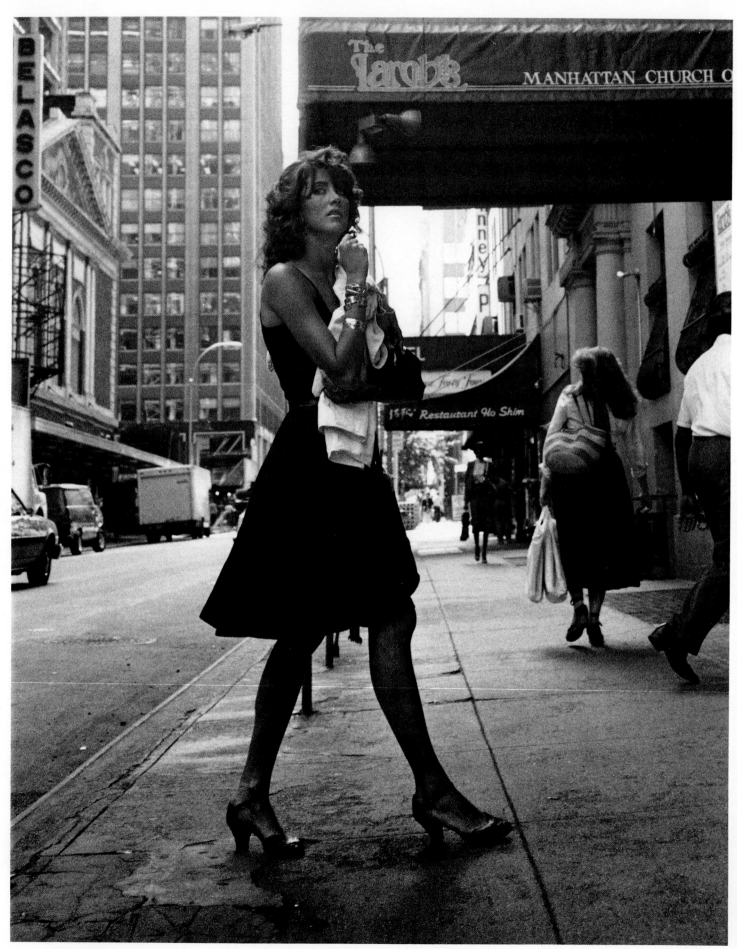

CLASS, 1980

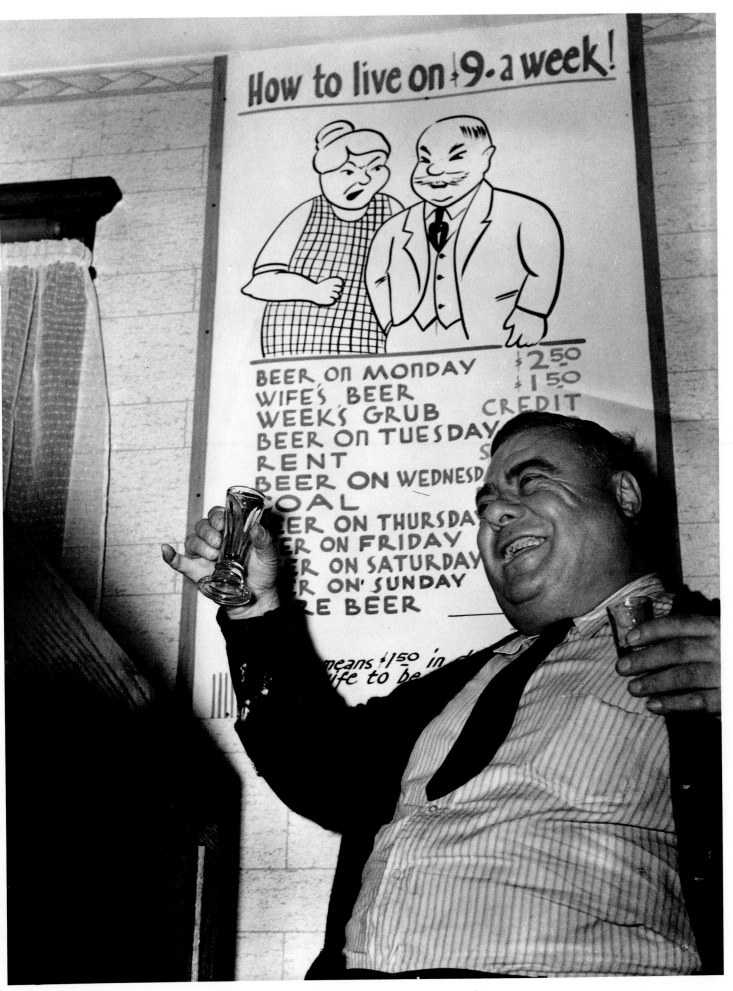

CLASS OF 1939

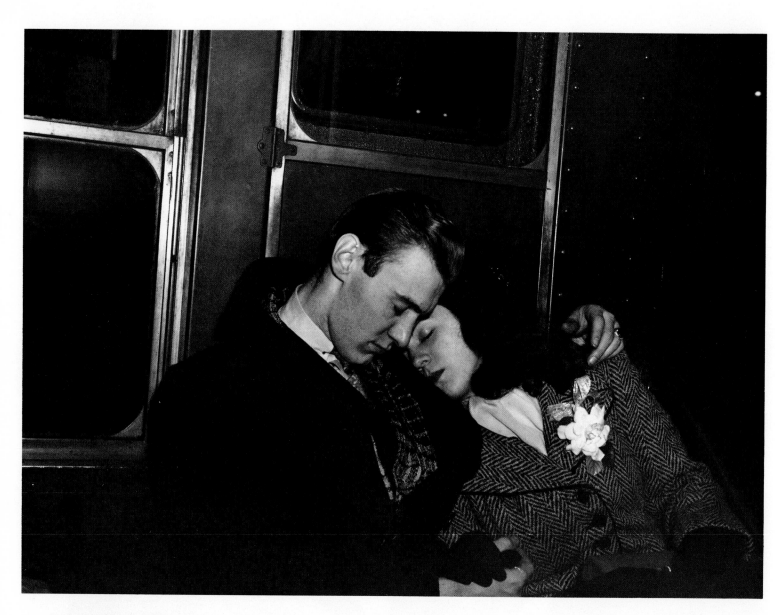

GOING HOME BY SUBWAY 1940

I wonder if this handsome trusting couple is still alive?
Still together at 60-plus? What was the occasion? Why
the orchid corsage? Should either or both of you see
this photograph, I'd like to know. Please write me
care of the publisher. Let's get together and make a
photograph of you now, with all the changes, maybe
for another book. And I'd like to invite you to a super
dinner at the Algonquin. We'll have laughs.

AN AFTERWORD

THOSE WERE INNOCENT DAYS JUST
before World War Two. Kids like me, out of
school, naturally and romantically moved
toward New York City.

The depression of the 1930s was still on.
But a young man or woman was at least as
likely to find a job (and love) in New York
City as in hometowns like Bethlehem,
Pennsylvania. And while you tried in
New York to make your way, all about you
was splendor: theatres, museums, book
publishers, magazine editors, symphony
orchestras, foreign films, big money, big
league sports, famous faces to spot on the
streets. Among the greats and the millions of
nobodies, you had a free feeling of
anonymity. You could do what you liked.

Carl Sandburg walked New York's streets
those days, and Alfred Stieglitz, Jack
Dempsey, Thomas Wolfe, Fiorello Laguardia,
Edna St. Vincent Millay, Arturo Toscannini,
Paul Robeson, Albert Einstein, Greta Garbo,

and my first big-city love, the painter and premature feminist Alvena Seckar.

Down in Greenwich Village were jazz music, Italian and Greek restaurants, the studios of artists. Further south were Chinatown, Liberty's Statue, and the slums where first generation Italian, Irish and Jewish immigrants raised their children. Uptown was the joy, sadness and promise of black Harlem, where whites went looking for sex, southern cooking and to hear Ella Fitzgerald at the Savoy. Also uptown were Columbia University, the medieval Cloisters, the Metropolitan Museum and, closer to Times Square, the Museum of Modern Art where one could experience European painters, classic movies and intellectual Jewish girls from the Bronx.

Out in Brooklyn was Ebbets Field where the Dodgers won the pennant for Brooklyn that year with the help of their 21-year-old "whirlwind," Pee Wee Reese. In Madison Square Garden Joe Louis defended his heavyweight championship four times, winning over McCoy, Paychek and (twice) Godoy. At the Metropolitan Opera House on 34th Street Lily Pons sang Lucia de Lammermour and Lakme with Enzio Pinza. In Union Square between 14th and 23rd Streets hot-eyed speakers promised us World Revolution; the Express Train of History, they said, was well underway. Europe was fibrillating with communism, fascism and war. Nazi bombs were already dropping on London.

In 1940 the place where everybody in the world wanted to be was New York City. Especially the young. Especially the poor from Latin America, Asia, Africa. Especially the refugees—from Hitler's Germany, Stalin's Russia, England's Ireland, Franco's Spain, Whitey's Mississippi, and Mom and Dad's house in 48 states. New York City in those days was Capitol of the World. Heart of all its possibility and exhilaration was Times Square.

Times Square was not a square but an almost crossroads. It was a big X where Broadway and 7th Avenue came briefly together and touched, like jazz dancers bumping backsides. Times Square was noisy and crowded and gay (those days gay meant joyous). Times Square was where you took your date, or found one. Times Square was where you bought your shoes, books, kazoos and sandwiches. You arranged to meet your friends there—"on the Hotel Astor steps," or "under the Wrigley sign." If you had no friends, no money, you still came to the Square. What better place in the world to be alone and hungry?

And when big events were happening— elections, world series baseball, important deaths, corruption scandals, declarations of war and peace—it was there, under the flashing news bulletins travelling around the New York Times Building, where everybody met. It was pleasant sharing the news in such friendly town meetings. You knew you were an American—perhaps a citizen of the world.

My first room, in 1939, was in an

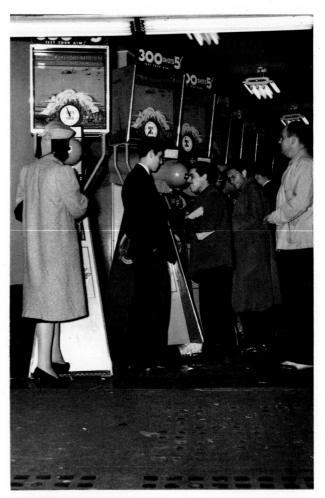

SHOOTING GALLERY 1940

"empty" mansion on West 53rd Street, with a view down from my window into the sculpture garden of the Museum of Modern Art. The elderly caretaker secretly rented out rooms to young people she liked. Mine cost four dollars a week. That was cheap even then, perhaps because it was winter and the building had no heat at all. My first job was also a lucky break, quantity photoprinting in the darkrooms of Apeda Studios on 47th Street. It paid $23.50 a week. But those days a complete breakfast at Nedicks (orange juice, coffee and a donut) cost ten cents. A good hamburger could be had at any White Tower for 12 cents (small) or 23 cents (large), including roll and all the ketchup and chopped onions you could eat.

My enthusiasm those days as now was words and pictures, writing and photography. I was learning both crafts. My equipment was a big Speed Graphic "press camera," with one lens and a flash gun. Since Life magazine declined to hire me (they said No twice), I gave myself an assignment, to photograph the most exciting subject I knew. Times Square.

Weekends, days off, nights, and later when out of a job, I hung around Times Square like a cop on stakeout. I'd be there at dawn to photograph first sun burning down 43rd Street past Toffenetti's Restaurant. I climbed to the top of the Times Building and shot down on the whole Square during rain. I photographed backstage at Broadway theaters, fired flashbulbs into people's faces aboard subway trains under the Square. I got skilled at guessing distances without using the rangefinder, learned how to aim and shoot casually and accurately from the hip without raising the camera to my eye. My big foil-filled flashbulbs fired off by accident, or so it seemed. Nobody ever punched my face, then, or tried to break my camera. I did this work for myself, at first, kept the negatives together, mostly unpublished, all these years.

Times Square 1940. Waiting for the War—and for all the unexpected, dangerous and wonderful things that would come afterwards...

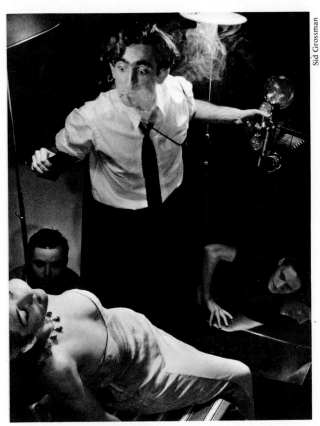

THE PHOTOGRAPHER 1940

Sid Grossman

1982

Sonoko Kondo

BY LOU STOUMEN

BOOKS

Speech For The Young / First Poems & Camerawork
Yank's Magic Carpet
Can't Argue With Sunrise / A Paper Movie
Times Square 1940 *(portfolio with text)*
40 Years *(portfolio with text)*
Ordinary Miracles
Times Square

FILMS

Tropico
The True Story of the Civil War *(Academy Award)*
The Naked Eye
Black Fox *(Academy Award)*
The Other World of Winston Churchill *(television)*
Image of Love

PRINCIPAL EXHIBITIONS

Ateneo Puertorriqueno, San Juan
Museum of Modern Art, New York *(four group shows)*
UCLA Art Gallery *(Dream of Islands)*
G. Ray Hawkins, Los Angeles
Witkin Gallery, New York
Friends of Photography, Carmel
National Gallery of Canada, Ottowa *(group show)*
Allentown Art Museum
Lehigh University Art Gallery
Focus Gallery, San Francisco
Fredrick S. Wight Art Gallery, UCLA *(Ordinary Miracles)*
Photo Gallery International, Tokyo
University of Oregon Art Gallery
Light Works, Syracuse University
International Center of Photography, New York *(Times Square)*
New York State Museum, Albany